TRACY MEMORIAL
NEW LONDON, N.H.

WELCOME

The door is open wide—
The beacon burning bright–Ah, look!
Man's greatest gift to man inside—
A Book

This book has been donated
in honor of Carolyn and Dick Sweetland

enchanted ireland

~

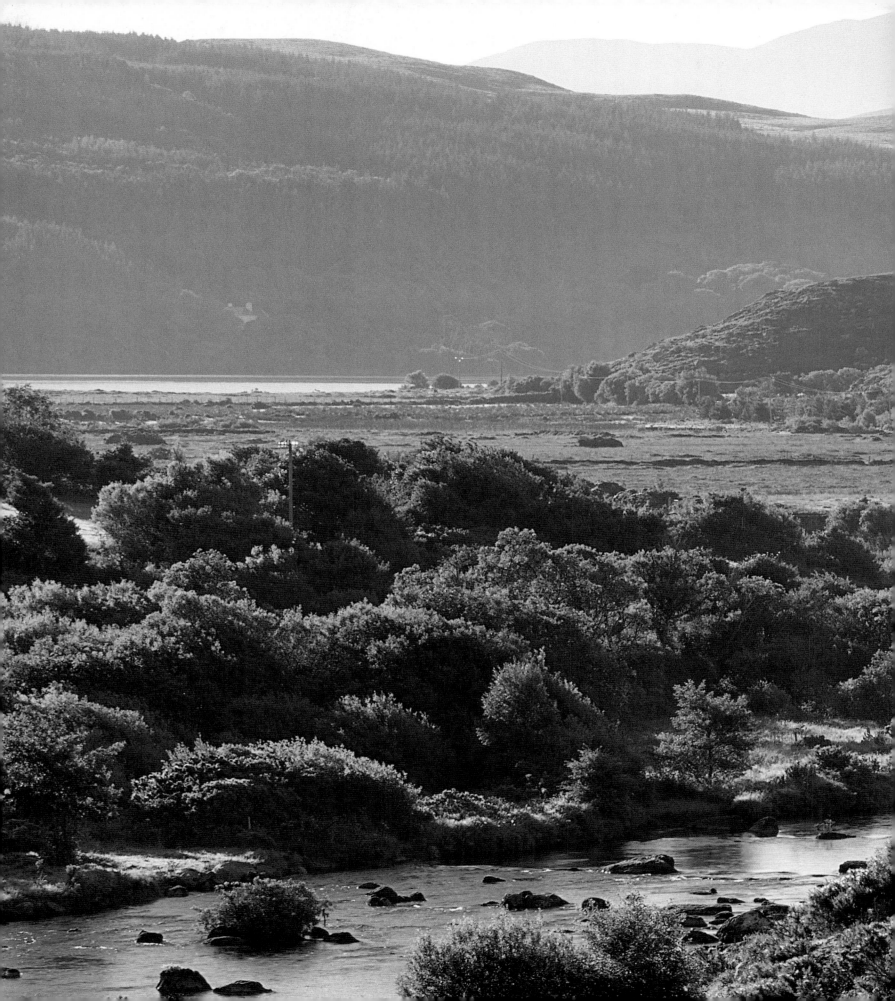

enchanted ireland

~

PHOTOGRAPHS BY
RICHARD TURPIN

TEXT BY
PAUL LAY

SMITHMARK

This edition published in 2000 by SMITHMARK Publishers, a division of
U.S. Media Holdings, Inc., 115 West 18th Street, New York, NY 10011.

SMITHMARK books are available for bulk purchase for sales promotion and premium use.
For details write or call the manager of special sales, SMITHMARK Publishers,
115 West 18th Street, New York, NY 10011.

Conceived and produced by
BRESLICH & FOSS LIMITED
20 Wells Mews
London W1P 3FJ

Text: Paul Lay
Editor: Janet Ravenscroft
Designer: Roger Daniels
Indexer: Peter Barber
Map by Madeleine David

ISBN: 0-7651-1765-7

10 9 8 7 6 5 4 3 2 1

Library of Congress CIP data on file

Title page photograph: View to Macgillycuddy's Reeks, Co. Kerry

Colour reproduction by Global Colour Separation, Malaysia
Printed in Hong Kong by Midas Printing Co.

contents

Malin Head

Giant's Causeway

Inishowen

• BALLYCASTLE

• DUNGLOE

• DERRY

DONEGAL

LONDONDERRY

ANTRIM

Station Island

TYRONE

• BELFAST

▲ Slieve League

• DONEGAL

• OMAGH

Boa Island

• BALLYSHANNON

FERMANAGH

• ENNISKILLEN

ARMAGH

• ARMAGH

DOWN

Donegal Bay

• SLIGO

MONAGHAN

• MONAGHAN

• DOWNPATRICK

• KILLALA

SLIGO

LEITRIM

LOUTH

• DUNDALK

Achill Island

MAYO

• LEITRIM

• CAVAN

CAVAN

Dundalk Bay

▲ Croagh Patrick

• KNOCK

ROSCOMMON

LONGFORD

• LONGFORD

MEATH

• NAVAN

• ROSCOMMON

ROSCOMMON

WESTMEATH

• BECTIVE

• MULLINGAR

GALWAY

• ATHLONE

• TULLAMORE

DUBLIN

• DUBLIN

• GALWAY

• CLONMACNOISE

Galway Bay

OFFALY

KILDARE

• NAAS

Aran Islands

• BALLYVAUGHAN

WICKLOW

The Burren

LAOIS

• PORTLAOISE

• WICKLOW

• ENNISTYMON

• ABBEYLEIX

CLARE

• ENNIS

TIPPERARY

• CARLOW

CARLOW

• LIMERICK

KILKENNY

• KILKENNY

WEXFORD

• ADARE

Mouth of the Shannon

LIMERICK

• CASHEL

• THOMASTOWN

• TIPPERARY

KERRY

WATERFORD

• WEXFORD

• DINGLE

• WATERFORD

• KILORGLIN

WATERFORD

Dingle Bay

CORK

• CORK

• KINSALE

a SMALL, SPARSELY POPULATED island at the fringes of Western Europe, Ireland should be a marginal scrap of land, its history and its fate mulled over by few. Yet it is among the most compelling and the most talked-about places on earth. Ultimately, this must be due to the astonishing vibrancy of her people, living north and south of a border less contested than before, their dynamic culture of ancient pedigree. It is her people's appropriation and mastery of the now ubiquitous English tongue that ensures that Ireland punches way above her weight in matters of cultural import. Which other country of remotely similar size has produced – in W. B. Yeats, George Bernard Shaw, Samuel Beckett and, most recently, Seamus Heaney – four Nobel Laureates?

Three of these literary giants are of a Protestant background. Ireland is a far richer mix of peoples than one might imagine. Celts, Vikings, English, Scottish, Spanish, French, even Germans, have all figured notably, for better or worse, in her history, and left their traces. Similarly, those who imagine the modern Republic as a monolithic Catholic state are way off the mark. That is not to deny the importance of the Church. It was the Irish Church that preserved the ideals of Greco-Roman civilisation as the Dark Ages descended over continental Europe; and it was she who inspired the tradition of scholarship that exists to this day: Ireland's workforce is, after Japan, the best educated in the world. But the Church is now part of a broader picture.

The diversity of Ireland's population is mirrored in her landscape: from the lush, affluent pastures of Tipperary, to the thrilling, Atlantic-battered cliffs of Donegal; from Clare's unreal and eerie Burren, to the mystical lakes of Fermanagh; Antrim's strange, bewitching Giant's Causeway, the Georgian splendour of booming Dublin, the remote, harsh and Gaelic Aran Islands. Some landscapes are well-travelled, others barely known. All have their advocates, all cast their spell.

There has been much talk of late about an Irish economic miracle, the 'Celtic Tiger' as it is known. And there is little doubt that for most of her population life has changed for the better: the Irish have never had it so good, and the sense of optimism is tangible. She is cool, she is hip, her rock stars, sports stars, film-makers and writers feted globally. There is even the possibility that the Troubles of the North are in sight of a solution. But as we enter a Third Millennium, what is most striking to the visitor is that the Old Ways linger on: Ireland has made modern her traditions. Hers is not a history one can or should forget, and it inhabits an equally unforgettable landscape.

the presence of the past

so we beat on, boats against the current, borne back

ceaselessly into the past

F. SCOTT FITZGERALD

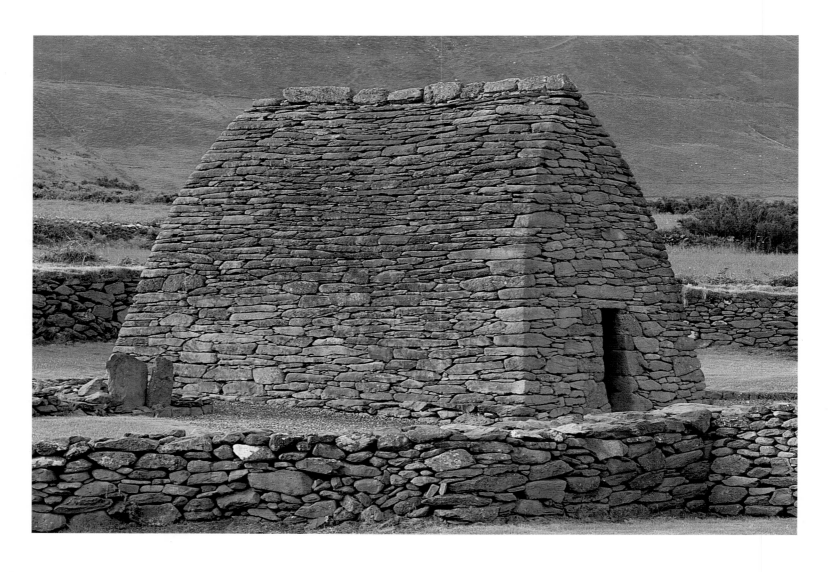

HISTORY HANGS HEAVILY over Ireland, its past one in which myth and reality are inseparable. In early Celtic society the most important relationship of all was that between king and poet. The poet, or *file*, acted as publicist for his king who sought to attain immortality as the all-conquering hero of his *file*'s praise-poetry. No tale was too wild, no action so unbelievable: one Celtic maxim stated 'a poem should not mean but be'. Facts counted for little, only the imagined, hyperbolic deeds of the king. One legacy of this dissatisfaction with life's mundane realities, its disappointments, is the Irish genius for ambiguity, irony and sometimes plain untruth that teases the historian's cold eye.

What we know for certain of Ireland's history began 10,000 years ago when mesolithic hunter–gatherers crossed the narrow land-bridges from Britain to the coastline of a densely forested and all but impenetrable land. Four thousand years later, Ireland by now an island, neolithic farmers landed there in skin-clad coracles and made the first tentative steps to clear the vast forest to make way for crops and animals. Little is known of these ancient people, but their twelve hundred or so dolmens – the sepulchral chambers of unhewn stone that congregate in the north and west – still cast their spell over us as they did over the Celts who, by 500BC, were the dominant people. The Celts imagined their forebears as grotesque giants, calling them the *Fir Bolg*, and incorporated the dolmens into a complex religious system that sought the sacred marriage of king and goddess, and displayed an obsession with fertility all too understandable in a harsh environment frequently ravaged by pestilence, famine and the threat of slavery.

Celtic Ireland was divided into around a hundred different kingdoms or *Tuatha* (peoples), grouped into Fifths – Ulster, Leinster, Munster, Connacht and Meath, the first four of which approximate the provinces of modern Ireland. The Celts were warriors who went into battle in two-horse chariots, hunted the heads of their enemies, and awarded their finest fighters copious food and drink. Hillforts were their essential structures and the outlines of their ditches and dykes are still imprinted on the landscape, evidence of the almost constant, internecine warfare that gave rise to Celtic hopes of a High King, a chieftain for all Ireland, who could unite the disparate tribes in peace and prosperity. He never came.

In the 4th century AD, Christian missionaries first set foot in Ireland and began the long struggle of conversion. There were many of them, but one remains ascendant: St Patrick. Born in Britain, the son of a deacon, Patrick was captured by Irish slavers at the age of sixteen, escaped six years later, and returned to Ireland to change the course of her history forever. The potent nature of Celtic Christianity brought Ireland into contact with the mainstream of European culture. The Dark Ages, paradoxically, were a time of unparalleled stability and achievement, and Irish monks were highly regarded scholars.

At first, Celtic monasteries were isolated, holy retreats from a sinful world. Some, like Skellig Michael, 13 km (8 miles) off the coast of Kerry, were little more than rocks jutting out of the Atlantic from which a single monk would commune with his God. But others became centres of

*A*t the western reaches of Kerry's Dingle Peninsula stands the perfectly preserved Gallarus Oratory. Built of drystone in the 8th century on the old Saint's Road to Holy Mount Brandon, it was a place of shelter for foreign pilgrims, hence 'Gallarus', which means 'House of the Foreigners'. Its sagging walls suggest Gallarus will eventually cave in, but such is its craftsmanship that this fate has been postponed. ～

cultural brilliance, attracting the rich and the powerful. The greatest monastic sites – among them Clonmacnoise in Co. Offaly, Clonfert in Co. Galway, and Enda on the Aran Islands – were more like ecclesiastical cities, the powerbase of kings, culturally brilliant, their vast estates dispersed all over Ireland.

Here the Celts' great oral tradition was collected and written down, though not in *Ogham*, their early script of lines and notches, but in Latin, and illuminated to dazzling effect. One collection of stories *Tuatha Dé Danaan* ('The Tribes of the Goddess Danaan') told of a mythical race of gods who inhabited Ireland long before the Celts, but others were loosely based on the lives of distant historical characters, akin to the British legend of King Arthur and no less fanciful. Foremost among them was the glorious, coarse, gigantesque *Táin Bó Cuailnge* ('The Cattle Raid of Cooley'), Ireland's national epic that tells of the young hero Cú Chulainn, the 'Hound Of Ulster', and his lusty battle with the mighty Queen Medb over possession of a prize bull. Later came the Ossianic or Fenian cycle, stories of Fionn mac Cumhaill, his son Oisín, his grandson Oscar and their war-band of outlaws or *Fian* who harry their enemies Diarmuid and Grainne. These are topographical tales, violent celebrations of the virgin landscape of Ireland, a land forever to be referred to in the feminine, and notable for the unusual prominence and complexity of their female heroes, promiscuous, strong and touched with divine power.

This was the Golden Age of Celtic Christianity. St Columba ventured far afield, founding monasteries in France, Germany, Austria, Switzerland and Italy. St Brendan the Navigator, the founder of Clonfert, may have ventured even further; some claim he reached America almost a thousand years before Columbus in a boat made of leather. But monastic Ireland found itself prey to Vikings whose raids began in 795. By the middle of the 9th century they wintered in Dublin, controlled the Shannon and plundered Clonmacnoise and Clonfert. Eventually, Celtic Ireland would learn to live and trade with the Vikings, who left their mark in place names such as Wexford, Wicklow and the Blaskets. A greater menace threatened.

By the 12th century feudalism had established itself as the dominant political system in Western Europe and its principal exponents, the Normans, had already conquered Britain. They cast covetous eyes over Ireland but, ironically, their chance to invade came at the invitation of an exiled King of Leinster who called on the Norman adventurer Richard FitzGilbert de Clare, otherwise known as Strongbow, to regain him his throne. The English king, Henry II, concerned that Strongbow was establishing an alternative powerbase, sought authority from Adrian IV – the only English pope – to claim Ireland for himself. Henry received the backing of Irish bishops and a number of chieftains, many acting against the wishes of their people. The foundations for foreign rule were laid.

Ireland's network of castles were the Anglo-Normans' chief means of control, though for centuries the Irish restricted English power to the 'Pale', the area around Dublin. Only in 1649, with the coming of Oliver Cromwell and his 20,000 troops, fresh from victory in the English Civil War and fuelled by Puritan ideology, did Ireland succumb fully. Her Gaelic-speaking, Catholic population was slaughtered or shunted to 'Hell or Connacht', the subsistence lands west of the Shannon. Centuries of domination would serve to enhance an idealised, heroic past of kings and poets.

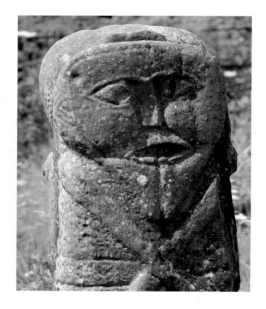

*t*he double-faced figure of 'Janus' that stands on Boa Island in Co. Fermanagh's Lower Lough Erne, is testament to the Celtic obsession with sex and violence. Seen here is a belt for the bearing of weapons; the reverse reveals a phallus, symbol of fertility. ～

*t*radition said that Ross Castle (opposite), could never be taken by land, but in 1652, on hearing this tale, Cromwell's commander and later surveyor of Ireland, General Ludlow, sailed his men close to its walls and the castle's defenders, despite their long, brave struggle, gave themselves up. It was the last place in Munster to succumb to Cromwell's forces. ～

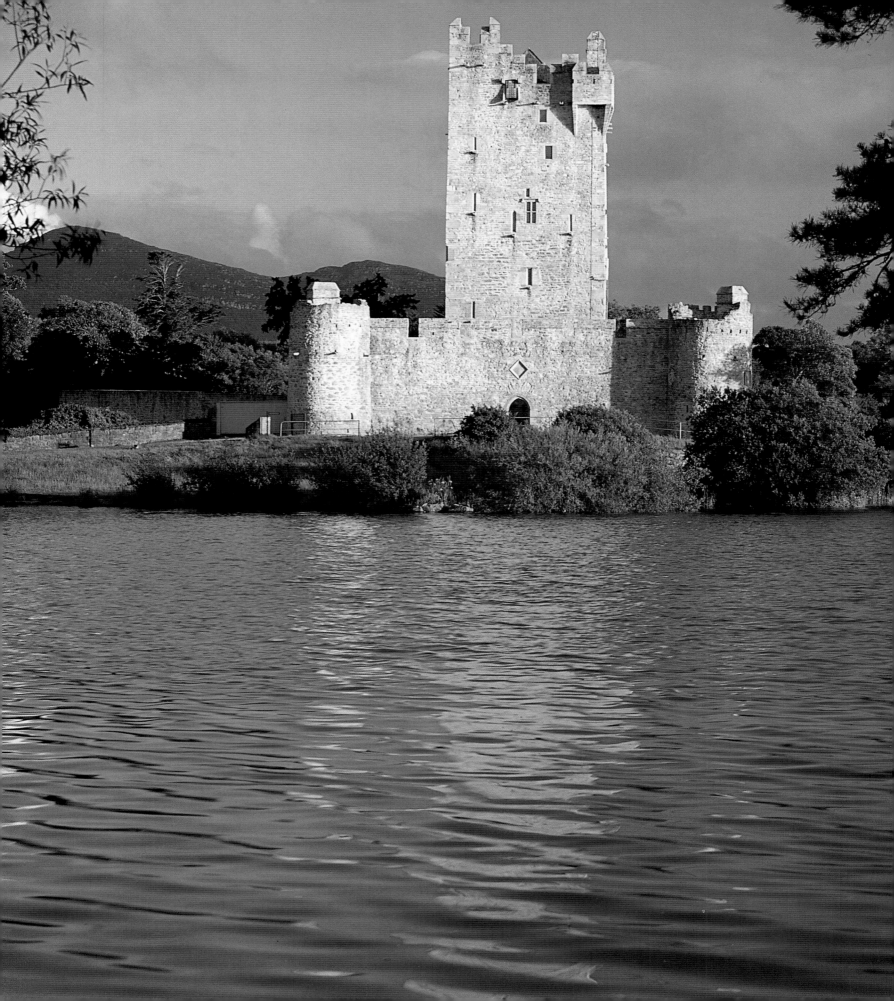

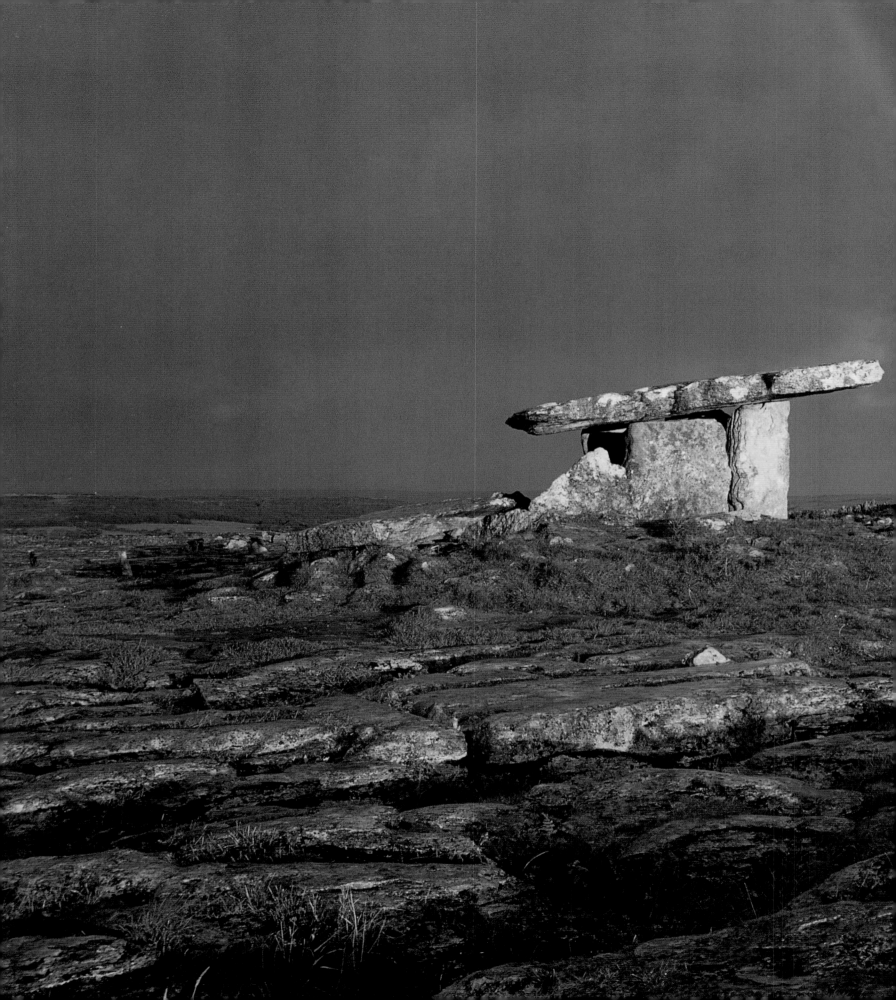

the Burren, the grey, cracked limestone pavement that covers 160 square kilometres (100 square miles) of Co. Clare, is a denial of all images of Ireland as a green, fertile land. Ludlow described it as 'yielding neither water enough to drown a man nor a tree to hang him, nor soil enough to bury.' But here, where the sun and rain conspire to weave strange, ever-changing patterns of light, the imagination takes flight. Dolmens and other relics of Ireland's earliest inhabitants, some dating back as far as 5000 years bring further grace to a bitter, blurred landscape mirrored in the trio of Aran Islands, visible from the Burren, that were once attached but now linger lonely in Galway Bay. ∽

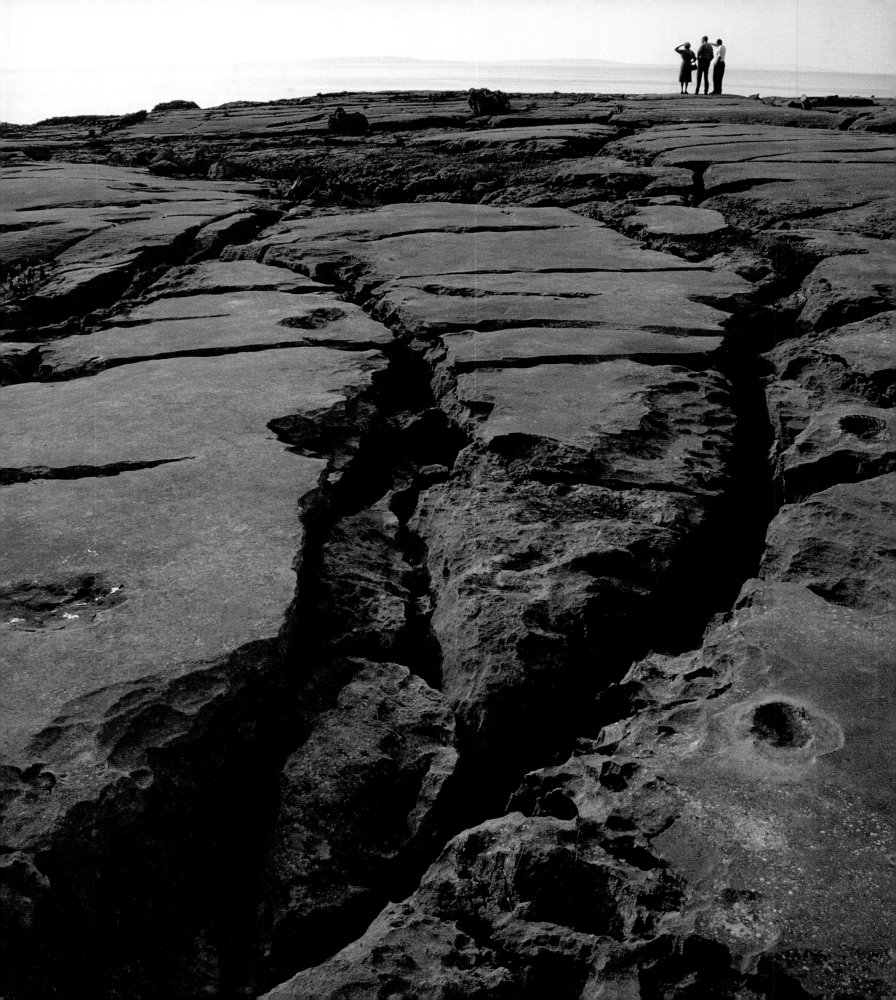

rykes are the name given to the great furrows etched into the Burren (left) that support its minimal but unique assembly of flora: arctic, alpine and mediterranean blooms congregate amid the cracks, sheltering from the raw, eternal wind. Their colourful presence, which gives the lie to the Burren's apparent sterility, is all the more impressive set against the monochrome surroundings. Yet this is transient land, nothing can survive for long, not even the turloughs – lakes peculiar to the Burren – that live or die by the yield of rain. Few men have the qualities to survive in such a cruel place, something that Cromwell knew all too well when he drove some of the defeated, dispossessed Irish here as his troops took command of Ireland's distant fertile pastures. ❧

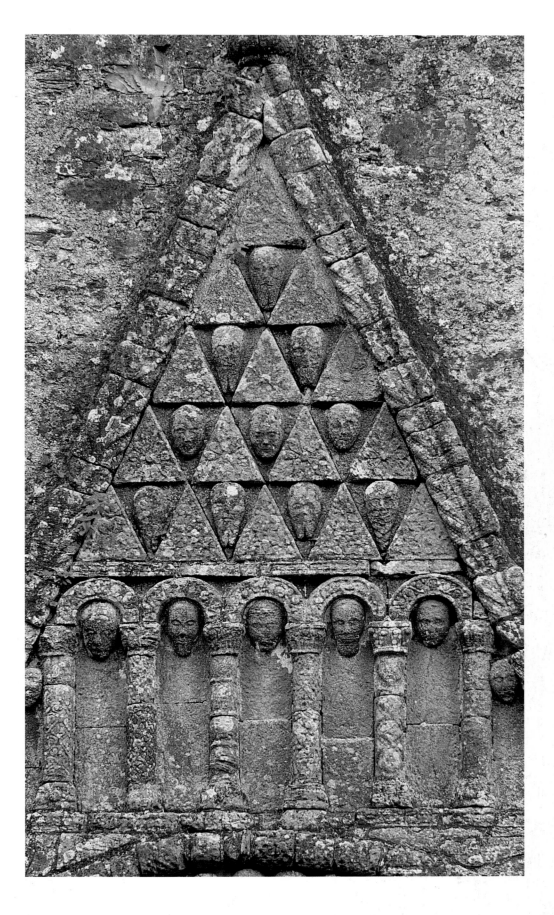

detail from the romanesque west door-way of Clonfert Cathedral, Co. Galway (right). Standing on the west bank of the Shannon, Clonfert was one of numerous monastic sites founded by St Brendan, this one in AD 563. The cathedral was built in 1167 by the chieftain Conor O'Kelly to celebrate reforms in the Irish Church. The west doorway is an exquisite creation, the finest edifice of any Irish religious building, notable above all for its carvings of twenty-five human heads framed by arches and triangular panels. Yet despite the grandeur of its design, Clonfert is barely recognisable as a cathedral at all, with a capacity of barely a hundred souls. The remoteness and poverty of the West Coast could not sustain the ample congregations common to the rest of Christendom. ❧

Many castles in the west of Ireland hardly merit the name, being more like lightly fortified houses. These were popular during the 15th and 16th centuries among the very few rich families able to maintain their status in such remote regions. Cregg Castle, which clings to the Burren in Co. Clare, is one such place. Nowadays, local tourist authorities hire these 'castles' out for medieval banquets, one aspect of the heritage industry that's closer to the original owners' intentions than guests might appreciate. ∾

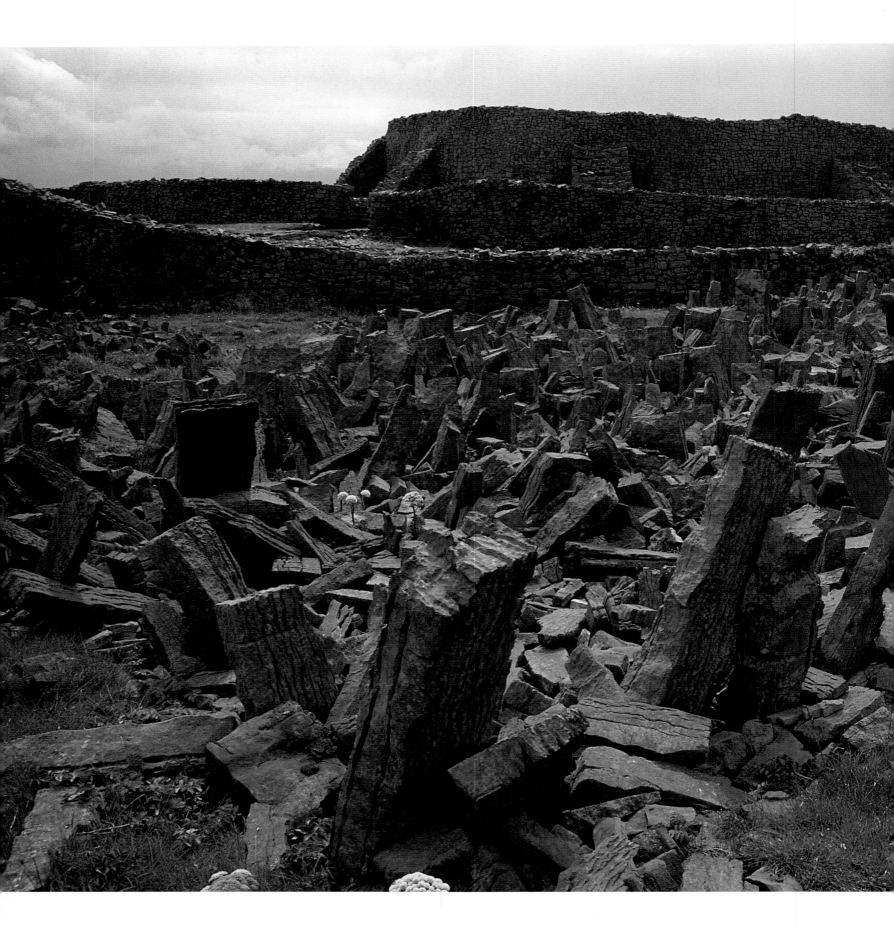

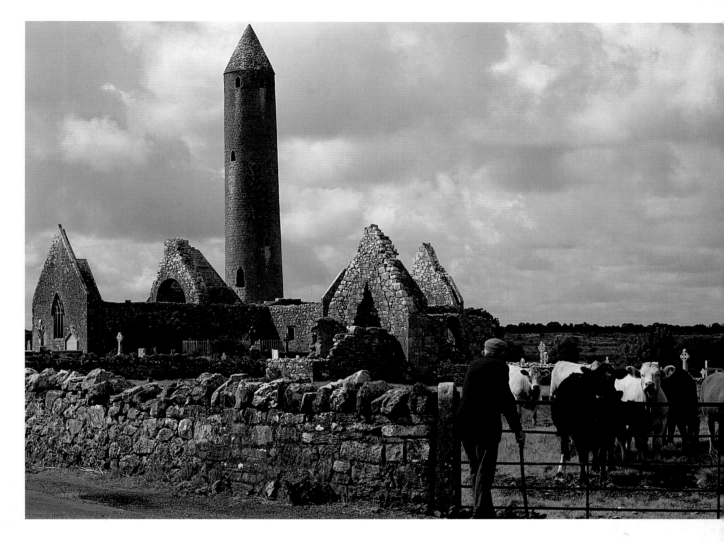

Dún Aengus (left), a massive, semi-circular ring fort, is one of Ireland's most startling and evocative prehistoric sites. Its position, perched 90 m (300 ft) high on the cliffs of Inishmore, the largest of the three legend-rich Aran Islands that stand 50 km (30 miles) out in Galway Bay, is both dramatic and defiant. The chevaux-de-frise that guard its entrance – jagged rocks that snarl at would-be attackers – appear capable of stopping even a modern tank in its tracks. It is said that if you look out to the west from Dún Aengus, when the weather conditions are right, you will see a mythical island, Hy Brasil, a haven for saints and Celtic heroes. There are many still living who swear of its existence and the island was marked on the oldest Irish maps. ∽

a farmer cares for his cattle beside the ruins of Kilmacduagh Monastery, Co. Clare (above). The Viking raids that began in the late 8th century gave a new impetus to Irish stone-building in preference to all-too-vulnerable wood and, with monasteries the principal targets of the Norsemen, a new and distinctive style of monastic architecture developed. Many of these lie in ruins across the Irish landscape, from Glendalough, Co. Wicklow in the east of the country, to Enda on the Aran Islands. ∽

In 1639, Dunluce Castle fell victim to a storm that ravaged the Antrim coastline and lost its kitchens to the sea. It was an ignominious end for the imposing home of Sorley Boy MacDonnell, leader of the MacDonnell clan, the 'Lords of the Isles'. 'Yellow Charles', as his name meant in Irish, was forced to abandon Dunluce in 1584 to the English forces of Sir John Perrott. But in a daring mission that saw his men scale the fiercesome cliffs in baskets, Sorley retook Dunluce, made peace with the English, and his son, Randal, became Earl of Antrim. Long abandoned, Dunluce Castle is one of Ireland's greatest ruins and, with its incomparable position, casts a strong spell over all who enter its labyrinthine interior.

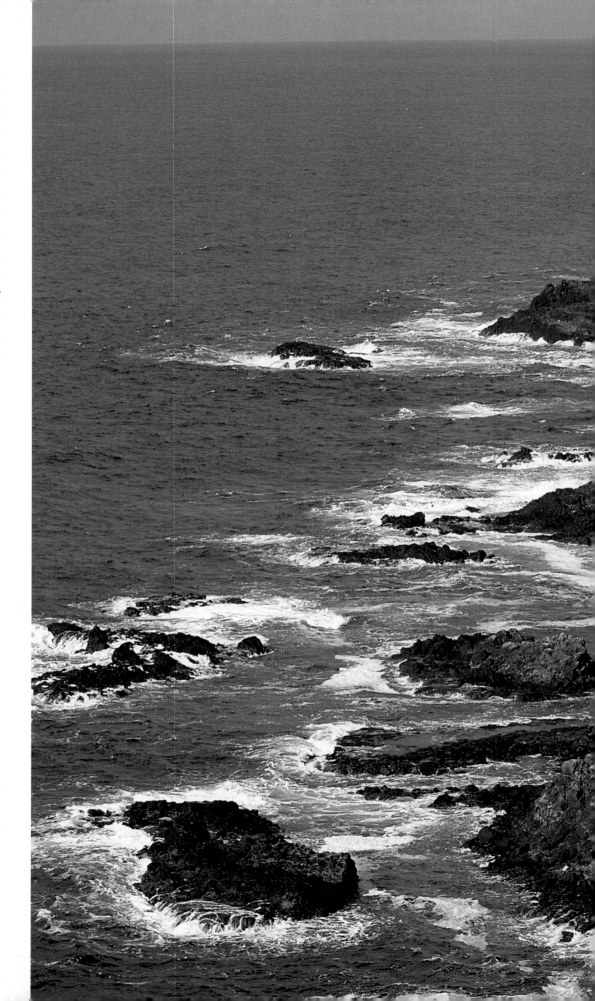

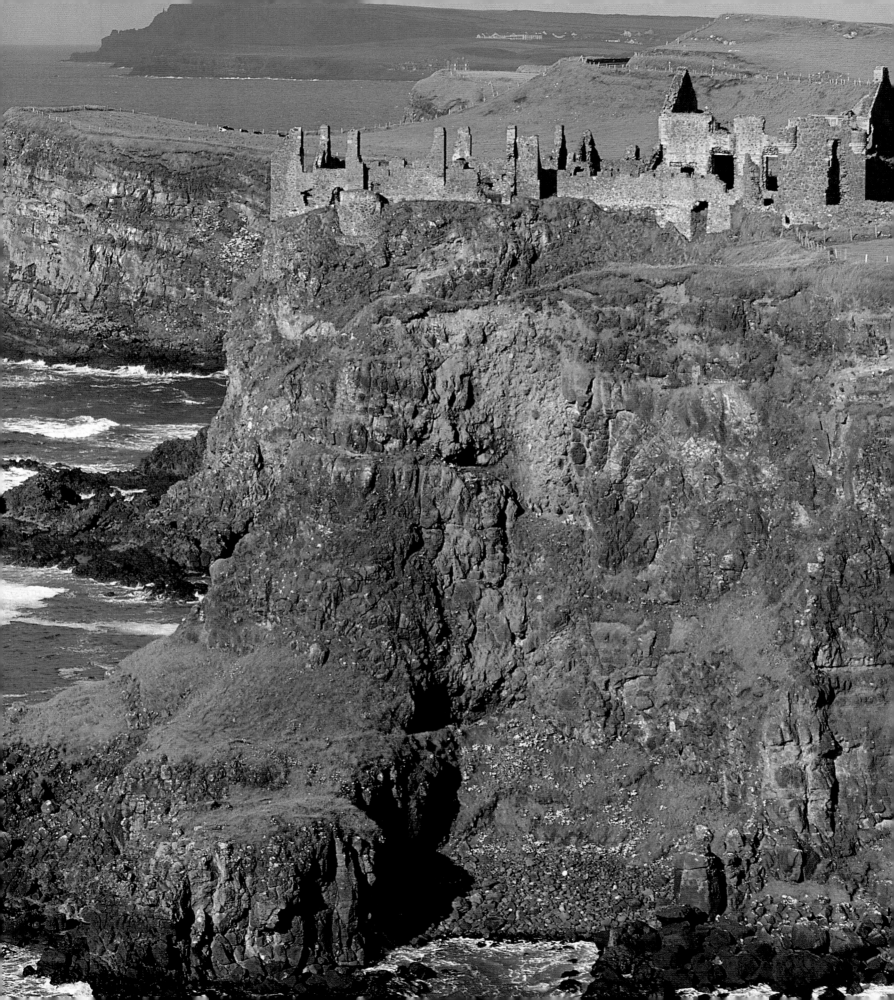

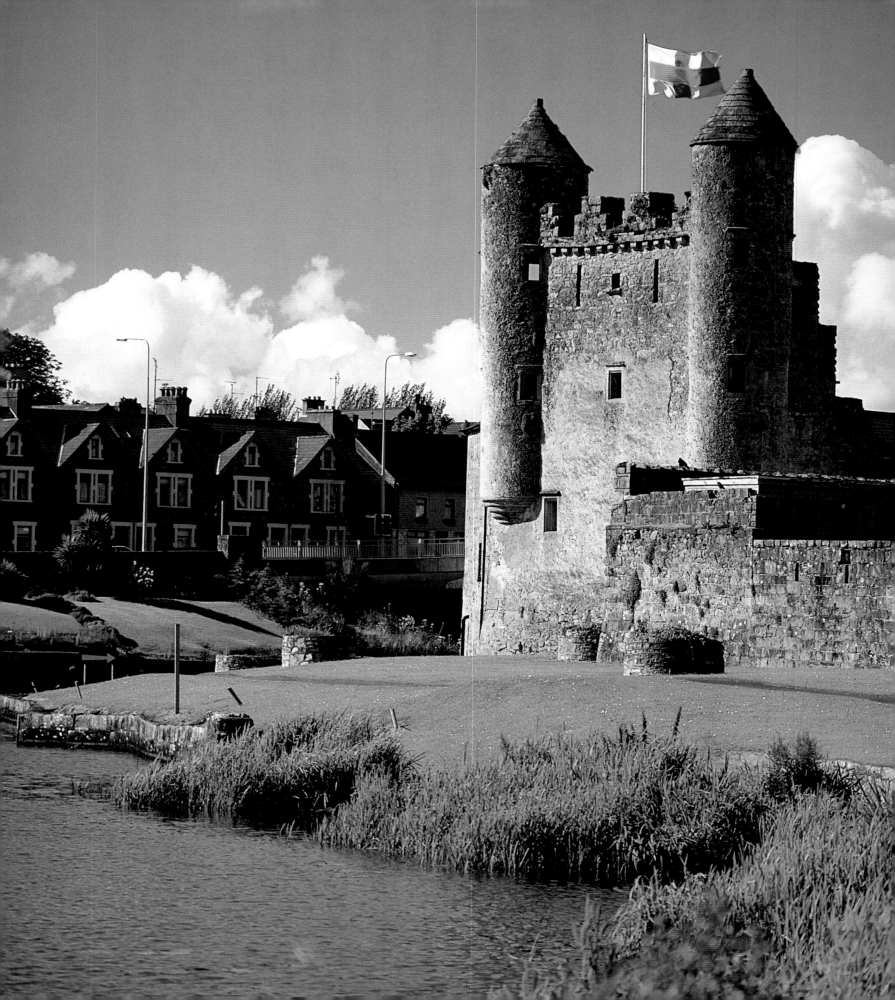

the Watergate of Enniskillen Castle, Co. Fermanagh (left), is reflected in the water that surrounds the neat and orderly little market town that sits on an island between lower and upper Lough Erne. The castle, which appears too gentle to be a military building, was built by Robert Cole who was given the town by the British in 1609. Enniskillen prospered over the centuries, its colonial atmosphere seemingly more British than anywhere in mainland Britain could ever be. Its famous Portora Royal School, tucked away on a hill that overlooks the town, produced two of Ireland's greatest writers, Oscar Wilde and Samuel Beckett. Sadly, the name of Enniskillen is now more closely associated with the IRA's Remembrance Day bombing of November 1987 that left eleven of its citizens dead and many more injured. The attack, on a town with little sectarian strife, brought worldwide condemnation. ∽

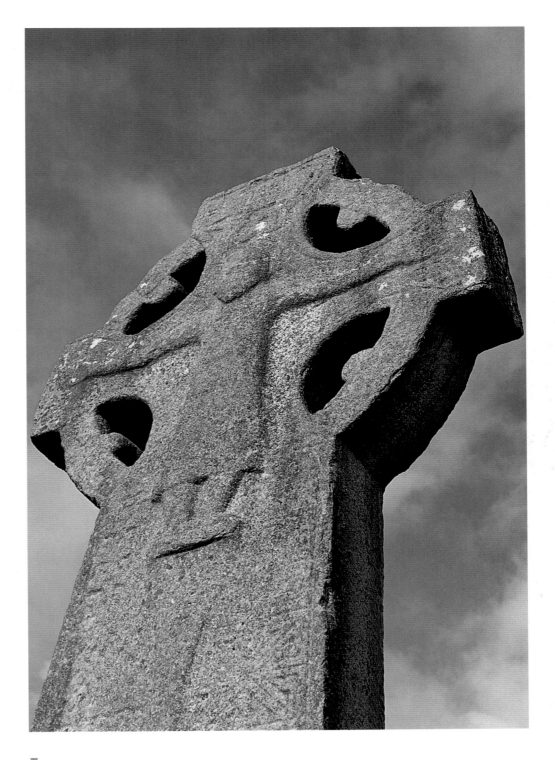

Kilfenora, a tiny village south of the Burren in Co. Clare, is famous for two things: its traditional music, and a cluster of impressive, well-preserved 12th-century high crosses that stand in the grounds of the village's cathedral. The one that appears above shows a simple image of the crucified Christ against a typically Celtic design. Foremost among the others is the famous Doorty Cross, which depicts Christ's entry into Jerusalem on the west face, with images of bishops and other important churchmen of the time on the east face. ∽

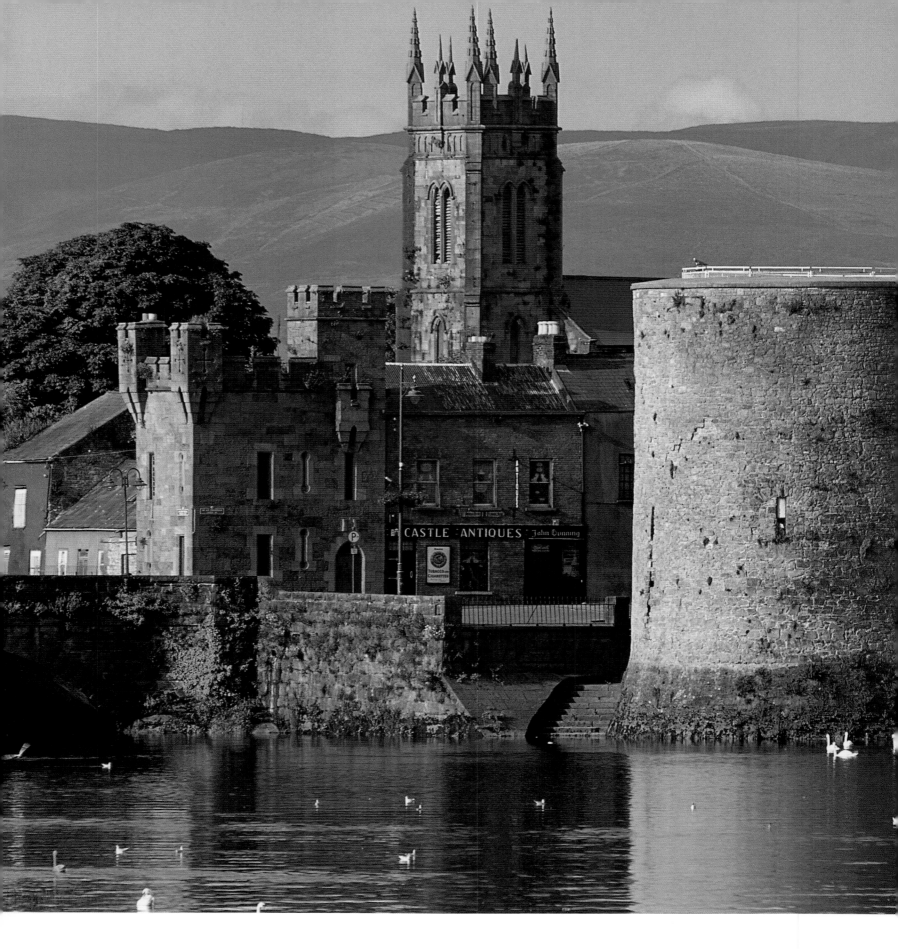

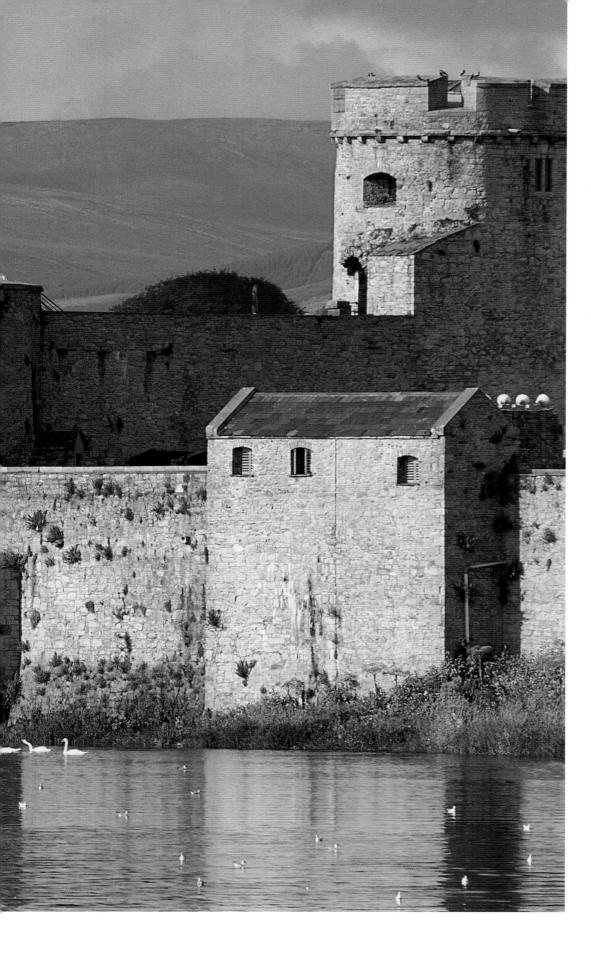

King John's Castle, built on the orders of the eponymous British king in 1210, is one of the finest medieval structures in Ireland. It brought some long-desired order to Limerick, for so long a luckless city, but only at the cost of forcing the local population into the ghetto of 'Irishtown', across the Abbey River. Trouble was to return to Limerick, whose name in Irish means 'a barren piece of land', when first Cromwell's forces besieged it then, four decades later, the Jacobite followers of Patrick Sarsfield chose the castle as the site of their last stand against the army of William of Orange. Following the Jacobite surrender, the English reneged on their treaty terms and Limerick became the victim of intense anti-Catholic measures that still leave a bitter taste. ∽

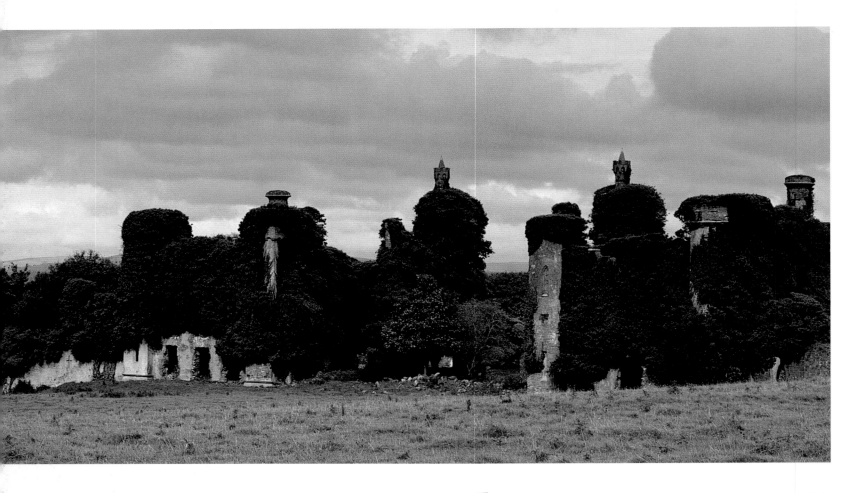

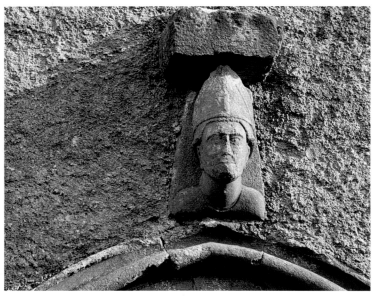

The combination of notoriously fickle weather and splendidly decrepit ruins can create some of Ireland's most delightful vistas. The medieval settlement of Thomastown, Co. Kilkenny (above), provides one of the best. The ruins of its 13th-century walls, castle and cathedral appear to change shape and colour depending on the shifting alliance of sunlight, rain and a seemingly ever-present canopy of swift cloud. Stand close to any of Ireland's historic sites and you will see the weathered, blunted faces of ancients, like this bishop atop Kilfenora Cathedral (left), or the slow reassertion of nature as at Thomastown Castle (right). ∾

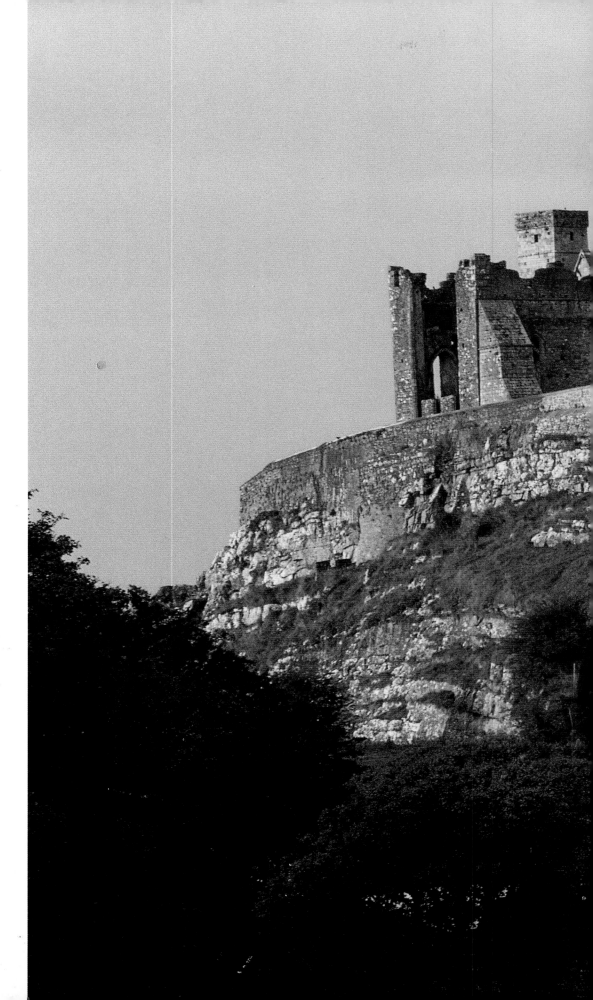

The ecclesiastical complex called the Rock of Cashel completely dominates the Tipperary town. Cashel was the seat of the legendary High King of Munster, Brian Boru. On the verge of assuming the role of High King of Ireland, Boru was killed at the Battle of Clontarf in 1014, though his forces managed to defeat a combined army of Vikings and Leinster chieftains. Legend says that the Rock was formed when the devil threw a huge stone at St Patrick who was planning to build a new church on the site. The Rock's chief glory, apart from its location, is Cormac's Chapel, a complete, intricately decorated romanesque church, built by the king-bishop of Cashel, Cormac MacCarthy between 1127 and 1134. It has no rival in Ireland. However, the scale and the design of the rest of the complex's architecture is impressive: the Hall of the Vicars, a 15th-century building meant for the performance of choral works but now containing St Patrick's Cross; the elegant limestone cathedral, erected a century after the chapel; and a fairy-tale pairing of the richly crenellated central tower and the outer round tower. ∾

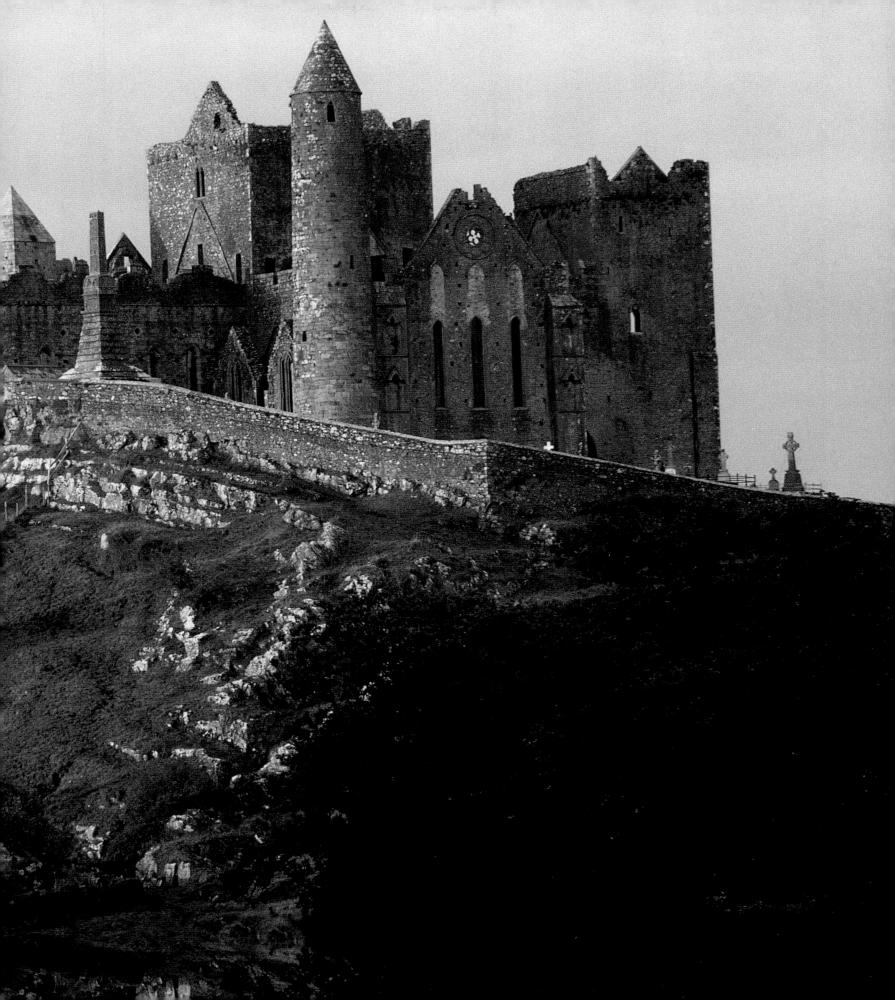

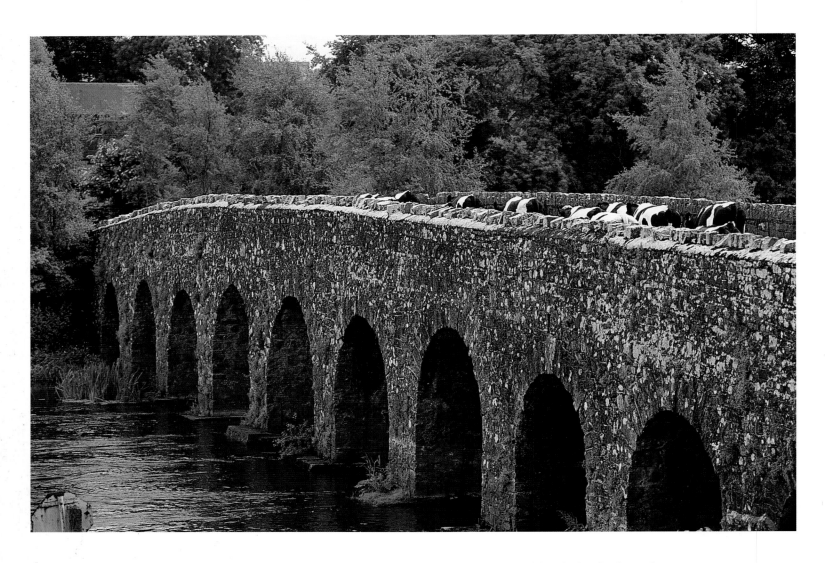

Cattle cross the Knightsbrook River on the medieval bridge (above) that leads to the Cistercian splendours of Bective Abbey, Co. Meath. One of the great joys of Ireland is that many of its finest historical buildings and most remarkable ancient sites lie hidden in quiet, unspoilt rural areas where modern life is seemingly yet to intrude. Many fixtures notable to the outsider, such as the carefully crafted Bunlahinch clapper bridge (right) in Co. Mayo's Murrisk Peninsula, are everyday objects for the local population, as important to the functioning of daily life today as they ever were, and one of the reasons why so many remain in such splendid shape.

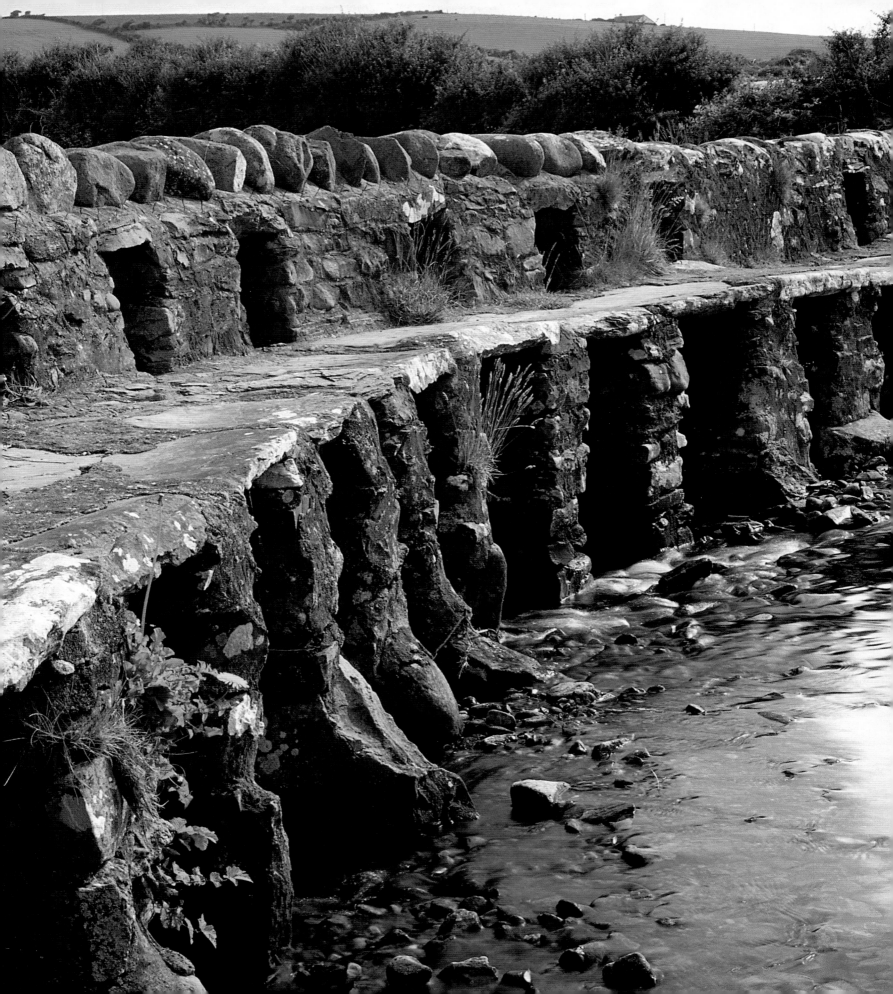

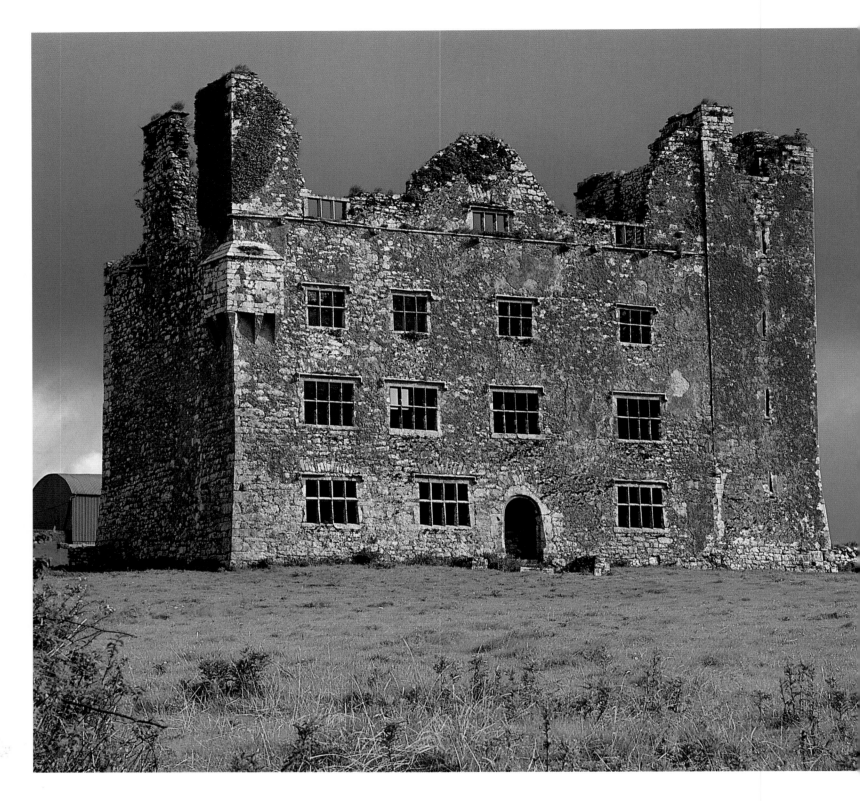

Leamaneh Castle in Co. Clare was the 15th-century stronghold of the O'Brien family which was then at the zenith of its considerable power. The head of the family, Tadhg O'Brien, even boasted that his allies were 'working his coming to Tara', a reference to the mythical seat of the high-kingship, a position he longed to attain. Their ambitions foundered over time but, due to the family's firm, some say cynical, support for the Protestant succession, the O'Briens were one of the few families of Gaelic origin to become part of the 18th-century landed elite.

The White Cross of Tola, with its high-relief carvings of a bishop below a crucified Christ, and scenes from the Old Testament story of Daniel in the lions' den, stands in the ample grounds of the 8th-century monastery founded by St Tola near Dysert O'Dea, Co. Clare. The real function of Ireland's distinctive high crosses remains something of a mystery. Some believe they may have been used as visual aids during outdoor masses, or maybe they were boundary markers or monastic status symbols. What is known is that most of them date from the 9th and 10th centuries when the skills needed to carve them were rare outside Ireland. The 12th century saw something of a revival, but then the art disappeared. They remain the enduring symbol of Celtic Christianity.

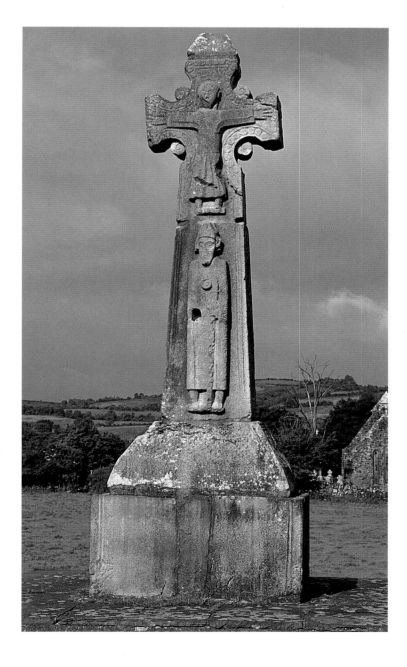

everyday magic

the sort of belief i see in ireland is a belief emanating from life, from nature, from revealed religion, and from the nation. a sort of dream that produces a sense of magic.

F.R.HIGGINS

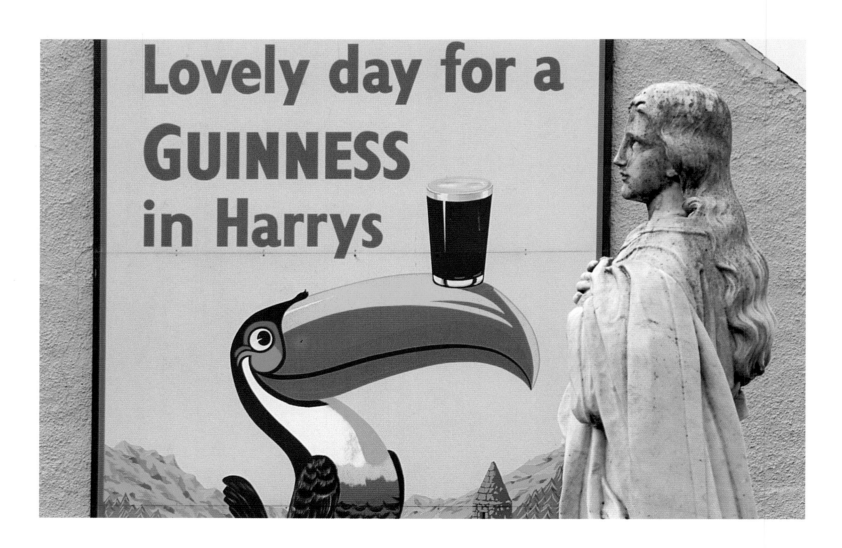

RELIGIOUS ICONS CONFRONT advertising hoardings; a nun collects a flask of holy water from an airport carousel; the priest, roll-up in mouth, Guinness in hand, decked out in full regalia, holds court in his local pub; a priceless 9th-century high cross stands forgotten in a farmer's field with only a tethered bull for company. By such incongruities is Ireland rendered special. So much of her everyday life, however routine, takes on a surreal and magical quality, a result of the constant friction between the sacred and the profane, the beautiful and the banal.

This was the territory of the great, drunken satirist, Flann O'Brien, who addressed the nation's benign madness in a trio of comic novels – *The Poor Mouth*, *At Swim-Two-Birds* and *The Third Policeman* – which anticipated the South American school of magical realism by three decades. Despite their crazy contentions, these wild flights of fancy, peopled with chronically poor peasants, incompetent gods, and absurd authority figures, held their readers in rapture because they were fundamentally true to the realities of a society in which nothing is deemed too strange, and where the combination of the Mass, the market and the pub, the 'holy trinity' of Irish social life, proves an explosive and inspiring mixture.

*t*he Guinness toucan, traditional salesman of the national drink, appears to offer a pint to a religious statue that averts its eyes from such earthly temptations. This typically Irish juxtaposition of sacred and profane is from Co. Westmeath though it is duplicated throughout Ireland in intriguing clashes between secular pleasures and religious duties.

The pub serves as hothouse, the nursery of Irish eloquence, a place to lubricate tongues with the 'black stuff', and where, from an early age, the art of conversation is practised and perfected. In church, words are weighted with grave authority, through ritual and incantation, and a reverence for life's mysteries is embraced. The markets, the horse fairs, the festivals send the language into battle, bartering, boasting, 'mouthing off', calling attention to itself, living on its wits.

If talk runs free in Ireland, it is closely pursued by the printed word, a concern with literature common to her people through all the ages. Books, elsewhere threatened by a modern, more passive, less concentrated culture, are valued here by a population of brilliant talkers, envious perhaps, yet also admiring of those who set down for posterity their own fanciful inventions.

It comes as no surprise that Ireland as a literary nation punches way above its weight. Nobel Laureates – William Butler Yeats, Samuel Beckett, Seamus Heaney – abound and, in part, modern Ireland was created by writers: the leader of the 1916 Easter Rising, poet-turned-revolutionary Patrick Pearse, sought and – due to the ineptitude and arrogance of Ireland's British rulers – gained a blood sacrifice, redolent of the ancient epics, that he believed would awaken the Irish nation to liberation.

His great and complex contemporary, W. B. Yeats, began as a rebel – he was a member of Pearse's Irish Republican Brotherhood – but became disaffected by the simplistic rhetoric of rebellion and sought to forge a shifting national identity through the pen rather than the gun. Yeats cultivated an interest in the hermetic and esoteric entirely in keeping with Ireland's pagan traditions, castigating the 'Newton's Sleep' of rationality, and identifying himself with the ancient Irish bards. The contradictions in Yeats's life – a Protestant Nationalist, a modernist captivated by a distant past, a defender of liberty

entranced by fascism – make him a difficult man to pin down: F. Scott Fitzgerald's declaration that 'the mark of a first-rate mind is its ability to hold opposed ideas while yet retaining the capacity to function' has rarely proved more apposite.

The loose literary movement that grew up around Yeats became known as the 'Celtic Twilight' and embraced such figures as the playwright J. M. Synge who developed an obsession with the remote, Gaelic-speaking Aran Islands. It sought to re-create a specifically Irish literature, drawing upon the folk and fairy tales, littered with 'banshees and the good people', that was still current in the *Gaeltacht*, the Gaelic-speaking areas of the far West. These writers turned for inspiration, like the bards of old, to Ireland's great natural treasures – the Giant's Causeway in Antrim; Sligo's Isle of Innisfree; the swan-bedecked lakes of southern Co. Galway; the bluff headlands of Cork and Kerry; the stark, rainwashed beauty of Connemara; and, in Synge's case especially, the raw world of the Aran islanders. They made the popular superstition-rich discourse of peasant Ireland public and respectable for the first time. For the Irish have long used language to imbue their world with a supernatural quality, a residue of paganism somewhat at odds with their long, loyal but sometimes less than deferential attachment to the Church. Unlike the English who sought to harness control of their new colony through the cold, rational science of cartography, the Irish have sought a more poetic realisation of their land, casting identity on a place through legend and inspiration. *Dudsenchas*, the art of naming, was the means by which a place came into being.

Perhaps this is why Ireland still contains so many settlements of extraordinary presence and vitality. Of course one expects wonders of the great cities, yet just as remarkable and as rewarding are the tiny, remote villages that manage to sustain, even if only for a few days a year, a rich and sensuous cultural life: Doolin, in Co. Clare, the mecca of traditional music fans, whose three pubs attract artists of world renown; Dungloe, the sleepy Donegal town that comes alive for its annual, ironic celebration of Irish maidenhood – with red hair to the fore – a gentle Celtic spin on the traditional beauty pageant; and the 'crack' conjured up every weekend in the solitary pub that stands on high ground beneath the inky, starlit sky of austere Inishmaan.

Can modern Ireland, a nation willed into being by poets, maintain its reverence for ancient wisdom, the superstitions of old, its wilful eccentricities, and the inspiring beauty of its landscape? Or

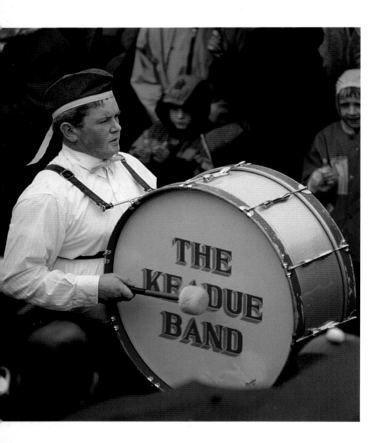

Drumming up a storm (above) in Dungloe. The Donegal town comes alive for the annual midsummer festival, Mary of Dungloe, which purports to be a celebration of traditional female beauty (right). In reality, like most of Ireland's myriad festivals, it is an elaborate, but no less enjoyable excuse for an almighty party. ◡

will the ravenous appetite of the Celtic Tiger, the long-awaited and much-deserved economic boom fuelled by a youthful, talented, highly educated populus, eat into yesterday's simple and singular pleasures? While no one should idealise or underestimate the sufferings of the past, few travellers taking the road to Galway today can be but saddened by the rural sprawl of hastily erected, monotonous bungalows that stand in such sharp relief to the bright, mural-bedecked houses of a century ago. Is Ireland becoming careless of a landscape to which it owes its very identity?

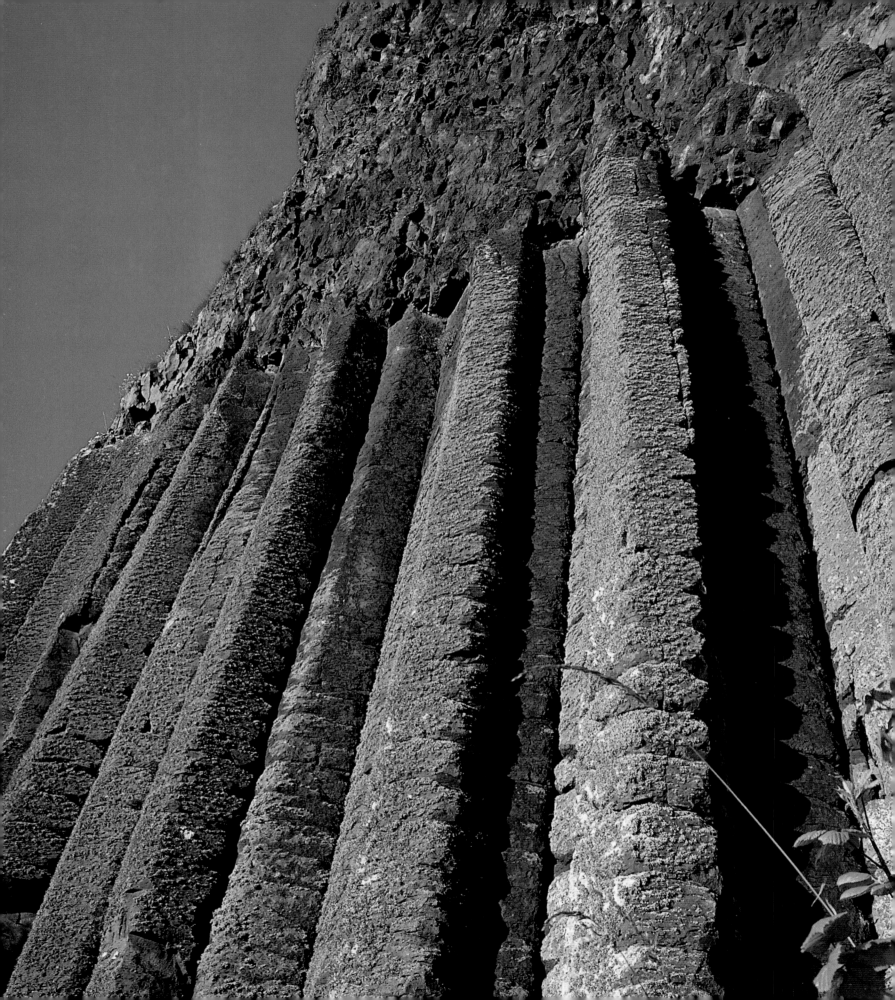

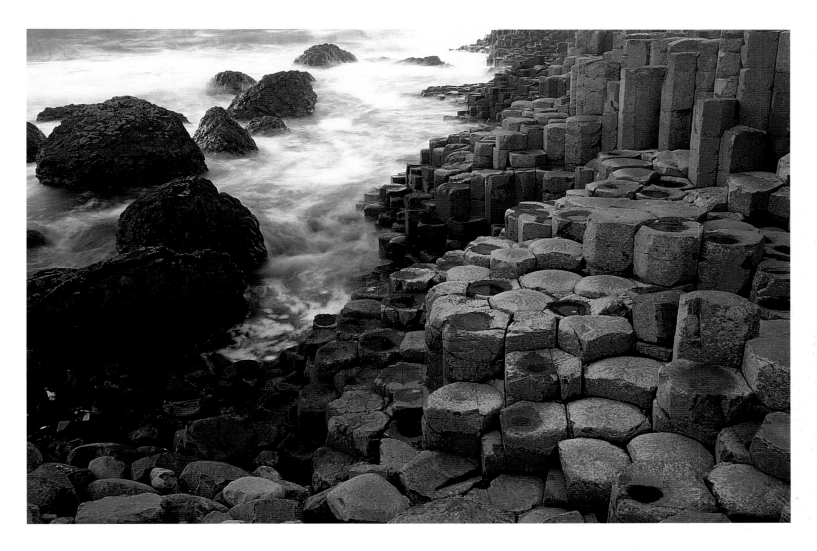

'*T*he Organ' (left) of Antrim's Giant's Causeway, Northern Ireland's strangest and most compelling natural attraction. Made up of 37,000 basalt columns (above), every one a polygon, it is hard to credit that the Causeway's remarkably regular geometry could be anything other than the creation of some ancient supermen. And, of course, the Irish have such a story. According to the legend of Fionn mac Cumhaill, the Ulster hero built the Causeway to make his way to Scotland in pursuit of a giant. In truth, it was the result of an enormous underground eruption 60 million years ago, and the great outpouring of molten basalt that resulted cooled rapidly into the crystallised shapes we see today. Most visitors are staggered by the sight, but the English author William Makepeace Thackeray was less than impressed. 'I've travelled one hundred and fifty miles to see that?' he is claimed to have said.

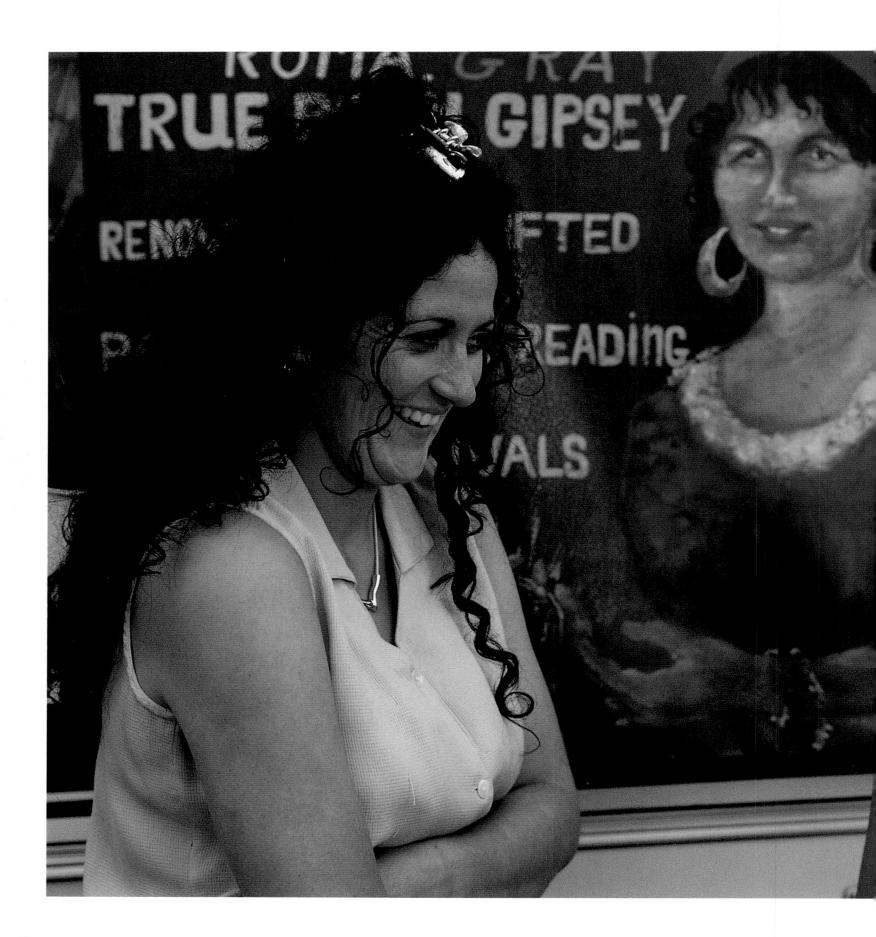

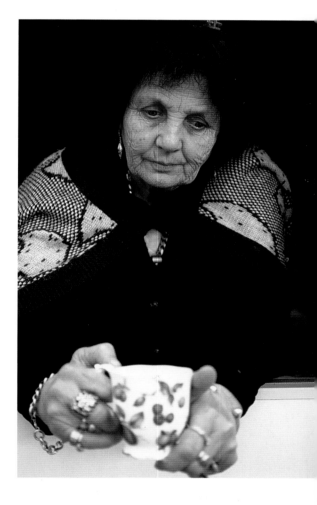

allinasloe, Co. Galway, is host to one of Ireland's most famous agricultural fairs. These largely died out in the early, depressed years of this century but the more famous were revived in the 1950s. For most visitors today they are nothing more than an enjoyable day out, a place to indulge in a little esoteric hokum, like the reading of tea leaves (above), a mode of fortune-telling closely associated with Ireland's 'Gypsy' community, the Tinkers.

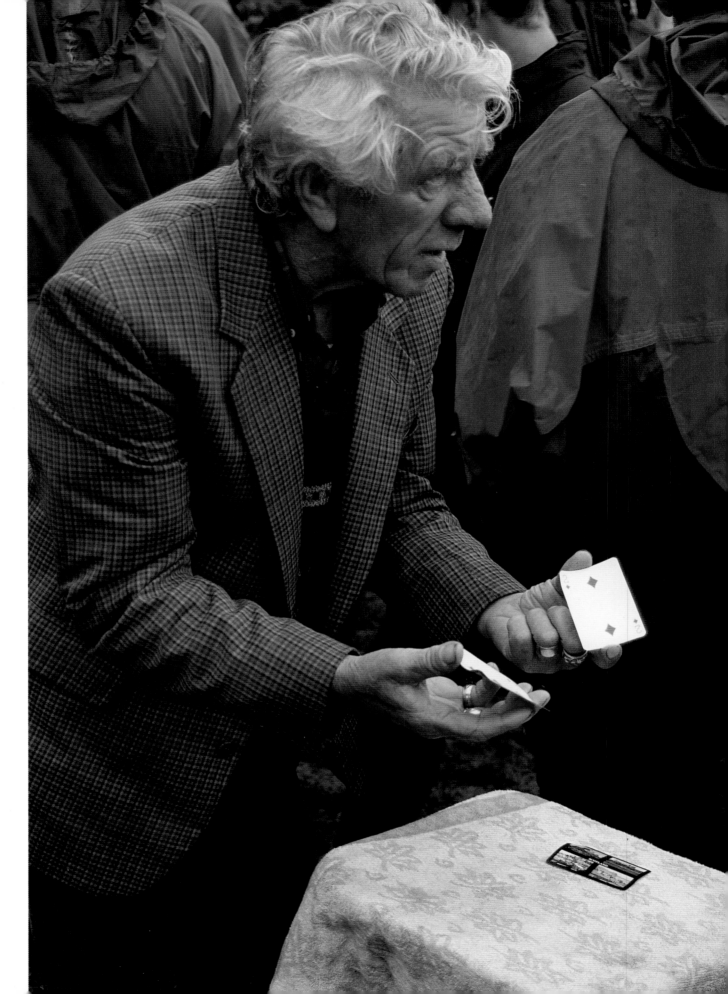

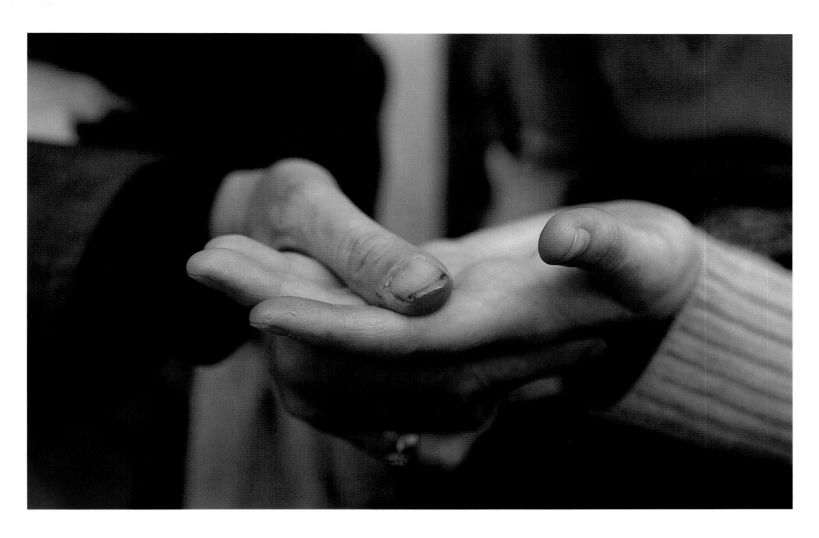

nlike European Gypsies, the Tinkers (today often referred to as 'travellers') are racially indistinguishable from the rest of the native population. With their distinctive argot, *Shelta*, they are a colourful presence at horse fairs like the one held at Ballinasloe every autumn, though they are often regarded with suspicion by the settled population. Nowadays, the younger, more vital members of the community tend to deal in scrap metal and used cars, but old-timers still eke out a living through more traditional means as card sharps or palm readers (left and above). Horsedrawn covered wagons (right) were the Tinkers' favoured means of transport in the 19th century, though today these are more often hired out to tourists, much to the annoyance of impatient local motorists. ↝

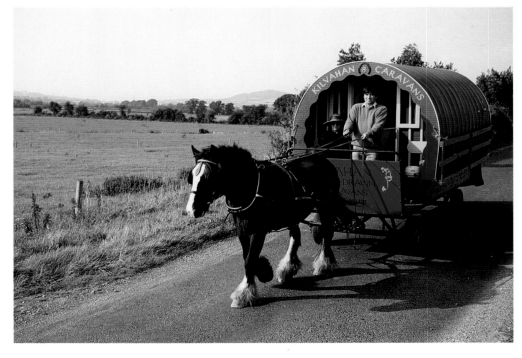

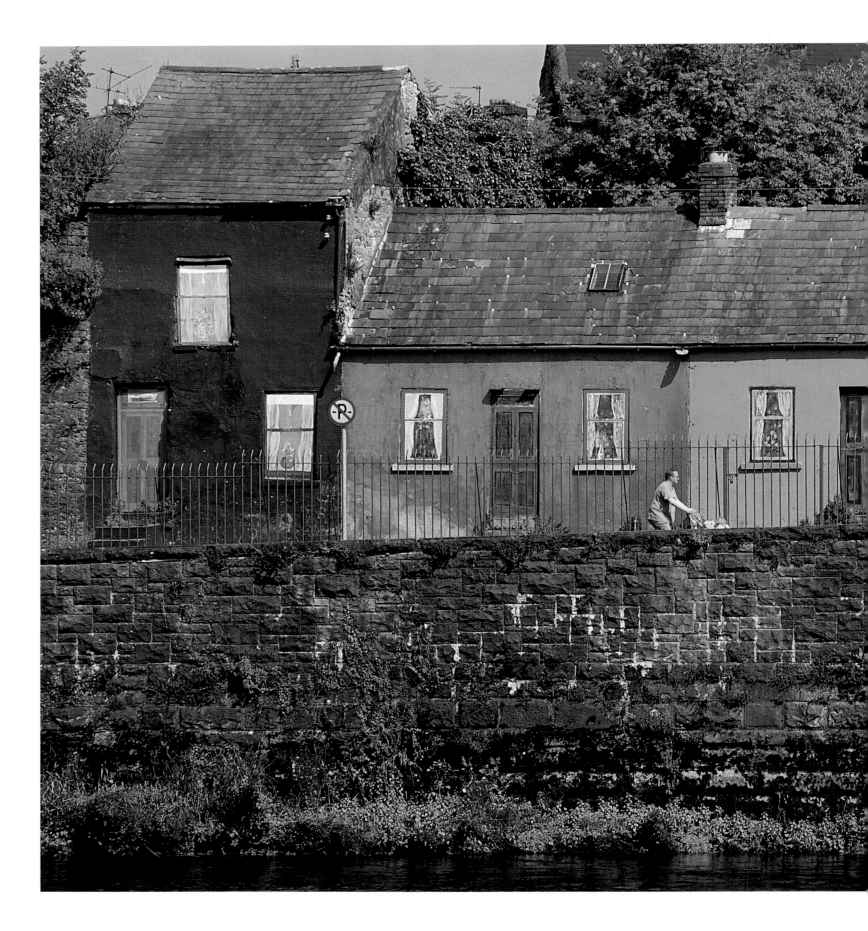

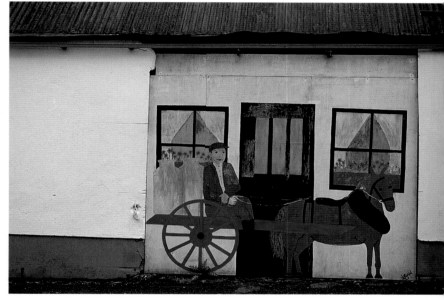

a father pushes his child past a row of ingeniously decorated houses in Limerick City (left). The tradition of absentee landlords, poor quality building material and, above all, emigration has ensured that derelict buildings are not uncommon. But murals such as these are commonly used to bring a splash of colour to unlovely homes and factories. This representation of the once ubiquitous horse and cart (above), in Co. Louth, is among the more elaborate means of disguising the ramshackle.

galway City is the mystical folk capital of the west of Ireland, a magnet for young travellers from all over Europe and the USA. Throughout the summer, its narrow, pub-crammed streets echo to the sounds of exuberant Guinness-fuelled laughter and traditional music sessions that last long into the night. If you can't find the *craic* here you're a lost soul. This former fishing town is at the heart of an economic boom that, after centuries of hardship and migration, has transformed Ireland's West Coast from an impoverished backwater into a prosperous and sometimes crazily optimistic region that provides a much-needed cultural counterbalance to the overweening dominance of Dublin.

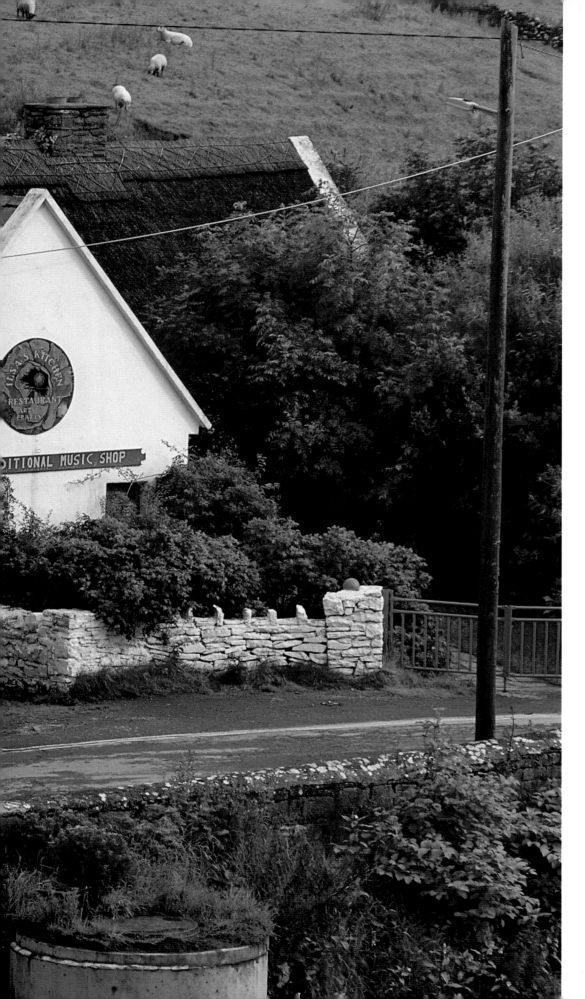

he mecca of traditional music fans, Doolin, Co. Clare is a tiny village that seems overawed by the high, doleful Cliffs of Moher. It contains a handful of music shops (left) and just three pubs, a low count by west of Ireland standards. But this is where the county's fiddlers display 'the lonesome touch', the sad, sour Clare style that demands the listener's close attention and rewards with its transformation of melancholy that leaves no one unaffected by its spell.　～

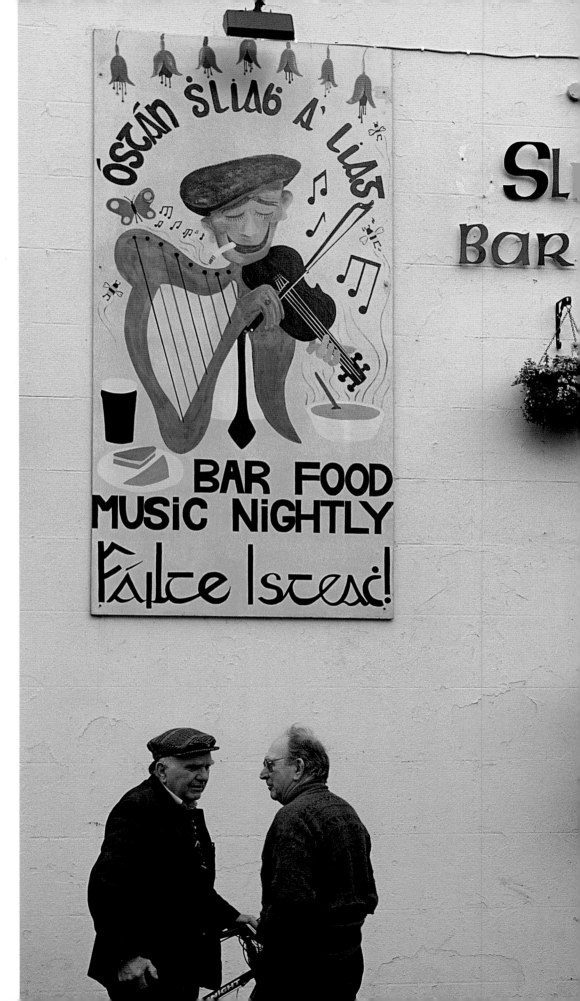

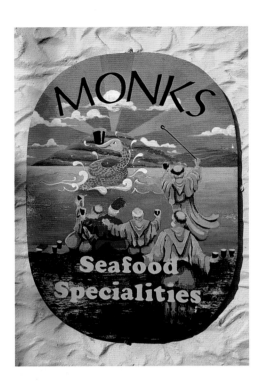

even the smallest village on Ireland's West Coast contains at least one pub or bar, the focus of community life, and a welcome destination for travellers in a land where settlements are far apart and the climate often harsh. All the bars fill a niche: some double as a post office or garage (far right, Kilorglin, Co. Kerry), refuelling stops in more ways than one. Others, like *Monks* (above) in Ballyvaughan, Co. Clare, have restaurants attached. *The Slieve League* in Carrick, Co. Donegal (main picture), is named after the nearby cliffs, the tallest in Europe, and has a national reputation for the quality of its traditional music sessions.

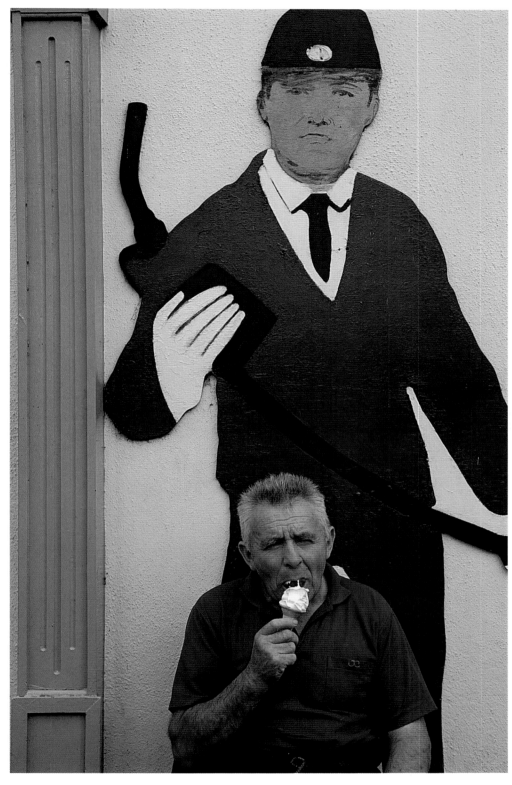

working the land

another field whitened in the april air

and the harrows rattled over the seed

P.J.KAVANAGH

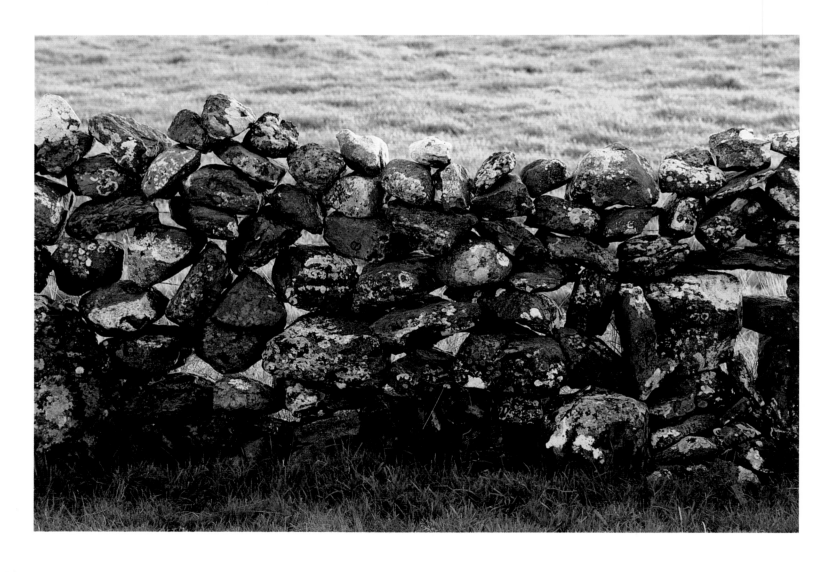

_t_HE OLD WAYS continue but only in the west of the country. Industry, mass tourism and the commuter belt have all rendered Ireland a little less rural, a mite less wild. A century ago, over half of Ireland's male labour force worked the land; now it's little more than 10 per cent, with much of the wealth concentrated among the herdsmen of the Midlands. A land of high rainfall, mild winters and cool summers, with an abundance of peaty soils, the heart of Ireland north and south was made for the raising of cattle. It is a land of beef and butter, and the lush pastures of prosperous regions like Tipperary's Golden Vale and Meath's Boyne Valley testify to the fact: their towns and villages grown plump and contented on the fat of the land.

It is a version of green and rural Ireland that stands in total contrast to that of the West, the raw 'authentic' vision of the country sought by travellers. There, in the margins, no one grows fat. The land yields little, and in the Aran Islands, least of all. Inishmaan, Aran's 'Middle Island' is an uncertain, shimmering mixture of rock, water and wind that has barely been touched by the outside world, shielded from its influence by its people's Gaelic tongue. Every acre of this besieged land, bar the empty roads where dogs laze in the rare sun, is woven into a patchwork-quilt of drystone walls that drip down like tears

a stone wall in Co. Galway, a classic fixture of rural Ireland. These precarious-looking, but surprisingly sturdy structures are especially common in the north and west where the tendency for families to sub-divide land among each new generation was unchecked for decades, resulting in a patchwork of rigidly demarcated fields that proved barely sustainable.

to where the last gasps of land drown beneath the cold encroaching sea; the few visitors who venture to Inishmaan always remark on the damp. A cow stands alone in one field, a donkey as its neighbour; some patches of soil, bolstered by muck and seaweed, sustain oats and potatoes, others nothing. When tides permit, the men supplement their limited diet with the fruit of the lobster pot. It is a hard life that few follow: there seem to be fewer young people here than any other place in Ireland.

This is the land of emigration, though America doesn't have its former pull. Why take the long haul when there are computer plants in Ennis, Co. Clare, or a hi-tech optical industry in Westport, Co Mayo, a legal practice in Cork City? You don't have to leave the West anymore, but why chase black-faced, blue-smudged sheep for a living, why live on the edge? Those who remain on the land do so because they must, or because they know no better. But in doing so they preserve one of Europe's last great wildernesses, their continued presence appreciated by the wealthy – from London, Hamburg, Dublin – who observe the lie of the land from their second homes and like it as it is: a landscape romantic beyond description, unhurried and ancient, barely Europe at all. How ironic that tourism, that most modern of industries, is sometimes the old ways' only ally.

The Aran Islands are the extreme. But back on the mainland, in the archetypal western regions of Connemara, Co. Galway, Dingle, Co. Kerry, Inishowen, Co. Donegal, things seem no less remote, and the stone walls remain. They follow the outlines of the 'reaves', prehistoric demarcations replenished for millennia with stones quarried from nearby outcrops or boulders, or collected from neighbouring land. The average life of a wall here is 200 years – the lichen will date them – and within their bounds

little has changed over that time. The lonely cottages whose windows face away from the gusting winds, are hewn from materials found about them: rough, uneven rocks for the walls, splintered wood for the rafters, and thatch for the roofs. An incessant barrage of rain results in an anxious obsession with roofing that's quite unknown elsewhere, especially the fear of 'brown rain' leaking through a damaged, sodden and sooty thatch.

You won't find herds of cattle here, but the ownership of at least one cow is crucial to the quality of existence. The cow provides manure, essential for growing potatoes in marginal land, and milk which, with the other staple crops of corn and oats, provides a basic but healthy diet. All the crops, along with hay for the horses, are reaped with a homemade scythe or shovel, sometimes even by hand. And the fuel is peat, the 'turf' whose glow and smell define traditional rural life. Turf is born of a ground forever wet, where plant remains compress and blacken into a layer of peat above the mineral soil. The moors run perpetually with water and the blanket bog covers even the steepest of heather-tangled slopes.

And slopes there are. The hill farmers of the West are the toughest of all, criss-crossing steep, barely discernible, bracken-strewn paths to keep an eye on their flocks. I recall a party of experienced Austrian climbers atop Dingle's Mount Brandon, the westernmost peak in Europe. They shone bright orange in expensive waterproofs, buffeted by biting wind, peering down nervously on surf-lashed rocks. A sheep dog pattered past them followed by an 'old fella', the shepherd, dressed in a grey suit and a brown cap, oblivious to the sheets of rain. 'How're ya doin'?', he asked. All he got in return was a shocked nod of admiration from the Alpiners. They inhabited a different world.

Just as intriguing as the means by which men and women still work the West's less than generous ground are the thought patterns generated by the landscape: the thrift and stubborn independence; the pin-sharp verbal responses; the wayward, crazed thoughts; the polite rhetoric, in stark contrast to the impolite surroundings. The 'Donegal digit' – a raising of the index finger in understated acknowledgement of any and all strangers – is famous way beyond the county. In the strong climes of Donegal its softening presence is always welcome. Donegal is like that. It ranks alongside tribal Connemara as the 'Best in the West', a place of exceptional, mountainous, austere beauty, but Donegal is softer. As someone once put it: if you found treasure in Connemara it would be a battle-axe, in Donegal a crock of gold.

Ireland is not all breathtaking beauty; she has her dreary strips of land, and they too are worked. Co. Offaly, despite the presence of the great Clonmacnoise monastery, is a county much disparaged, all marsh and bony trees, the Bog of Allen and Boora Bog, hacked for their peat by JCBs. It's a shelterless, dark and desolate expanse of monotony, stilted in summer, unimaginable in winter. Yet still some find fascination here, in the rare mosses and birds and carnivorous sundews and bladderworts that entrap insects. After all, to describe any of Ireland's diverse landscape as bad, or to pass similar judgement on the country's notoriously fickle weather, is of service to no one. These things simply are and, from their mysterious benevolence comes Ireland, and for that we should be thankful.

m any farming communities relied on the hand pump for their water supply until well into the 20th century. Not only people were dependent upon them but working animals too, especially horses, for so long the backbone of Irish cultivation. At the end of the 19th century there were half a million horses in Ireland and only in the 1960s did the number of tractors exceed them. Today, working horses are largely limited to the world-famous Irish thoroughbreds or fully harnessed 'shires' like this one (opposite) on display at Co. Galway's Ballinasloe Horse Fair. ∾

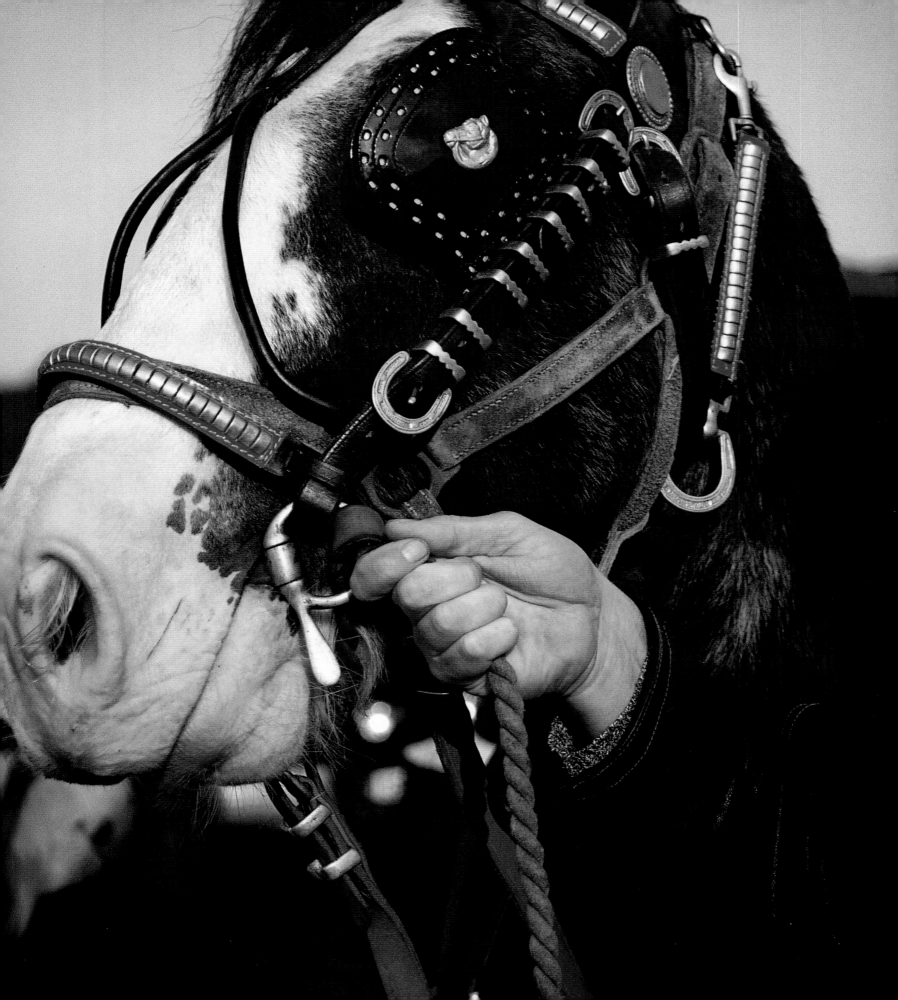

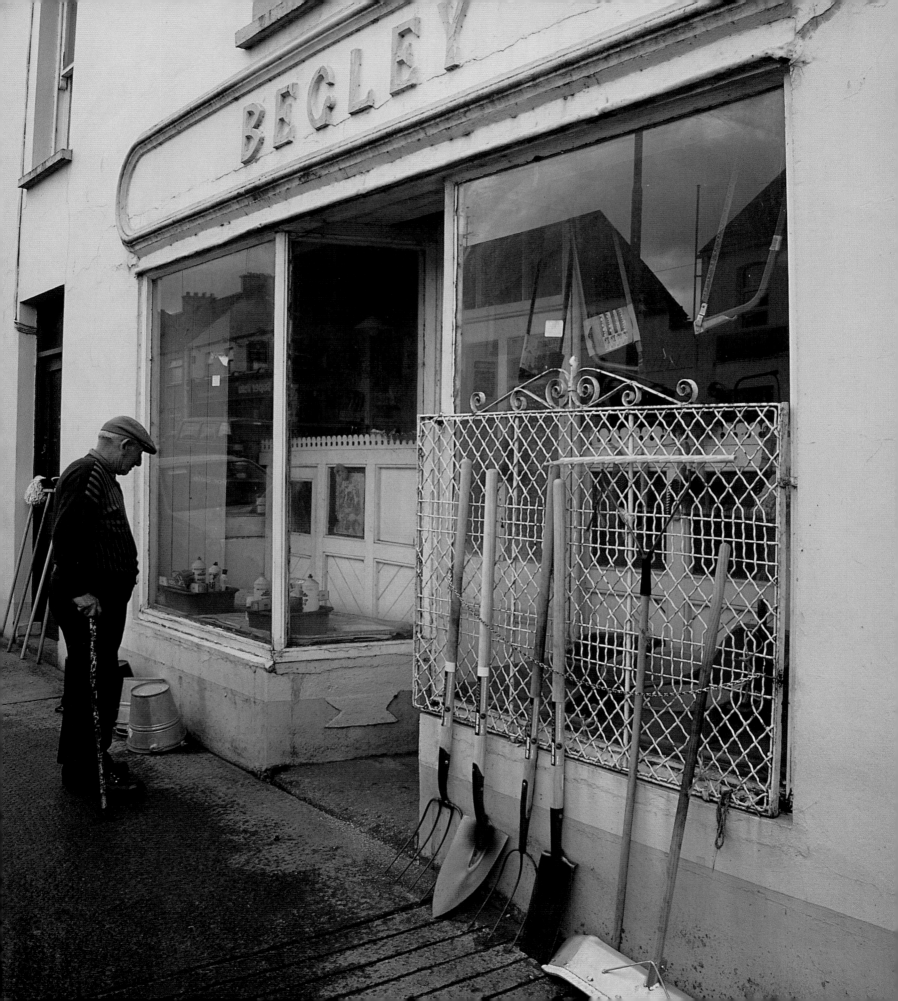

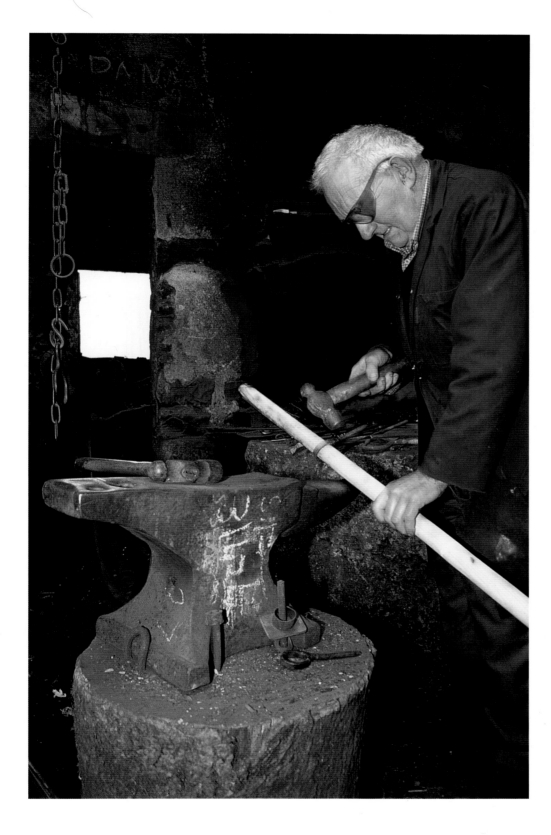

Spades are lined up outside Begley's blacksmith shop in Abbeyfeale, Co. Limerick (far left). The spade was the one absolutely essential tool of the small farmer and there were myriad types; one factory in Cork used to produce around seventy-five different forms of spade blade. To use a spade rather than the plough is no sign of inferior husbandry; quite the opposite. The subtle spade is a tool more akin to that of the gardener than the farmer, and its yields are usually much higher than those of plots worked by the broad brush of the plough. The scythe is used for cutting hay for horses, and Mr Begley still makes versions of this tool (left), which was probably introduced into Ireland by the Normans.

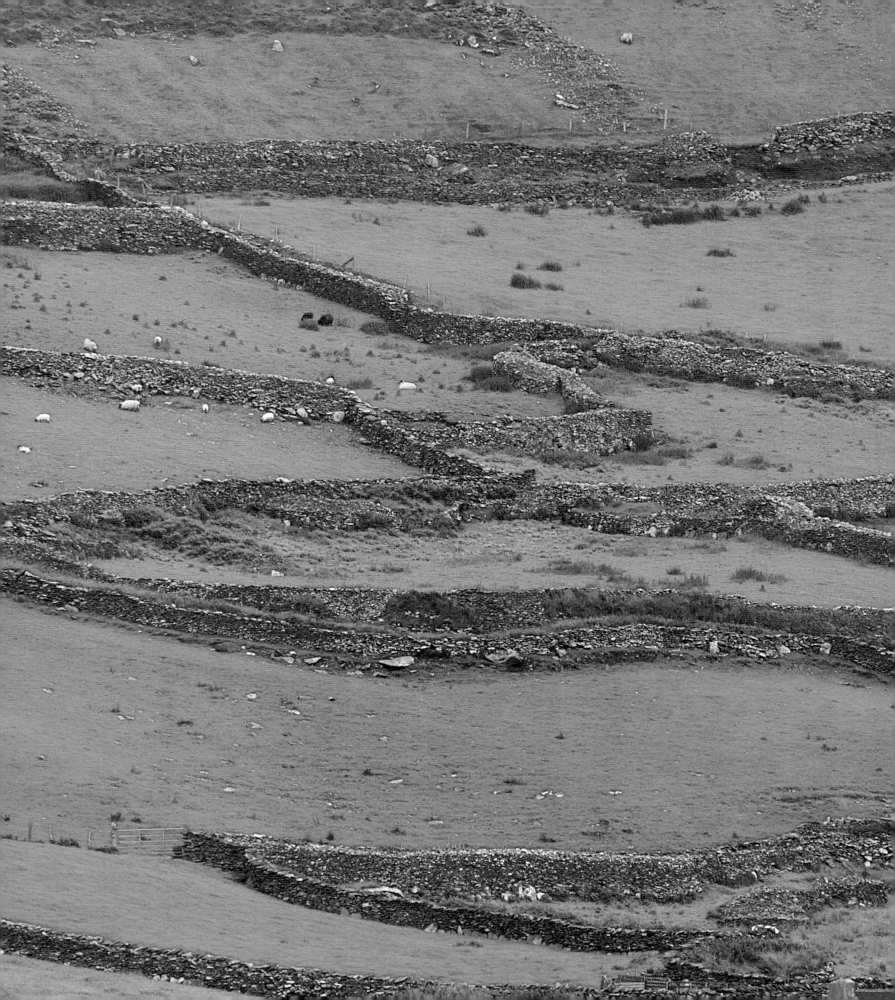

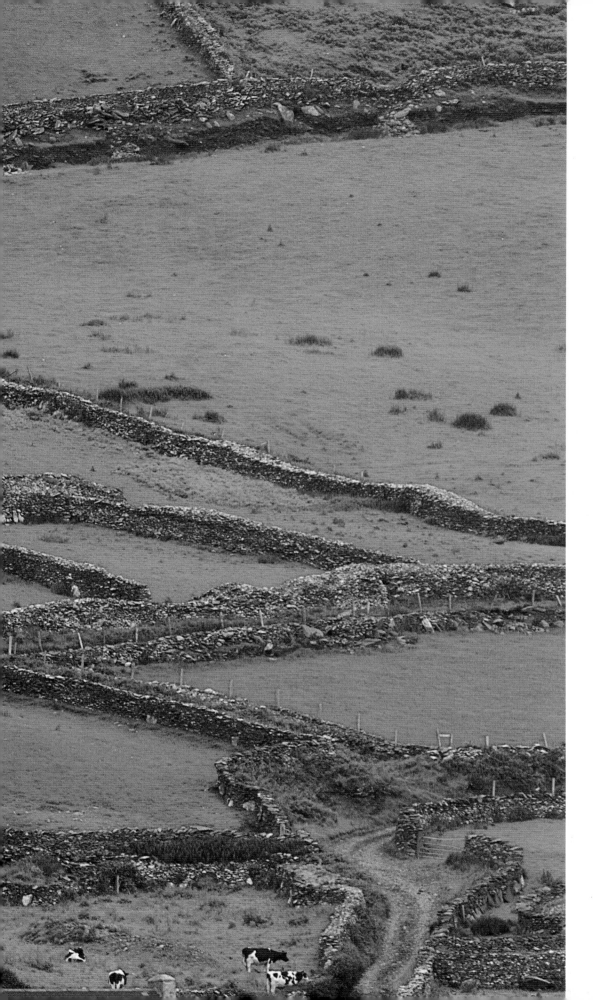

Írregular field patterns in Co. Kerry's Dingle Peninsula. Remote regions like Dingle, at Europe's extreme western seaboard, are difficult places from which to garner a living: the soil is poor and small-scale hill farming is notoriously hard. The Blaskets, Dingle's offshore islands, lost their population in the fifties, and even farms on the mainland, like this one, find it difficult to remain viable. Tourism provides many farmers and their families with an opportunity to diversify, and Dingle has been more careful and concerned in its nurturing of this development than many other parts of the West. It is a policy that may well pay off in the long run and help to maintain this remarkable landscape.

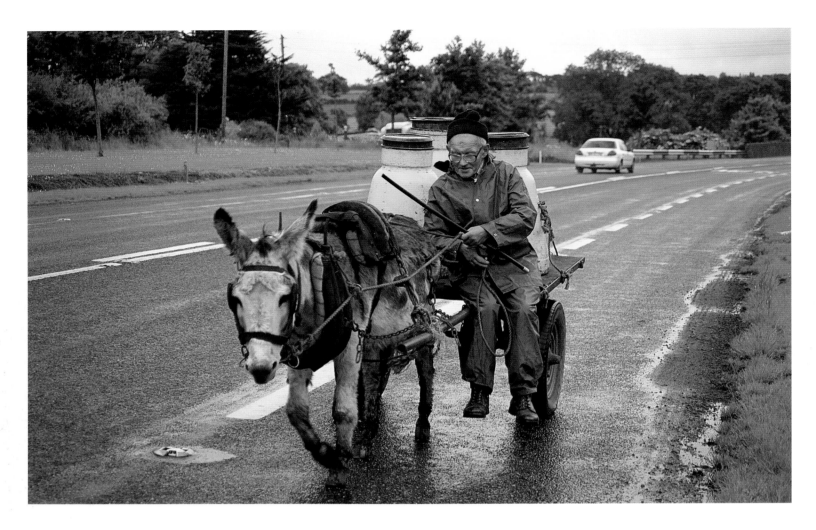

a donkey pulls a trailer of milk churns along a busy road near Reens, Co. Limerick. Donkeys are no longer the common sight they were in Ireland and their use may well die out with the present generation of owners. The writer Michael J. F. McCarthy had an unusual but telling theory about Irish donkeys: he claimed that they were held in much higher esteem in Catholic than in Protestant Ireland. In 1911, when he wrote, there were 17,000 donkeys in Tipperary, 20,000 in Cork and 25,000 in Mayo; yet in Antrim, with a greater Protestant population than any in the island there were a mere 783 of the creatures. Religion gets everywhere, it seems, in Ireland. ❧

*u*nlike donkeys, the dreaded bungalow is expanding at an ever-increasing rate throughout rural Ireland, a trend that is of great concern to environmentalists. These 'identikit' structures are, claim their critics, despoiling vast areas of the country's most beautiful locations and are utterly out of step with local building traditions. But the booming economy and Ireland's relatively good transport links mean that more and more people, foreign as well as Irish, are seeking the opportunity to live in and commute from the countryside, or to purchase a second home there. ❧

In the limestone uplands of Fermanagh (previous page), the soil is so poor that farmers adopt a system called the cultivation ridge or 'lazy-bed', an agricultural method of great antiquity. Potatoes are the main crop grown in this manner, which involves laying out a bed by plough then shaping it by spade. Why they are called 'lazy' is a mystery as these beds are arduous to maintain, requiring careful management to coax the best out of a soil that is unpromising to begin with. The ridge and furrows serve to drain off some of the water, and adding manure improves productivity. ∽

Sheep farming has boomed in Ireland over the past century: in 1909 there were 4.4 million sheep in the country, now there are almost 10 million. This is largely due to the opportunities offered to landlords by the depopulation of marginal upland areas in the west and north and the continuing trend towards livestock farming. Systematic sheep rearing on such a large scale is one of the few ways to make money in such a difficult environment. Irish lamb has an international reputation and is one of the key ingredients of the 'New Irish Cuisine', much discussed among the middle classes of Dublin and Cork. These blackface sheep (right), penned in at Clonmany agricultural festival, Co. Donegal, are among Ireland's most popular breeds. ∽

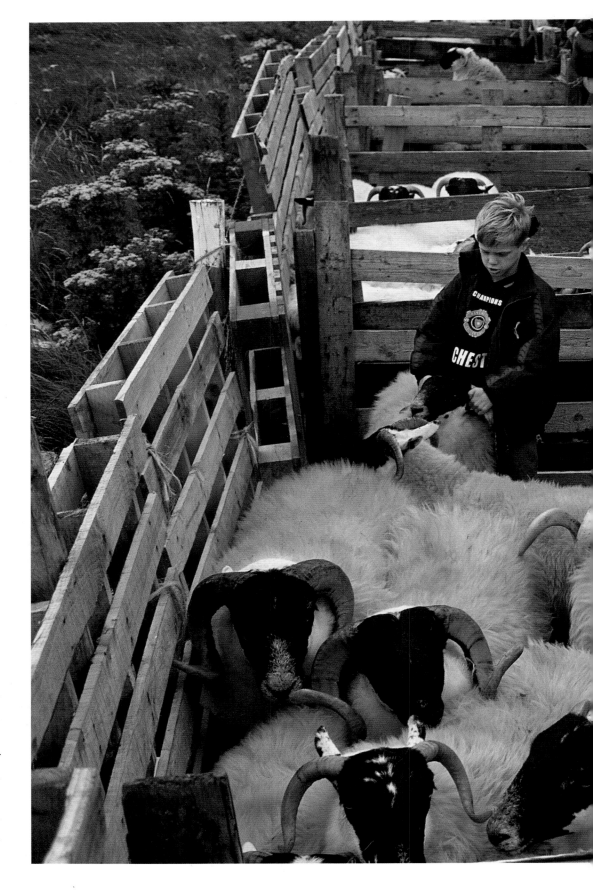

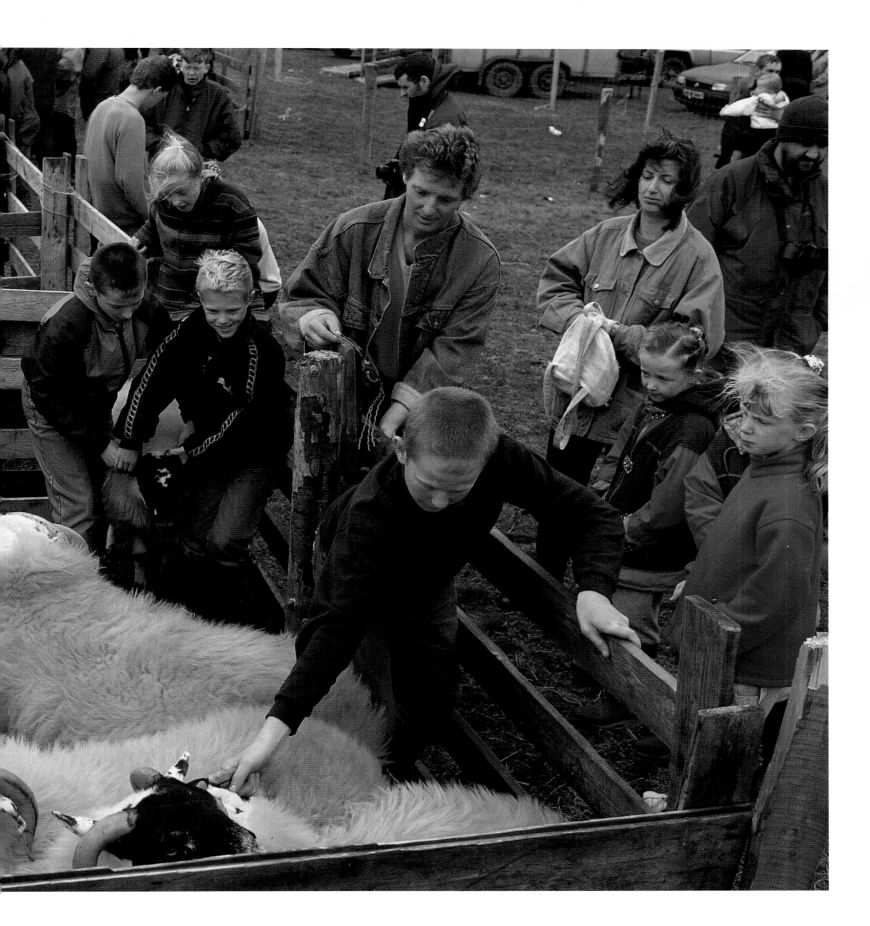

Supermarkets have not yet made much of an inroad into Irish rural life so local communities must rely on family-run shops like these: an ironmonger in Gort, Co. Galway (left) and a grocery store in Castleisland, Co. Kerry. Along with the pubs, the shops are often at the centre of local life, though customers may have to supplement the grocer's limited stock by buying meat and vegetables directly from farms, or by growing their own.

Striped fields run across the valley of the striking Gap of Mamore, Inishowen Peninsula, Co. Donegal. 'Striping' is a common process in Donegal, where landlords replaced the old excessively subdivided 'rundale' system with so-called 'ladder farms' in which fields run from the valley floor to the mountain side in the characteristically parallel pattern seen here. In such a remote area cultivation must be concentrated to make economic sense. ∽

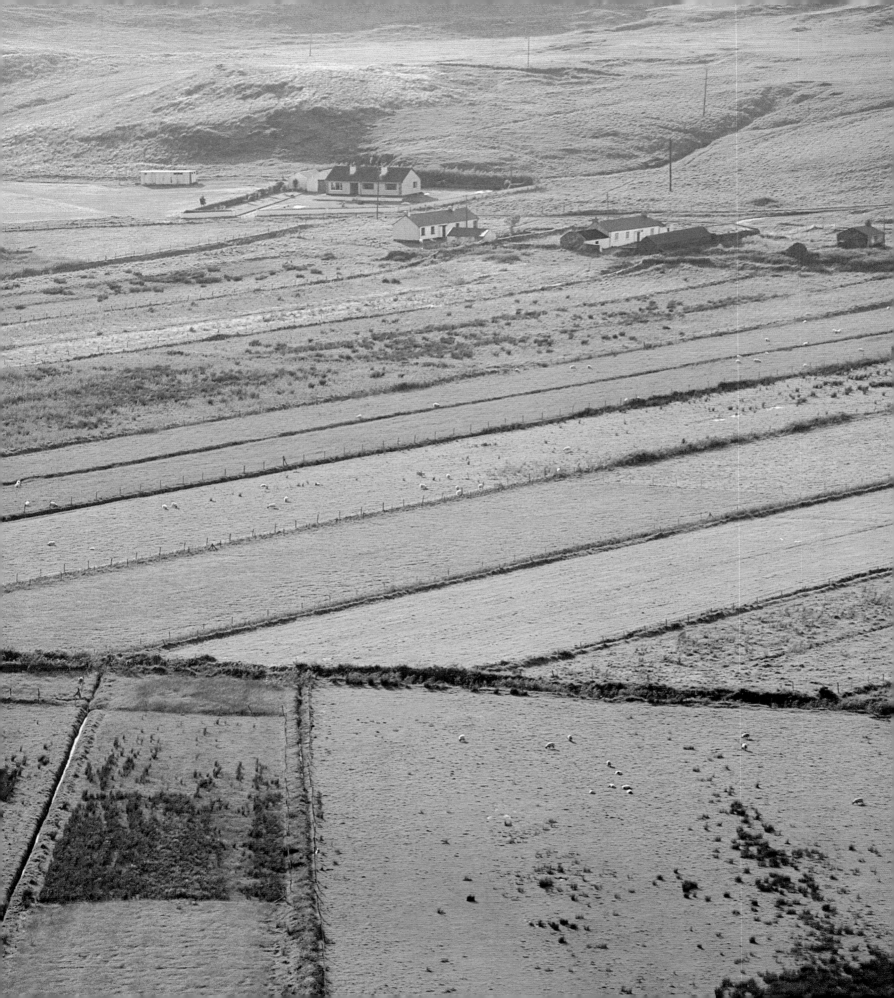

a farmer with seemingly inappropriate footwear takes a closer view as sheep go up for sale at the Clonmany agricultural festival, Co. Donegal. Sheep are Donegal's major agricultural product and, smudged blue or red depending on their owner, they are hard to avoid anywhere in the county, creating a particular hazard for car drivers. Some sheep farmers (right) have seen their lot improve greatly over recent years, in part due to generous funding from the European Community's controversial Common Agricultural Policy, but also because of more modern methods introduced to hill farming and the buying up of greater areas of land by the wealthier single landlords. ◞

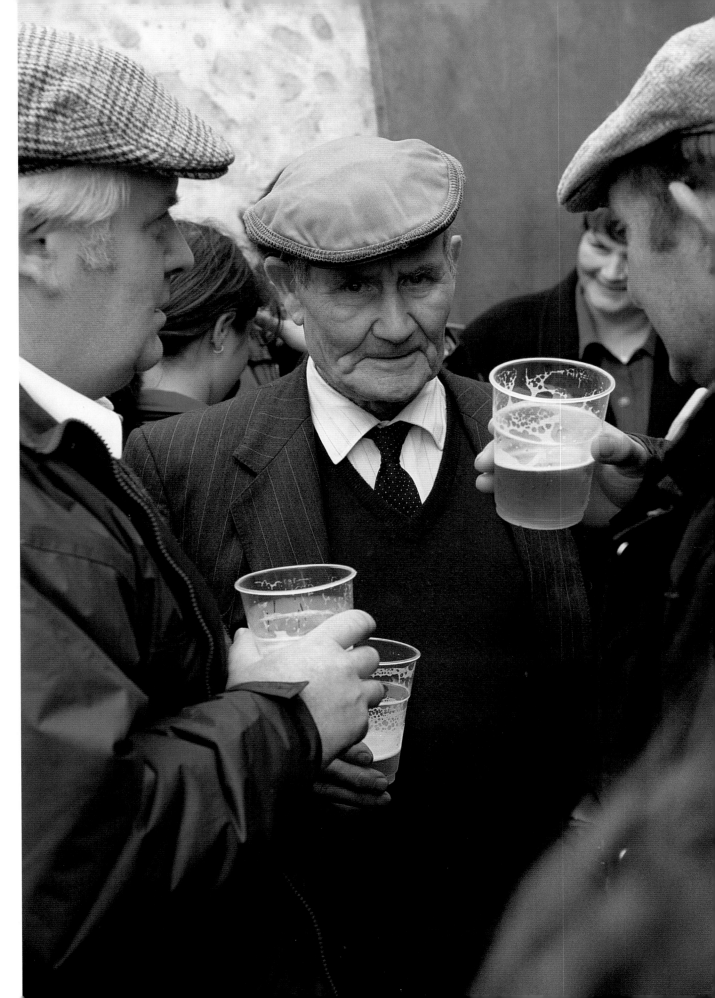

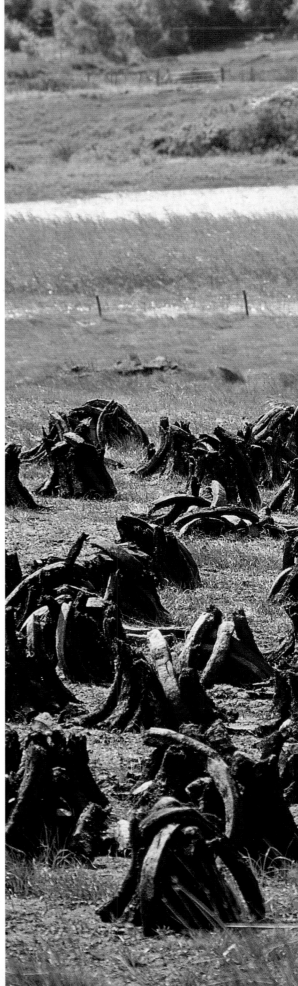

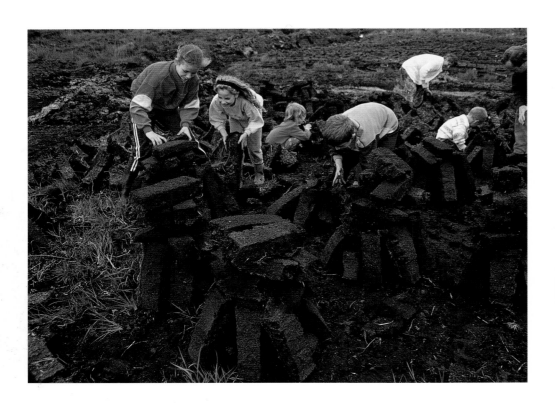

Bogs cover 14 per cent of Ireland and are a cheap source of fuel, though in recent years measures have been taken to minimise their industrial exploitation. But the right to dig peat or 'turf' for domestic fuel goes back a long way, and was usually part of the leasehold agreement between landlord and tenant. Here, John Cullnane and his family (above) from Tuam, Co. Galway, gather turf. There is said to be something deeply therapeutic about 'hand-winning' the rich black sods, then heaping them onto a blood-orange fire on a dark winter's night. But first they must be stacked and dried out in the sun (right) as they are in this typical scene from Connemara, Co. Galway. ᗒ

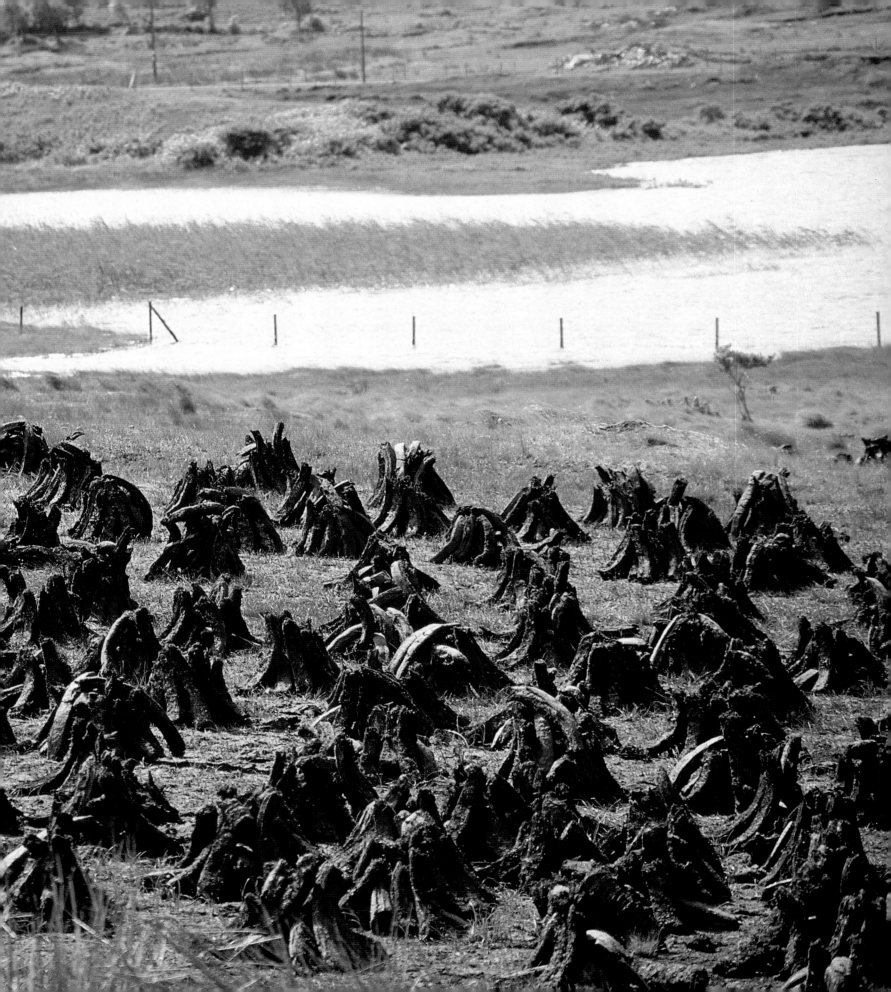

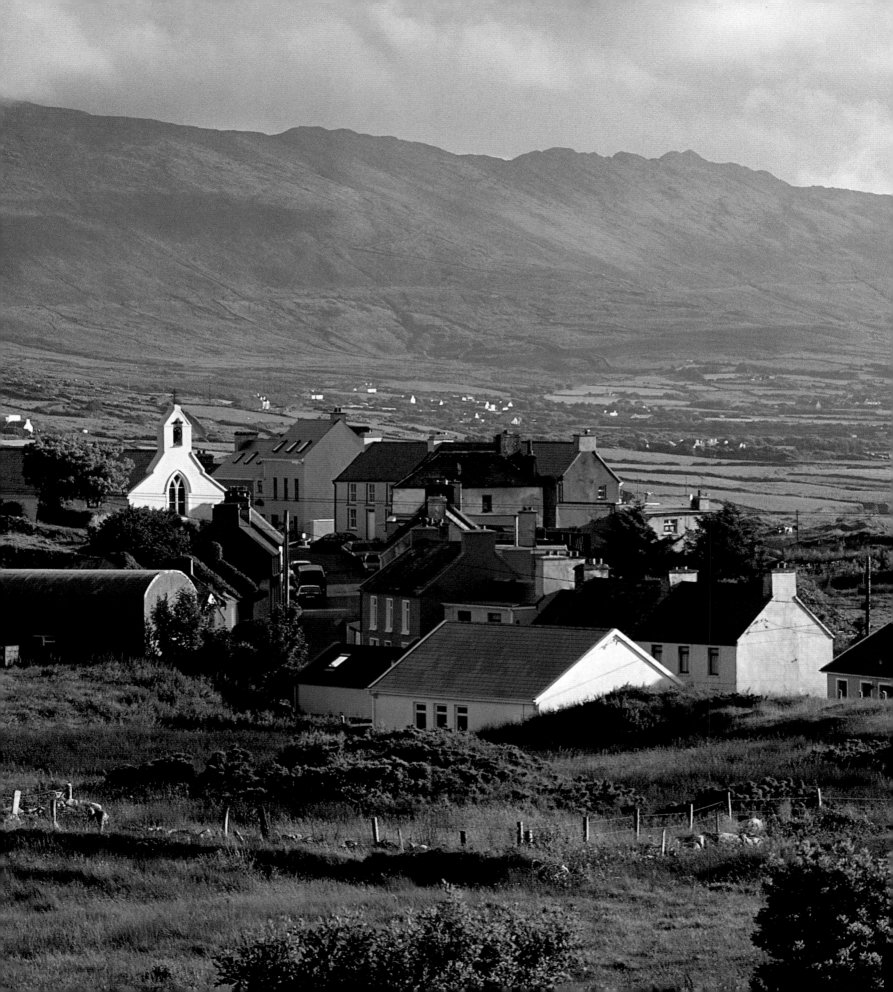

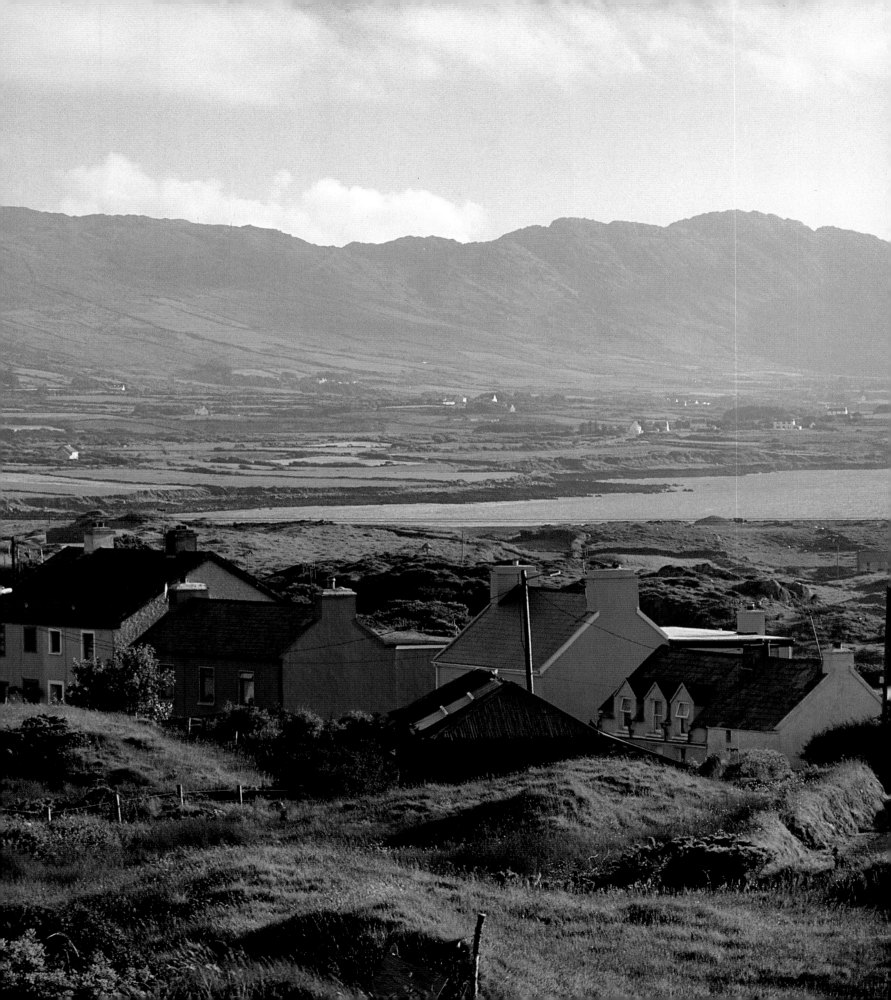

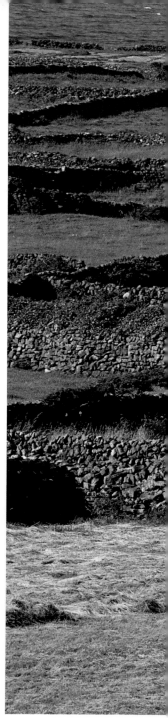

he little village of Eyeries (previous page) clusters around its church, watched over by the sombre, encircling Caha Mountains. The Beara Peninsula on which it stands, shared between counties Kerry and Cork, is a mean rib of land stretching out 50 km (30 miles) into the Atlantic and as barren and remote a landscape as can be found on the mainland. As a consequence, it is little visited by tourists. Though there is much open land on the peninsula it is very rocky and the soil is poor. The locals rely heavily on fishing to see them through the harsh winters, though the sea here is noted for its treachery. 〜

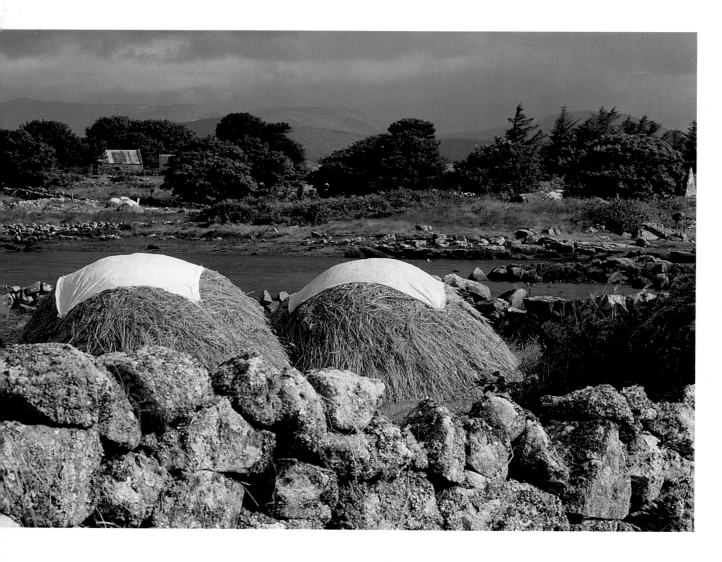

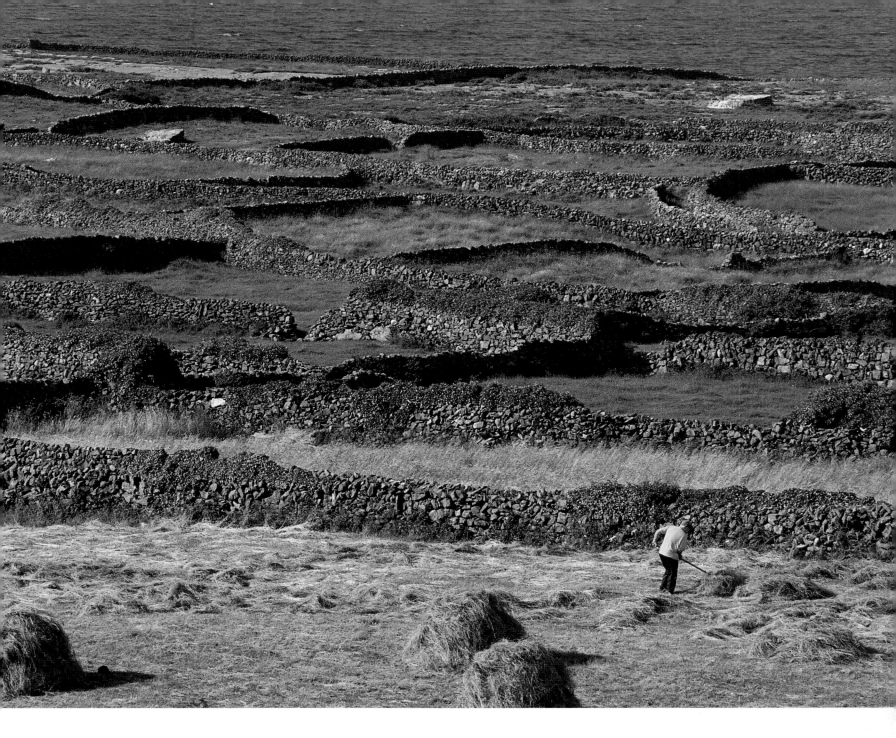

MAKING hay while the sun shines on the Aran Island of Inishmore (above). The Aran Island's distinctive, almost kaleidoscopic patchwork pattern of fields can seem claustrophobic to visitors; even some roads are hemmed in by walls the height of a man. But the concentrated fields maximise the production of crops in a parsimonious environment where the sea is never far away. Hay is an essential harvest to feed the few, valuable horses and cattle found in the wilder parts of the West such as Aran or Connemara (left).

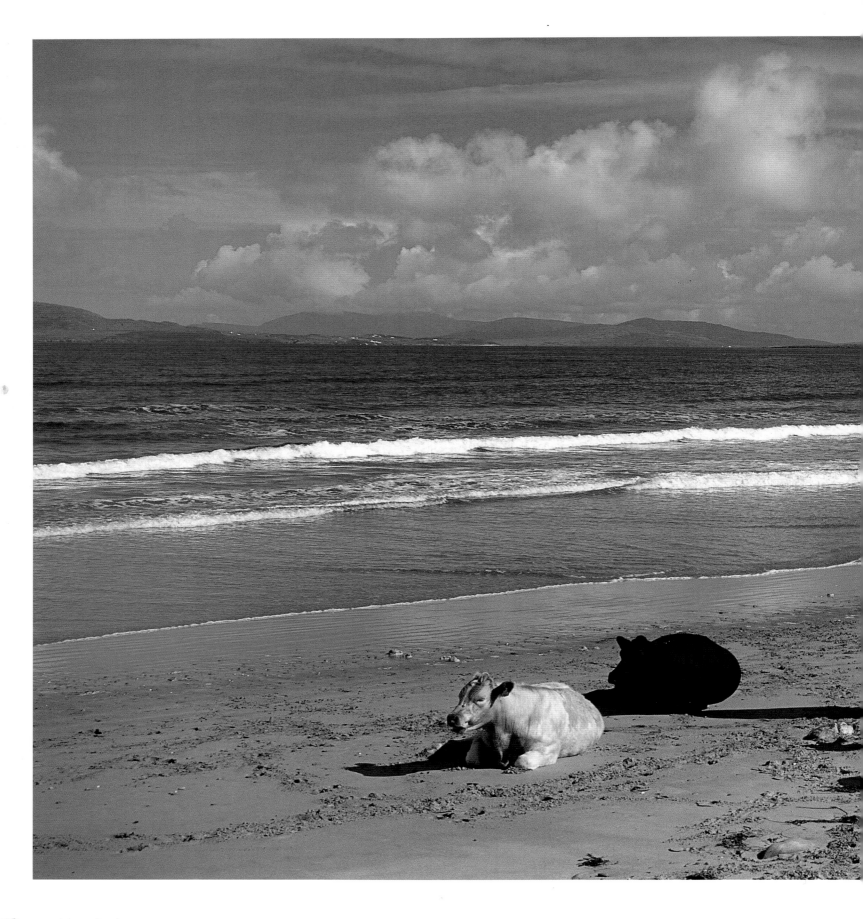

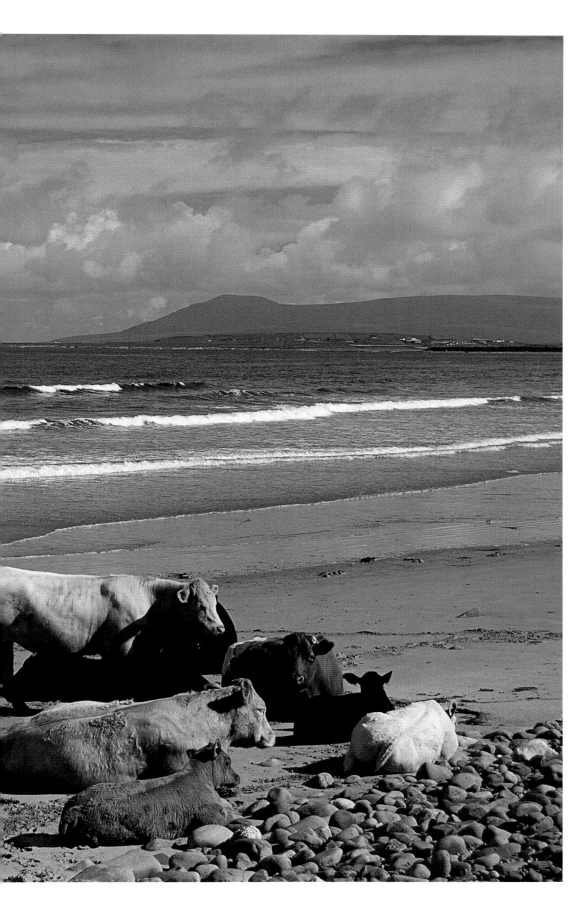

the local tourist board claims that the beach on Silver Strand is second in quality only to those of Florida's Key West; but the haunt of Ernest Hemingway has probably never seen families of cattle lounging around its beaches, as they do in Co. Mayo. And who can blame the bovines for setting themselves down beneath the sun and looking out over glorious, island-infested Clew Bay? Irish farms can be extensive, with no one quite sure where one farm ends and another begins. The relaxed manner of their keeping means that animals are often seen traipsing around the most unlikely locations. Maybe it is this 'free-range' quality that accounts for the fine beef and dairy products.

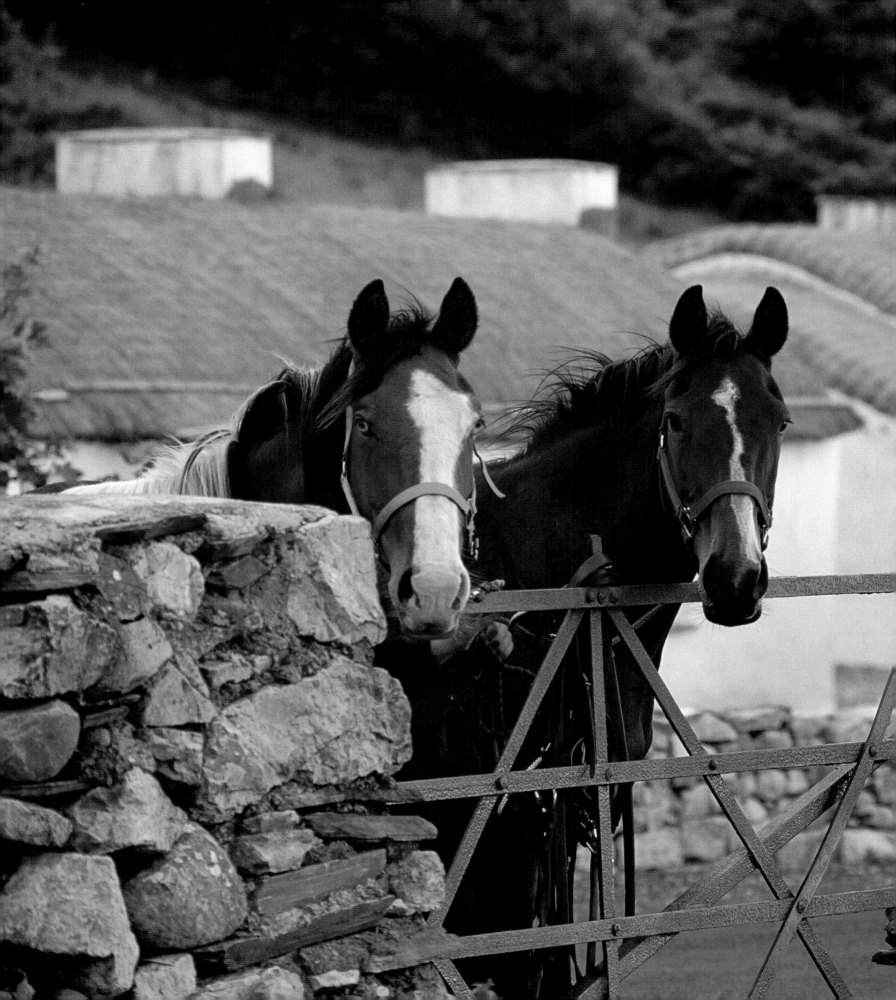

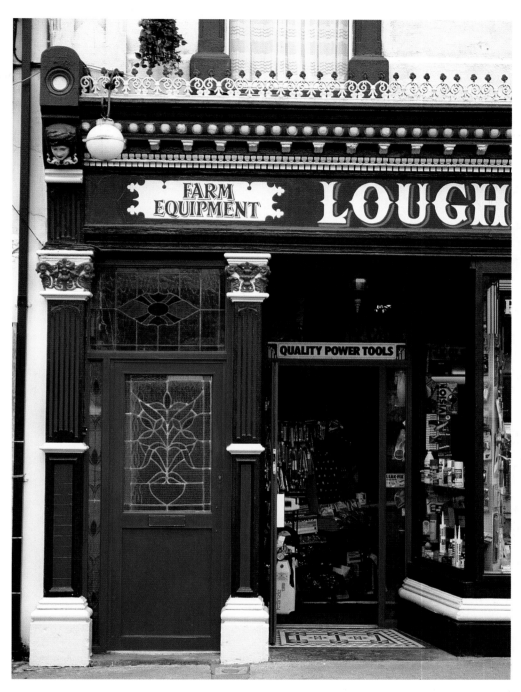

wo working horses stand before the gate of a cluster of whitewashed, thatched cottages in Co. Donegal's Inishowen Peninsula (left), which remains one of the most traditional and spectacular regions in Ireland. It is the place to go if you seek the 'old ways' of Irish rural life. In contrast, Co. Tipperary is the heartland of the modern cattle and dairy industry and its prosperity is reflected in the handsome frontage of this farm-equipment store in the county town.

ꝺublín

when í ꝺíe í want to ꝺecompose ín a barrel of porter anꝺ have ít serveꝺ ín all the pubs ín ꝺublín. í wonꝺer woulꝺ they know ít was me?

J.P. DONLEAVY

NO CITY IN the world, not Paris, London, Berlin or New York, has been so well-served by the spoken and written word as Dublin. Its literary network of cafés and pubs, cradles of conversation and loquacious endeavour, make it the consummate writers' city. And paramount among its chroniclers is James Joyce. In *Dubliners*, his first masterpiece, published in 1914, Joyce wrote tentatively of a place of false starts and missed opportunities, a Catholic city ill at ease with itself, living in the economic shadow of Belfast and British rule; but in *Ulysses*, the greatest novel of the 20th century, he broke the bonds of colonialism and, in self-imposed exile, traced exhaustively the city's geography in the first great work of an independent Ireland. It is said that one could rebuild the city of Joyce's day from a thorough study of *Ulysses*; though the great man might find it difficult to comprehend Dublin's modern-day prosperity. Yet the city he knew and so brilliantly described still closely resembles the airy, elegant, mysterious Dublin of today, its great skies unimpeded by tall buildings, and the River Liffey, the 'black pool' or *Dubh Linn* of the Vikings, remains reassuringly murky.

Temple Bar is currently the trendiest spot in Dublin, a clutch of cobbled streets between Dame Street and the Liffey redeveloped after years of neglect. Many of its pubs and clubs are more 'cutting edge' than this one, but all have suffered from the plague of British weekenders who come here for 'stag' nights and usually end up naked, tied to railings, very, very drunk. The authorities have vowed to stamp out such bad behaviour. ❧

The Norsemen had wintered on the Liffey for decades before establishing a permanent settlement in AD 888, naming it *Baile Átha Cliathe*, the 'Ford of the Hurdles', the city's Gaelic name to this day. The Liffey, crossed by shaky, unsure Ha'penny Bridge, split Dublin in two then and does so now. Both sides of the river have their adherents, all fiercely loyal and impervious to the arguments of their opponents.

The Northside, dominated by the wide avenue of O'Connell Street, has traditionally been a working-class area, where grim tenements, rampant with disease, once crowded together. The beggars and bag ladies still linger, proof that not everyone has a share of Ireland's new riches, and O'Connell Street is marred by too many fast-food outlets and their resulting litter, and the loss of the trams that were perfectly suited to its imperial breadth. The Northside is not and may never be chic, but it does contain Phoenix Park, Dublin's breathing space and Europe's largest urban park. It is home too to the defining cultural artefacts of modern Irish nationhood: the Abbey Theatre, where Yeats strove to construct a dramatic repertory of the Irish for the Irish and succeeded beyond even his wild dreams; and the General Post Office, at the heart of O'Connell Street, on the steps of which Patrick Pearse declared the Republic, an act that cost him and his comrades their lives. Still in everyday use, it acts as a hall of memory to the rebels who came to be loved more in cruel death than life. It would be notable for its Neoclassical architecture alone if it were not for the bullet holes in its staunch stone statues.

The Southside has long been the more fashionable area, and the more prosperous. Distinguished by its great Georgian squares, their coveted façades embellished by legions of tiny plaques commemorating past residents such as Daniel O'Connell, W. B. Yeats and Oscar Wilde, it remains the habitat of Ireland's cultural and political elite. The term 'D4', oft-quoted in withering jest by the city's journalists

and comedians, refers to the fashionable postcode of a privileged mandarin class, the nation's power-brokers, who ply their trade in nearby Leinster House, the Irish Parliament.

The most beautiful and prestigious site on Southside is Trinity College, or TCD. It looks exactly as a great university should do with its austere brick buildings, dating from the Elizabethan age, arranged around a vast cobbled quadrangle. Its many famous graduates include the statesman Edmund Burke and the wit Oliver Goldsmith, whose statues are paired outside the entrance; Jonathan Swift; Wolfe Tone; Bram Stoker; J. M. Synge; and Samuel Beckett. Catholics no longer risk excommunication for attending Trinity and today make up 70 per cent of its students. Joyce, a Catholic, looked upon Trinity with envy, though his alma mater, University College or UCD, Dublin's other university, now stands with Trinity as one of the Republic's most prestigious places of learning.

It's no surprise to discover that both Trinity and UCD are within easy reach of so many of Dublin's most celebrated pubs, in particular the great throng of boozers clustered around pleasantly commercial Grafton Street: *Davy Byrne's* on Duke Street where Leopold Bloom, Joyce's Ulysses, partook of gorgonzola and burgundy; *Doheny and Nesbitt* on Baggott Street, prime contender for the title 'most beautiful pub in the world' where, behind impeccable stained glass, Dublin's legal brains sup Guinness 'built not poured' by droll barmen adorned in aprons of another age; or *Kehoe's*, whose fresh-faced, female clientele avoid unwanted attention in a discreet 'snug'.

The Irish, or to be more accurate the Dublin pub – the idea of it anyway – has spread around the world. But the replicas you'll find in every major conurbation never fail to get it wrong. The Dublin pub is unique to the city, each example a singular, residual creation with its own ambience and look that cannot be instantly manufactured. These are institutions purposely devoted to the pursuits of talking, thinking and drinking… mainly drinking. And, if one Monday morning you are feeling fragile, you may console yourself with a sip of tea in Bewley's Oriental Coffee House, on Grafton Street, a decorous institution that owes much of its popularity to the restorative power of potato soup.

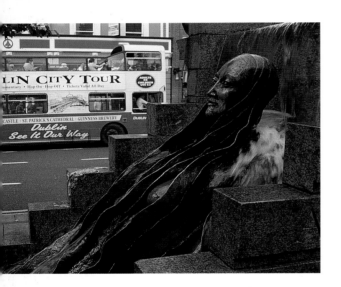

Sean O'Faolain once wrote that 'nobody except a Dubliner should write about Dublin'. But that begs the question of who is a Dubliner these days, when everyone, Dublin-born, provincial immigrant, foreigner and tourist, all want a slice of an ever-expanding pie, the *craic*, the blarney. Dublin, home to one-third of the Republic's population and one-fifth of the island's, is still seen as 'too small' by some locals yet much too big and brash and begrudging for the rest of the country. But for the first time in its history this compact, confident city, European in style and aspiration, is keeping hold of its children.

Dublin is a world city now, home to global rock stars U2, bestselling author Roddy Doyle, film-maker Neil Jordan, mould-breaking feminist former president Mary Robinson. Supermodels and film stars shell out for a night at the Shelborne Hotel, and the clubs and pubs of mazy, redeveloped Temple Bar feel more Manhattan than Mayo. But if, after a while, you find Dublin as provincial as some of the locals claim it is, it is not hard to escape. You see those mountains to the south? They're the Wicklows, beautiful, rugged, unspoilt and only half an hour away.

The 'Floozie in the Jacuzzi' or the 'Whore (hoo-err) in the Sewer', the Anna Livia Millennium Fountain (above) is supposed to embody the River Liffey, after Joyce's description of it as 'Anna Livia Plurabelle' in his final, daunting work, *Finnegans Wake*. ❧

In typically Irish fashion, Dublin provides a lovely mix of the elegant and the relaxed. A sunflowered Citroen 2CV is parked outside a row of the city's celebrated Georgian terraces. ❧

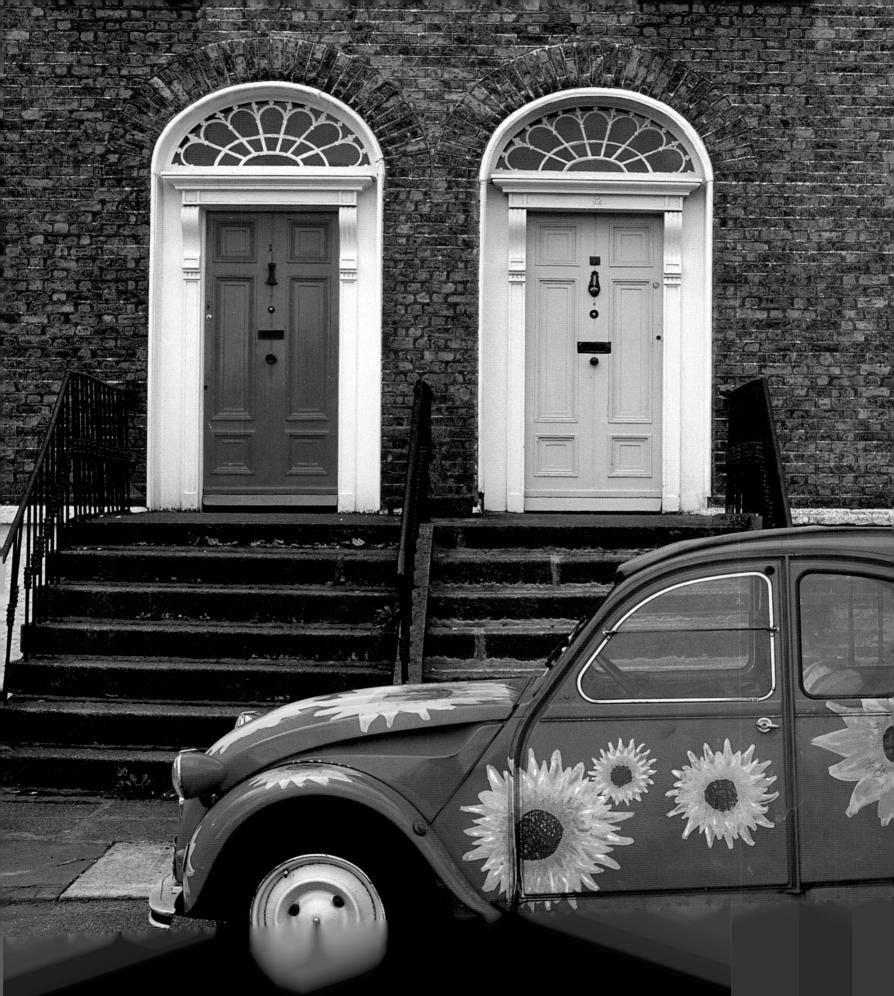

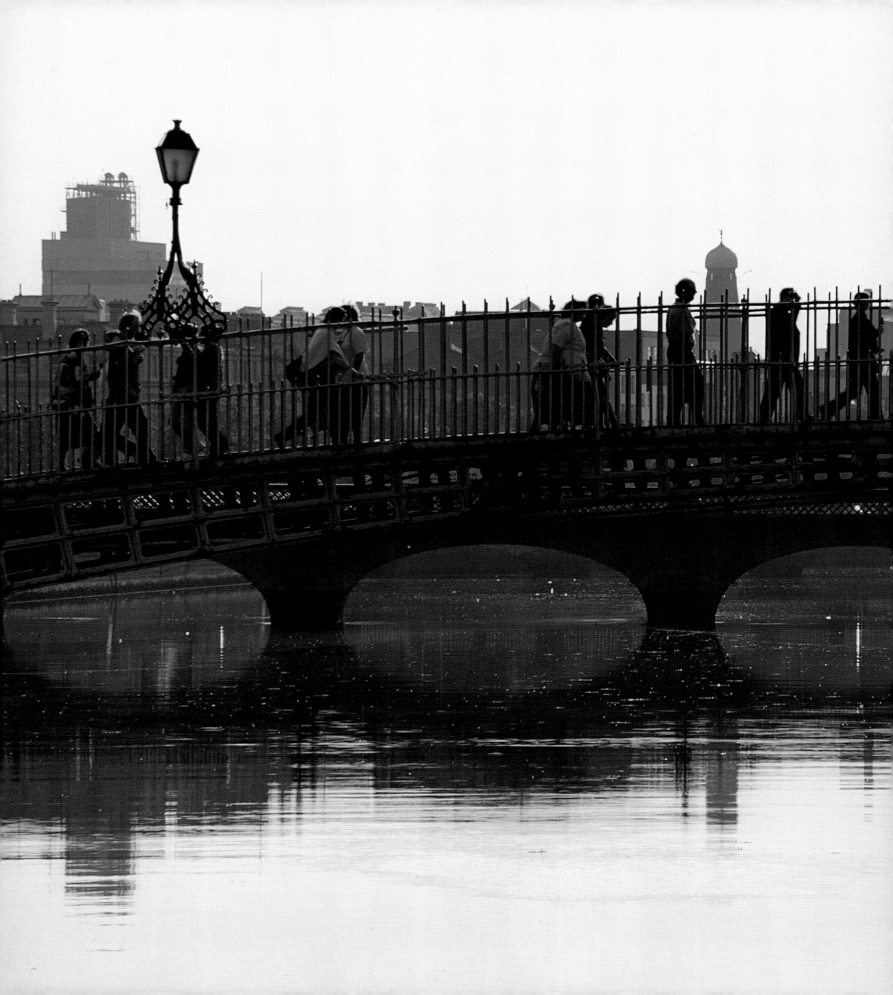

ha'penny Bridge makes for the nicest crossing of the Liffey. The cast-iron, high-arched footbridge was built by John Windsor and opened in 1816. Originally it was called the Wellington Bridge, after the Dublin-born British general, though irreverent Dubliners preferred to christen it after the ha'penny toll they had to pay. Few people are aware that its official name is actually the Liffey Bridge. A recent restoration job seems in keeping with its proximity to the fashionable Temple Bar district which it links with Liffey Street on the Northside.

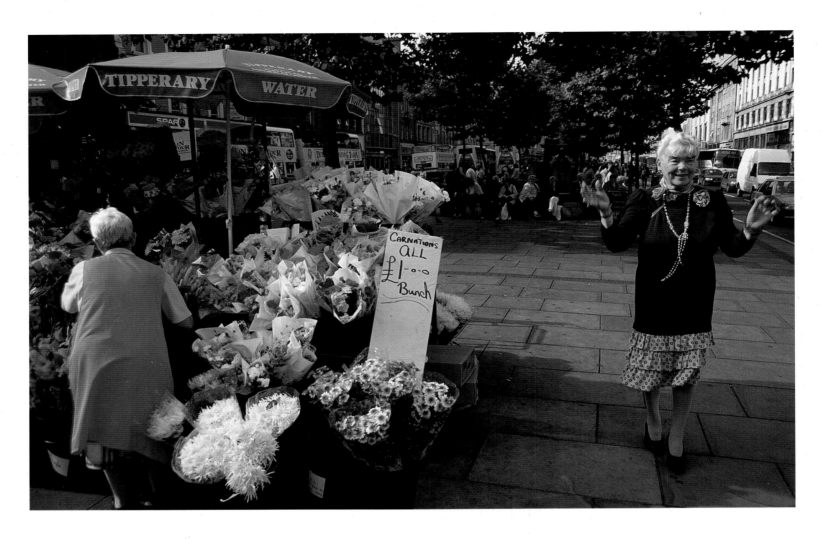

ublin has long indulged eccentricity. Mary Dunne, seen above, is well known for the outdoor sermons she gives on O'Connell Street, though conversions are probably limited in a city with a somewhat sardonic approach to religion; Mick Hyland (left) looks suitably dressed for a production of one of fellow Dubliner Samuel Beckett's plays – who's he waiting for? – and a Dublin character (right) adopts a regal pose in St Stephen's Green, Dublin's elegantly land-scaped urban retreat. ∾

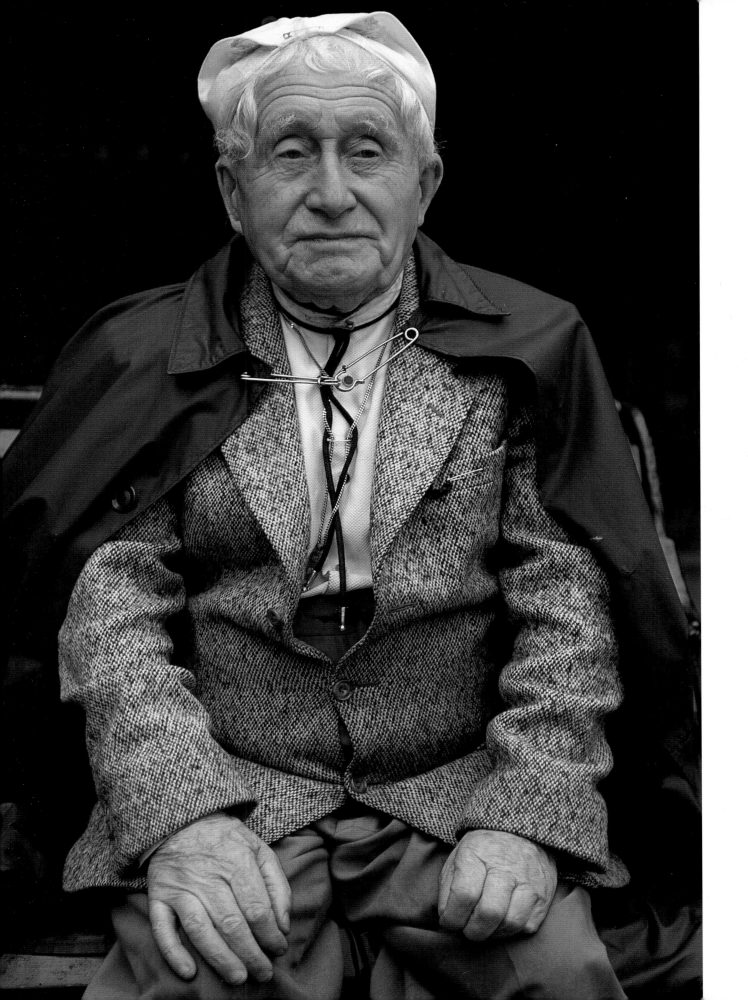

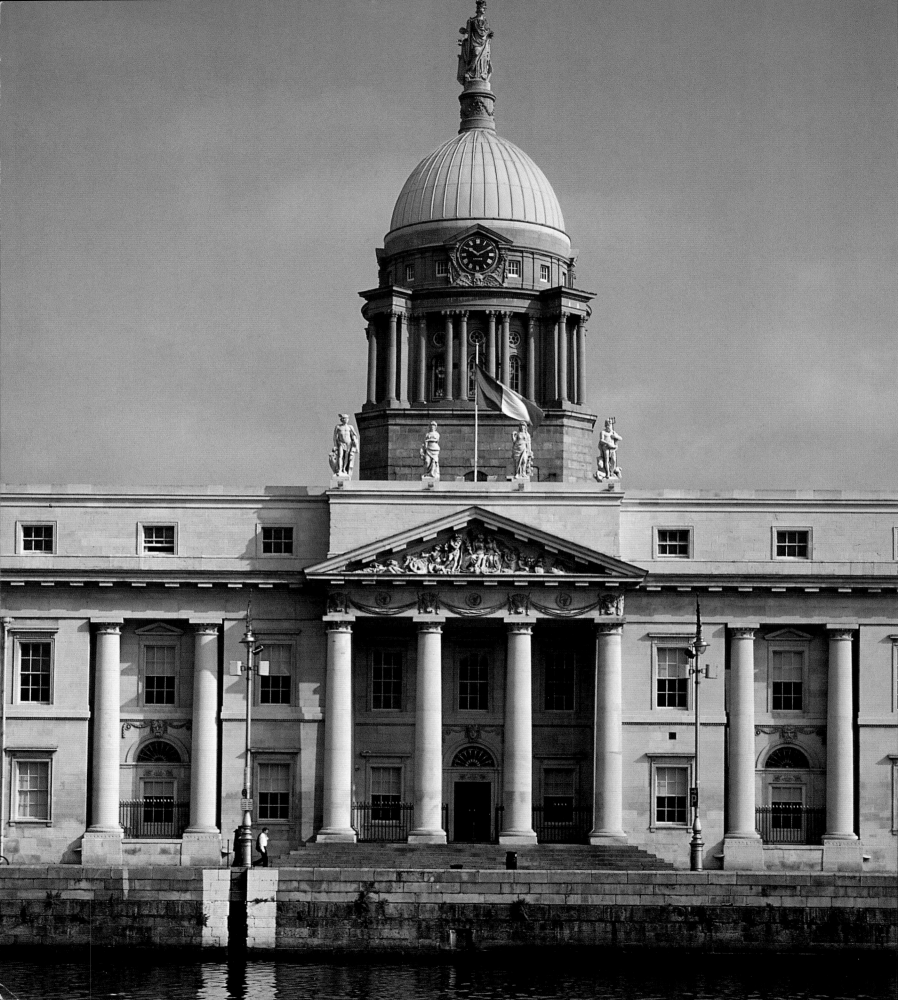

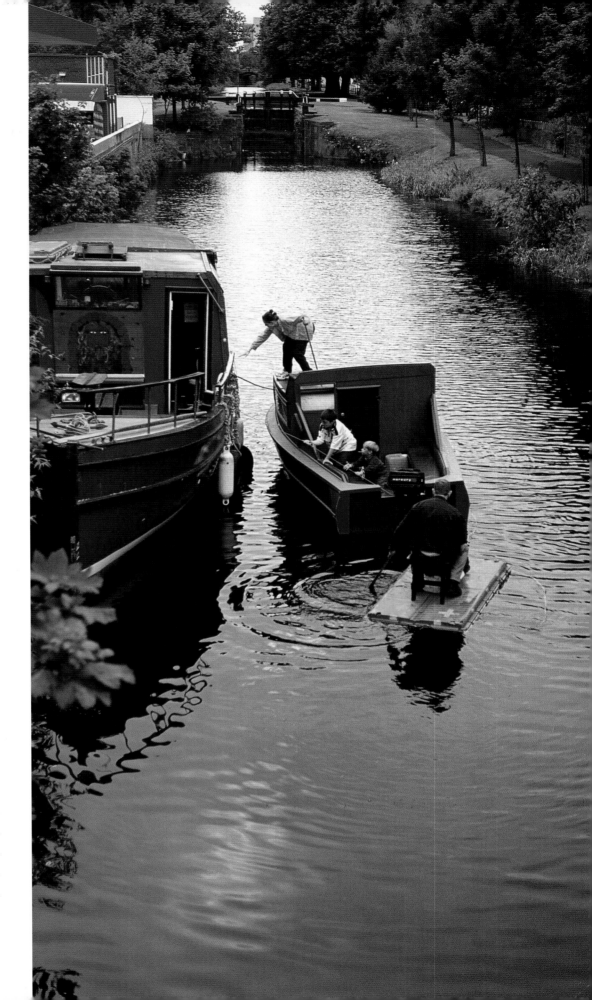

there is no finer building on the Northside of the Liffey than James Gandon's neo-classical Custom House (left). Unfortunately its purpose was rendered obsolete only nine years after its completion when, in 1800, the Act of Union with Britain saw all Irish customs and excise business transferred to London. Reduced to a shell by the IRA in 1921, the Custom House was not finally restored until 1991 when it reopened as government offices. Sadly, it is not open to the public so, for the very best view, stand on the south bank of the Liffey and wallow in its illuminated magnificence. ∽

the Grand Canal, the longest in the British Isles when it was completed in 1796, has been closed to commercial traffic since the 1960s and offers a relaxing day out. The poet Patrick Kavanagh was this area's most famous habitué. He's perhaps best known for his great love song *Raglan Road*, a location just a short walk from the canal's Baggot Street Bridge. A statue of Kavanagh presents him reclining on a bench close to a stretch of water he evoked in a late series of nature poems. ∽

The gorgeous, exuberant red pub called *The Long Hall* (below) is the kind of bar visitors to Dublin think they'll only dream of, and it comes as a pleasant surprise to find that such places really do exist. Very traditional and very smoky, its great long bar ends in an alarming collection of antique clocks. The stoic, inscrutable staff are as much a fixture as the pub's fittings. *The Long Hall* is just one of dozens of classic pubs in the proximity of Grafton Street, including *Davy Byrne's*, which features in *Ulysses*. Dublin's main, pedestrianised shopping area, Grafton Street (right), heaves on a Saturday afternoon, with shoppers, buskers, and assorted street artists, but its principal attractions are rather more sedate: Brown Thomas, the best of Dublin's department stores; and Bewley's, the famous café whose upstairs room is named in honour of James Joyce. ⌒

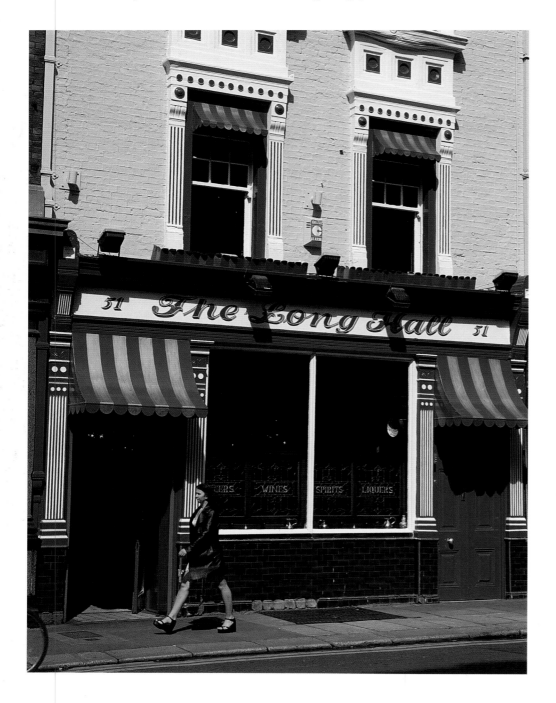

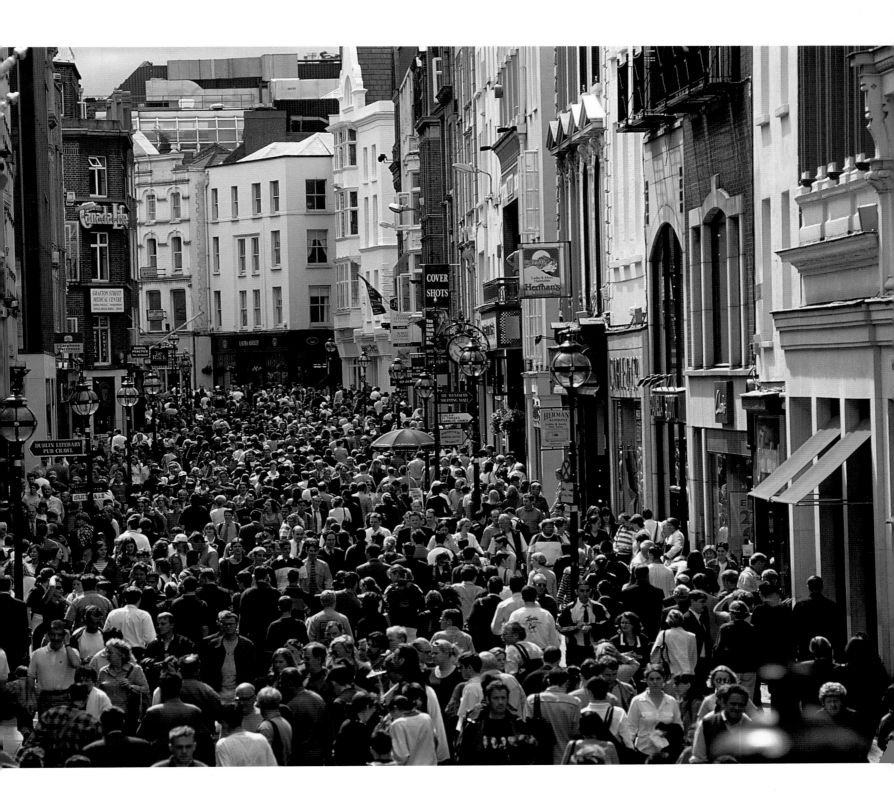

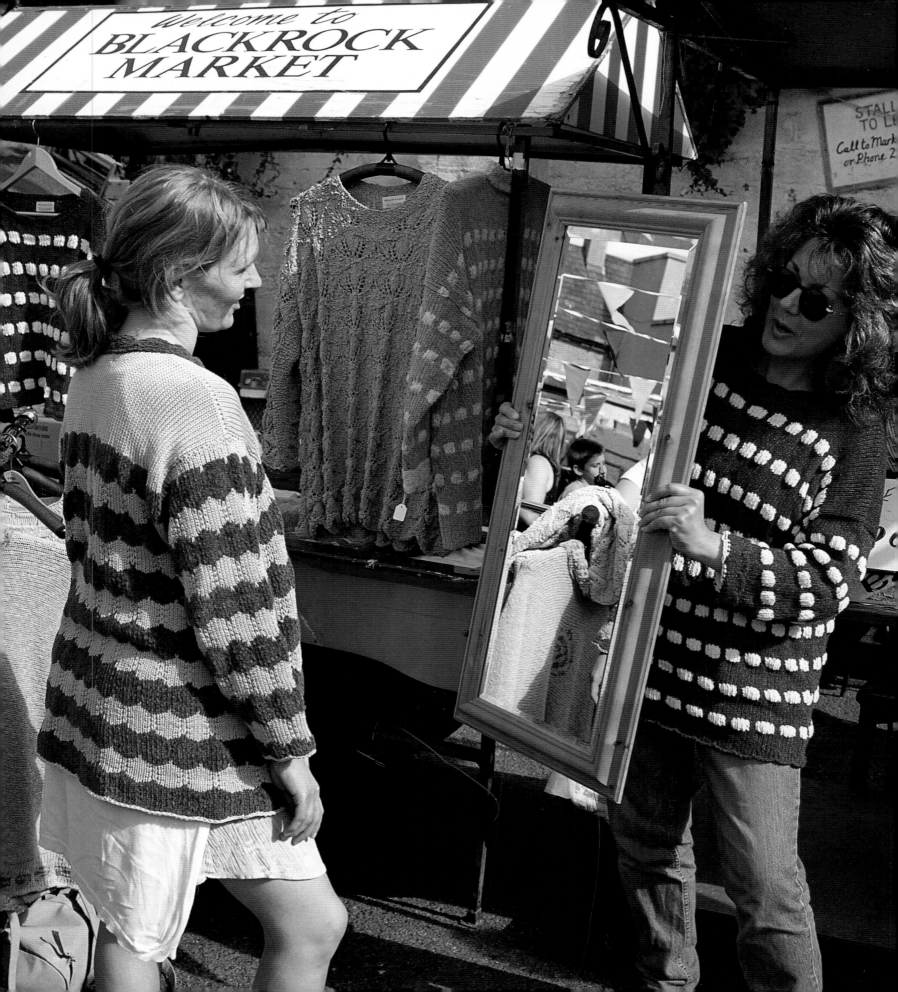

*a*s a shopping experience it's unlikely that Dublin will ever compete with the likes of London, New York and Milan, but the city's relaxed manner, its ample public spaces and eye for the bizarre have their compensations. And with half the city's population under twenty-five there's no shortage of energetic entrepreneurs ready to take advantage of the current economic boom. The satellite towns that spread out in every direction from the capital are often overlooked by visitors, but are very much on the locals' circuit. Blackrock, a coastal town to the south of Dublin, is especially pleasant. It holds a Sunday market (left), contains two rather upmarket shopping centres, and has a very fine though rather wayward high street. The attraction of such towns as Blackrock is reinforced by DART, the efficient Dublin Area Rapid Transport System, and the widespread bus network (above: a woman waits at a bus stop). ∽

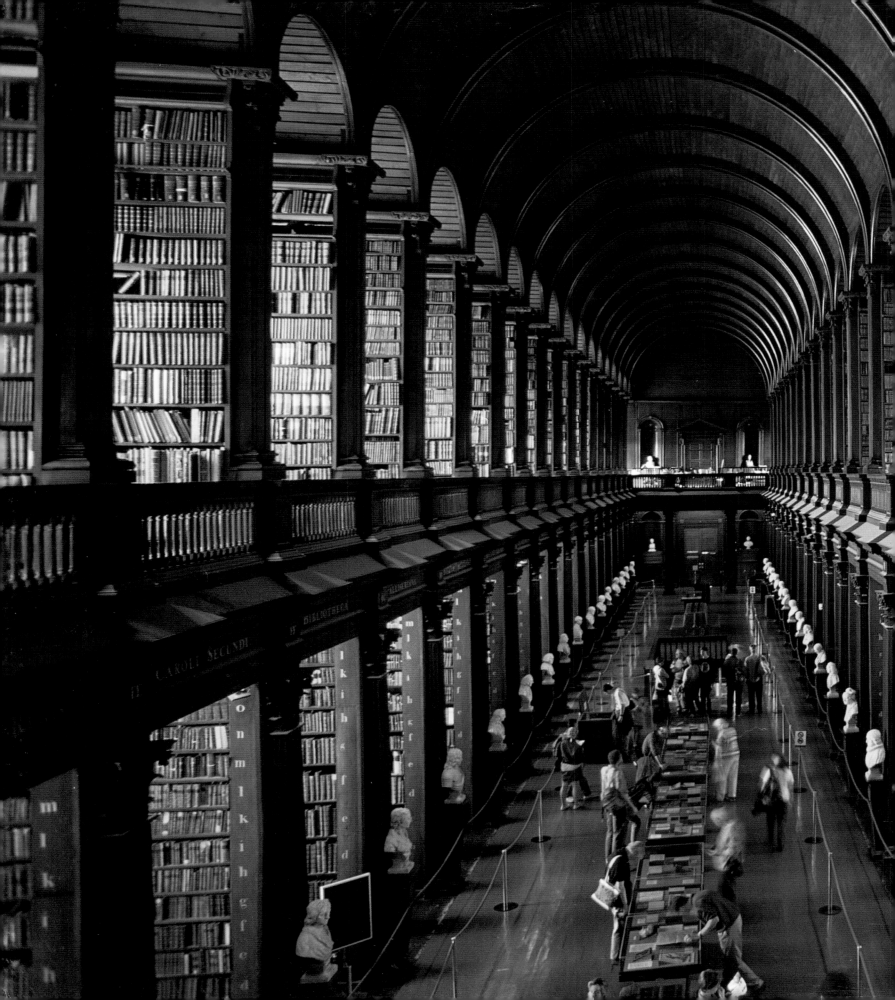

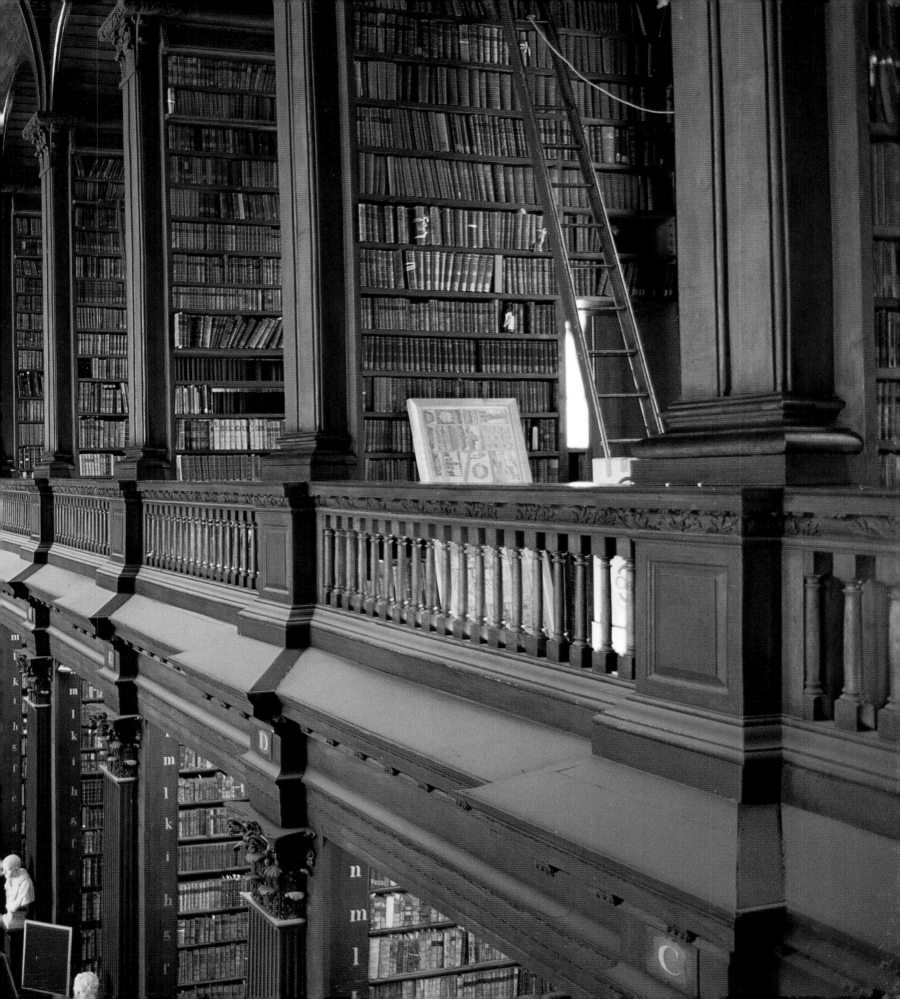

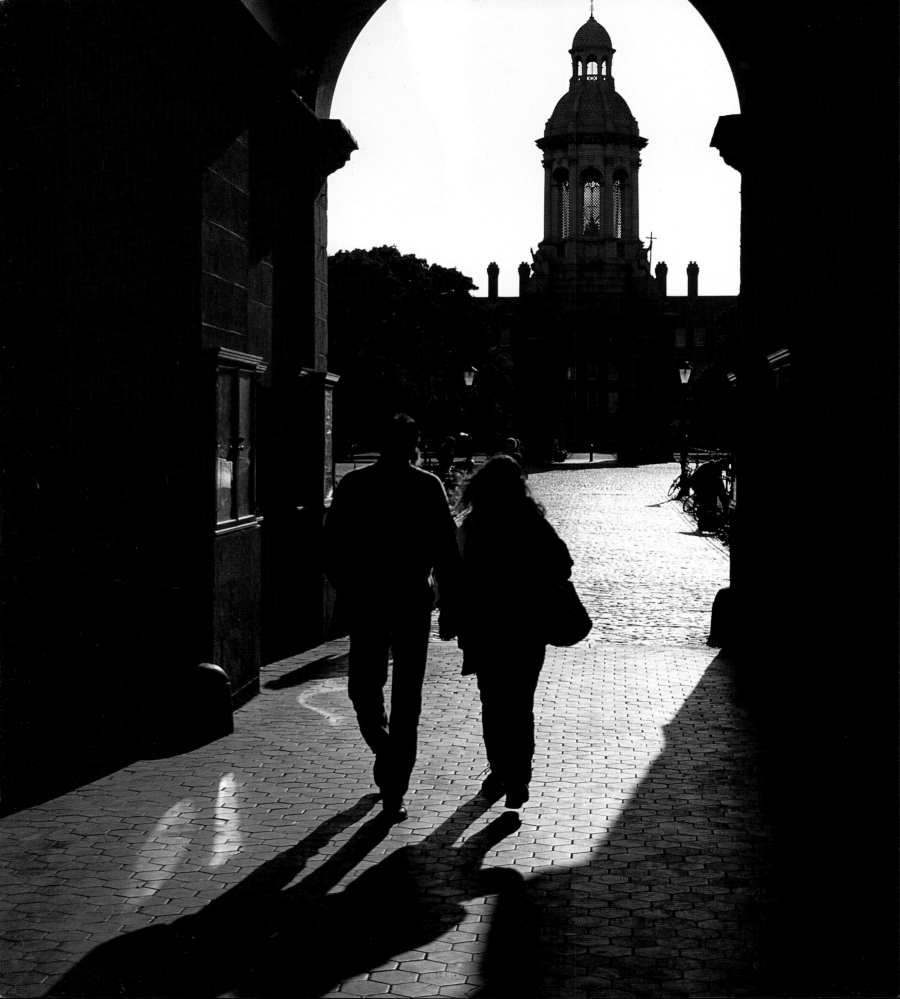

the Long Room of Trinity College Dublin (previous page) is home to 200,000 antiquarian books, though that's just a fraction of the university's 3 million manuscripts. Built in 1732, the Long Hall's bust-lined passage stretches just over 61 metres (200 ft). It's most famous possession is the 8th-century Book of Kells, Ireland's most celebrated illuminated manuscript. Some believe the text may actually be of Scottish origin, a product of Iona, St Columba's original monastery, or even English. At the far end of the Long Hall stands the oldest harp in Ireland and an original copy of the 1916 Proclamation of Independence.

the entrance to Trinity College (left) opens onto perhaps Dublin's most romantic location, Parliament Square. At its centre stands Charles Lanyon's campanile built in 1853 on the site of a priory that stood long before TCD.

the doors of Dublin's Georgian terraces are unmistakable. Leeson Street (right) is one of the finest, striding across the Grand Canal by means of a delightful bridge. The basements in the area from Leeson Street all the way to St Stephen's Green – known locally as The Strip – were once notorious for their seedy drinking clubs. But things have been rather different since cash-rich U2 turned up and founded *Kitchen*, Dublin's number one club, which has led to the rejuvenation of the whole area.

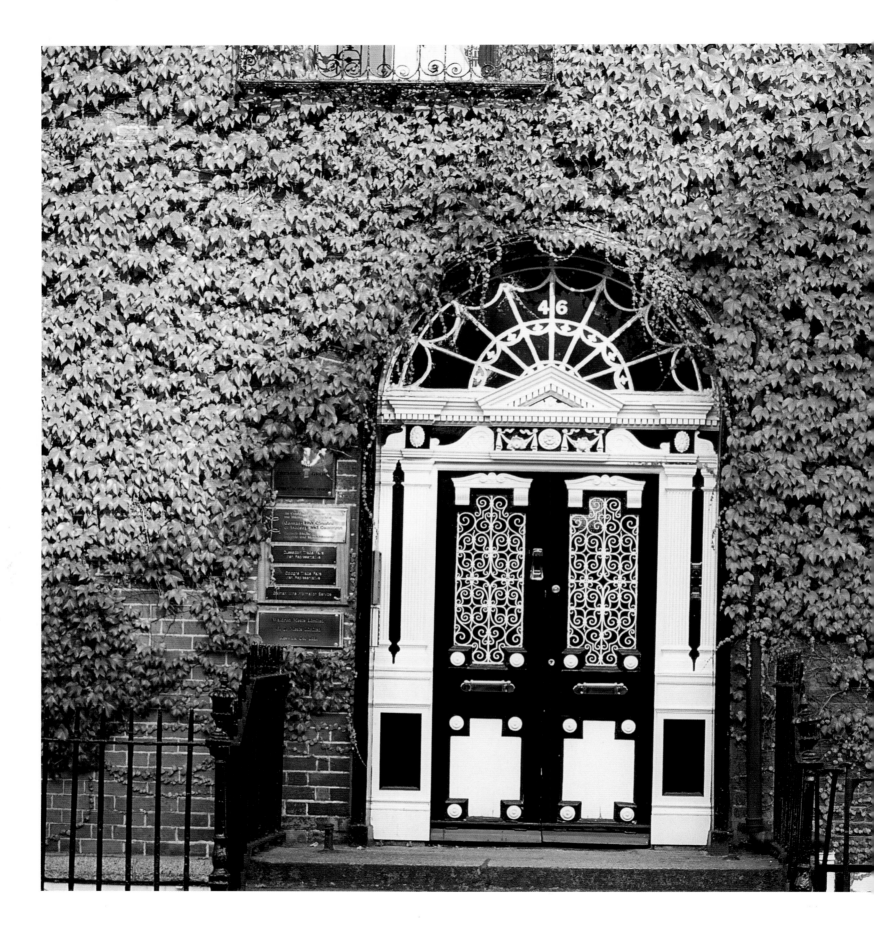

*t*he exteriors of Dublin's Georgian terraces are usually embellished with little more than a bright coat of paint and a garish brass knocker (above). But this ivy-clad example in Pembroke Street (left) is rather more extravagant. The normally sober façades of these red-brick buildings belie extraordinary internal decorations, usually in the form of highly decorative plasterwork, which can come as something of a surprise to the unsuspecting visitor. ∾

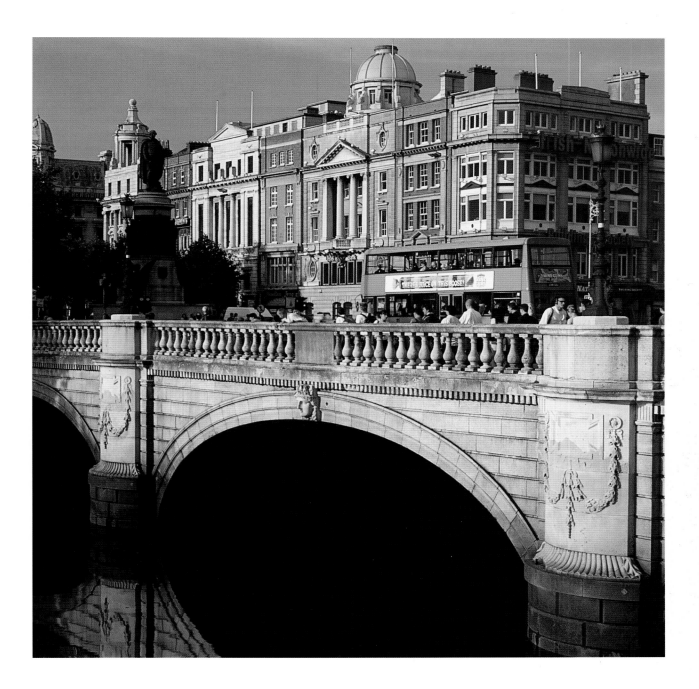

St Stephen's Green is surrounded by grand Georgian buildings (left) and provides a much-needed haven from the bustle of the city. The two sides of Dublin meet on O'Connell Bridge (above), formerly the Carlisle Bridge but re-named in honour of 'The Liberator'. Nothing could say more about the cultivated eccentricity of Dublin than the fact that the city's central crossing point and most important bridge is wider than it is long.

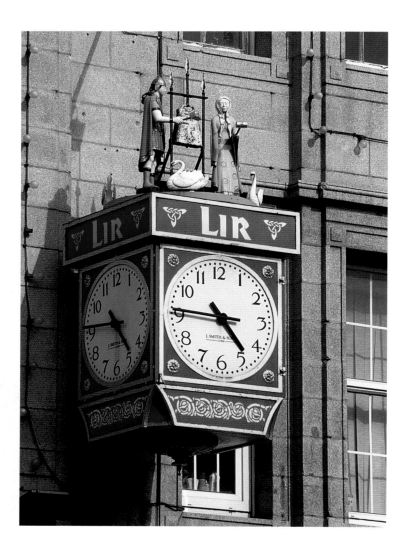

ublin, despite its many attractions, can appear a colourless place, especially when the weather's bad. At times its architecture seems almost defined by plain exteriors. Yet there are exceptions: the Lir Clock on O'Connell Street (above) is one decorative delight that commemorates the legendary figure of King Lir whose daughters were changed into swans by their jealous stepmother; and the Sunlight Chambers on Parliament Street (right), whose frieze tells the more banal but seemingly no less colourful story of Sunlight soap.

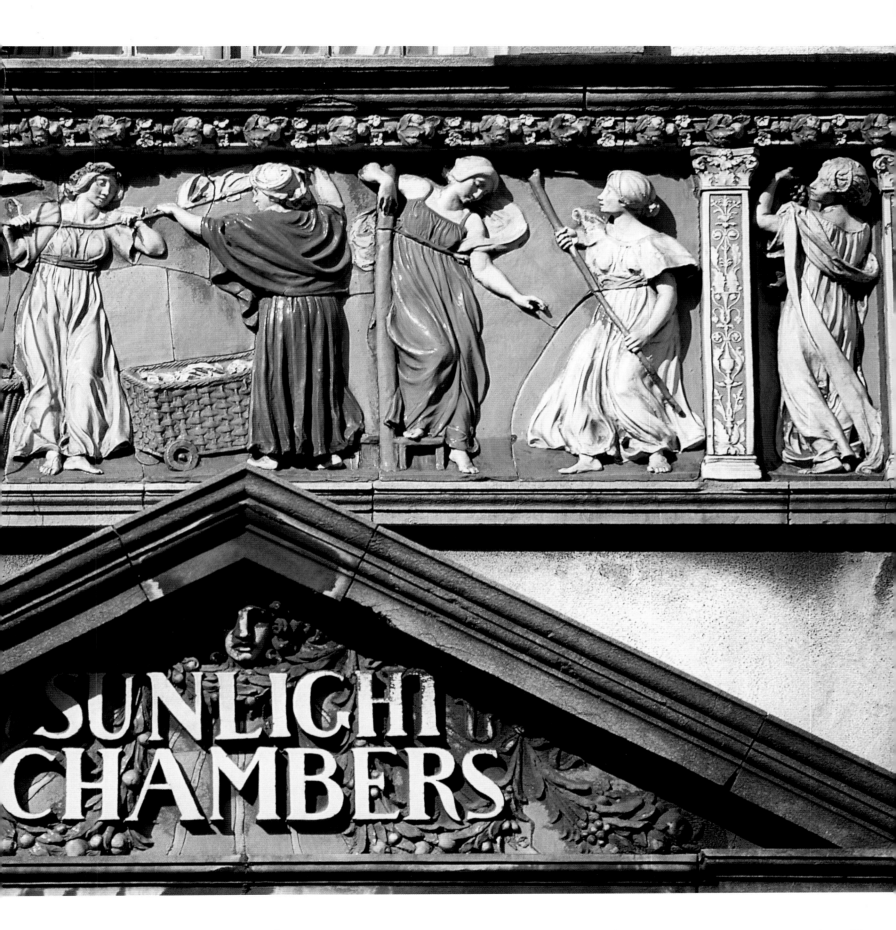

SUNLIGHT
CHAMBERS

crediting marvels

running water never disappointed

crossing water always furthered something

stepping stones were stations of the soul

SEAMUS HEANEY

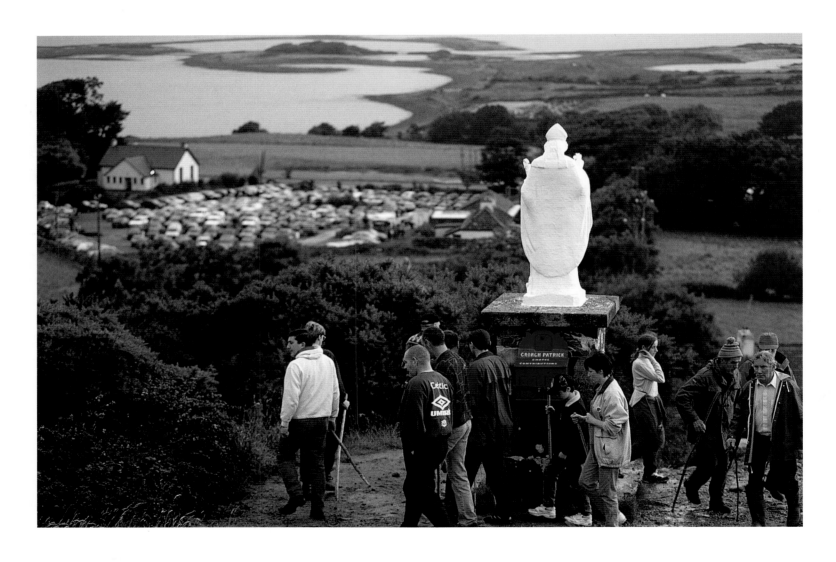

*t*HERE IS STILL something of the pagan about Irish Christian worship. Few of the ecclesiastical fashions promoted elsewhere in modern times, merry counters to an agnostic age, have taken root here. Pain, sensuality, the elemental landscape, grace, the inevitable tragedies of life, the proximity of death: these are the essential ingredients of the 'old' religion. Eternal life comes at a price and cares nothing for comfort.

The forcible suppression of 'popery' from Cromwell onwards only served to ensure Catholicism's hold on the native Irish. In the Penal era of the 18th century, it was the succour of a harried, impoverished people who treasured the tiny turf crosses they concealed in their ragged clothes in defiance of punitive British law. The long bouts of repression and persecution have given Ireland's religious rituals a curiously local, rebellious and earthy air that maintains its links with a pre-Christian past.

Nowhere is this more apparent than at Croagh Patrick, the sacred mount in Mayo where, it is said, St Patrick spent forty days and nights in fasting and prayer. On the last Sunday – Garland Sunday – of every July, close to the old Celtic festival of Lughnasa, of which it is in a way a continuation, a great snake of stick-wielding pilgrims winds its way along the wearing ascent, their tread tentative and slow over sharp, piercing quartzite rock, the pain a reminder of the presence of God. They recite prayers and perform penitential exercises or 'stations' as they climb. And 765 m (2,500 ft) high, at the summit, the bravest spend a night in conditions cold at best, often bitter, and personal confession is exacted by the priest.

Ireland's other great site of Patrician pilgrimage stands in the centre of Lough Derg, 'St Patrick's Purgatory', in Co. Donegal, where the saint fasted to expel demons. It's an altogether more exclusive experience. Its focus, a craggy islet called Station Island, celebrated in verse by the Nobel Laureate Seamus Heaney, can only be visited for the single purpose of pilgrimage. Travellers spend three sleepless days there, energised by nothing more than God, tea and black toast, all the while walking over rocks, heads bowed in prayer. For whatever reason the experience is popular with students, serving as a sort of 'chill-out room' for the soul.

The site was first written of by Henry of Saltrey in his 12th-century text *Tractatus de Purgatorio Sancti Patricii* which recounted the experience of a knight, Owein, who travelled to a deep cave, the gateway to Hell, where St Patrick fasted. Over time it became a major attraction for Europe's medieval pilgrims, despite the efforts of Pope Alexander VI who forbade the venture in 1497. Ironically, Cromwell succeeded where Popes had failed, condemning such superstition, but in the 19th century Lough Derg's popularity grew again, a result of the 'devotional revolution', a reform and remarshalling of Irish Catholic identity that in time percolated down to the lower orders.

The priesthood, as Catholic emancipation neared, had grown more confident, closer to the orthodoxies of the Vatican, and cast a scornful eye on the Wakes and Patterns beloved of the rural poor. The Wake, a festive gathering of community around the dead body prior to burial, was a popular reaction to mortality and still lingers, albeit tamed, across Ireland's deep religious divide. It was as much a part of the culture of Ulster Protestants as Cork Catholics, and unique in that aspect. Family and friends would

drink and sing and spin tales in honour of the deceased. Priests looked down on such impiety, and could hardly ignore the sexually explicit rituals and games that became associated with it.

The Pattern was a more obviously pagan inheritance. It took its name from the Irish *patrún*, as its observations took place on the feast day of a saint, usually near a holy well. Wells were the traditional focus of supernatural protection and relief from illness, favours garnered by a single circuit of the source, the recitation of charms, and the leaving of a piece of cloth. A sociable affair, the Pattern combined religious observance with, inevitably, dancing and drinking. But the organised Irish Church's newly adopted strictures and the tighter moral discipline of a fiercely politicised nationalism were disapproving of such licentious, 'magical' activity. Few Patterns continued post-famine, as a more affluent, literate society turned its back on 'superstition'.

But the old religion has deep roots and it continues to adapt itself in a surprising and bold manner, and nowhere more so than at Knock. Sited in the plains of Mayo, the once tiny village of Knock is Ireland's great modern pilgrimage site, all car parks, commercialism and chrome taps running holy water for the 750,000 annual visitors It all began on 21 August 1879 when fifteen locals reported their visions of the Blessed Virgin, St Joseph and St John. The Church immediately set up a commission to examine the claims, followed by another in 1936, and eventually Knock was established as a centre of Marian pilgrimage – superior, of course, to Ireland's other sites, which could only call on the relatively humble figure of St Patrick. A folk museum was built in 1973, then an enormous basilica and, to trump them all, an international airport, capable of bringing pilgrims from all over the world. It was Monsignor Horan, a remarkably dynamic local priest, who opened himself up to vitriol and ridicule by seeking to persuade both big business and government of the good and godly sense of his showpiece project, and in 1986 his prayers were realised: an airport with the capacity to handle the largest Jumbo jets was opened. 'There never was a miracle like the airport built at Knock', sang Christy Moore. Its benefits were not only spiritual: 'We thought Horan was a fool,' one local told me, 'but he made us rich. These used to be famine lands. Now everyone wants to move to beautiful Mayo.' God does indeed work in mysterious ways.

One aspect of Ireland's religious life may puzzle and surprise the visitor. For such a religious country, Ireland has few great churches; only from the mid-19th century was a massive programme of church-building allowed, and too often the result has been neo-Gothic pastiche, empty of spirit and ambition. Efforts have been made by more progressive modern architects to create religious buildings worthy of Ireland's traditions: Liam McCormack's church of St Aenghus in Burt, Co. Donegal, an atmospheric well of light that stands close to and resembles the ancient hill-fort of Grianan of Aileach, is one example. But it is to the great outdoors, to the centres of pilgrimage, that one must go to discover the essence of Ireland's religious traditions.

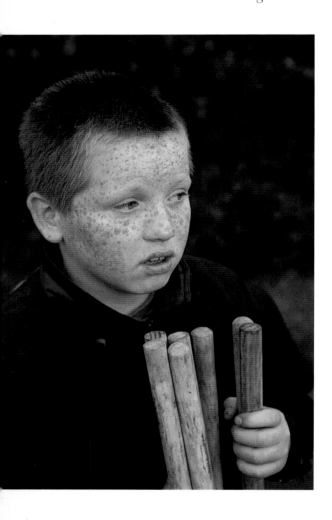

Pilgrims circle the statue that marks the starting point of the climb to Croagh Patrick on the Garland Sunday pilgrimage (previous page). A young boy (above) sells much-needed walking sticks to pilgrims about to begin the ascent. The hardiest of them – and they are often women – walk in bare feet (right) across Croagh Patrick's quartzite scree, which is harsh enough in parts to mangle all but the best of boots. Scarred soles are the way to a pure soul, it seems. ❧

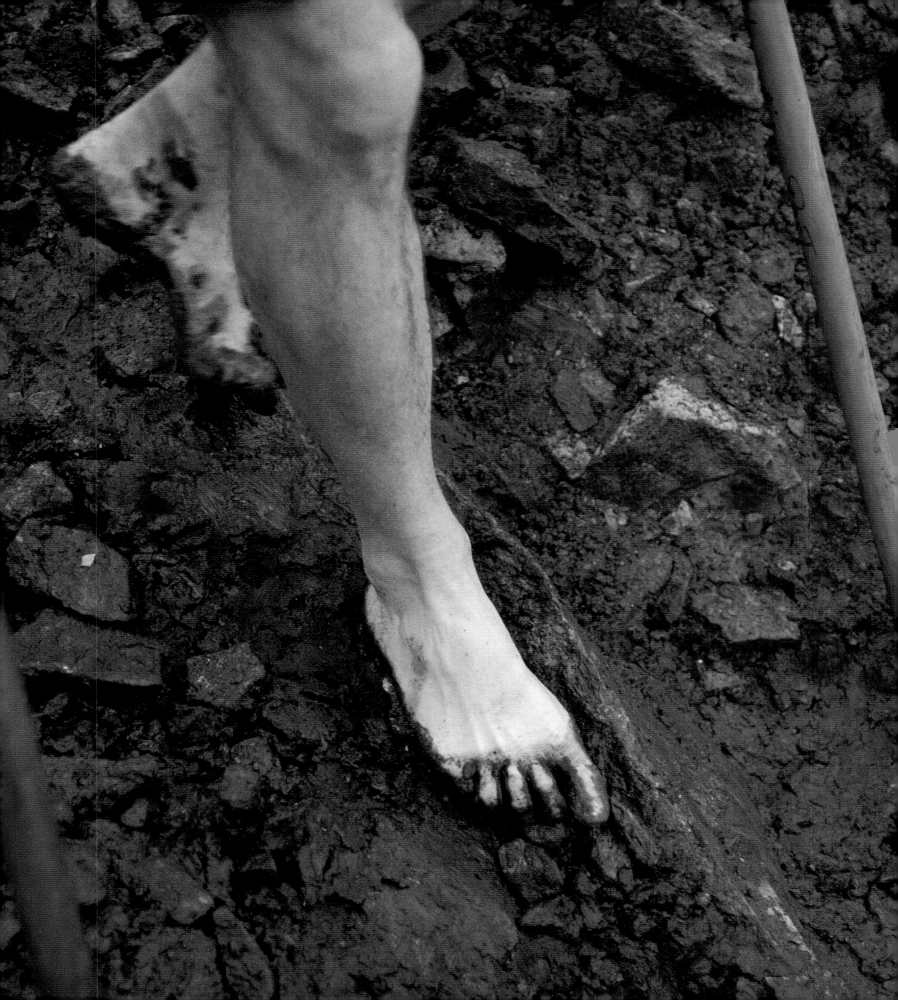

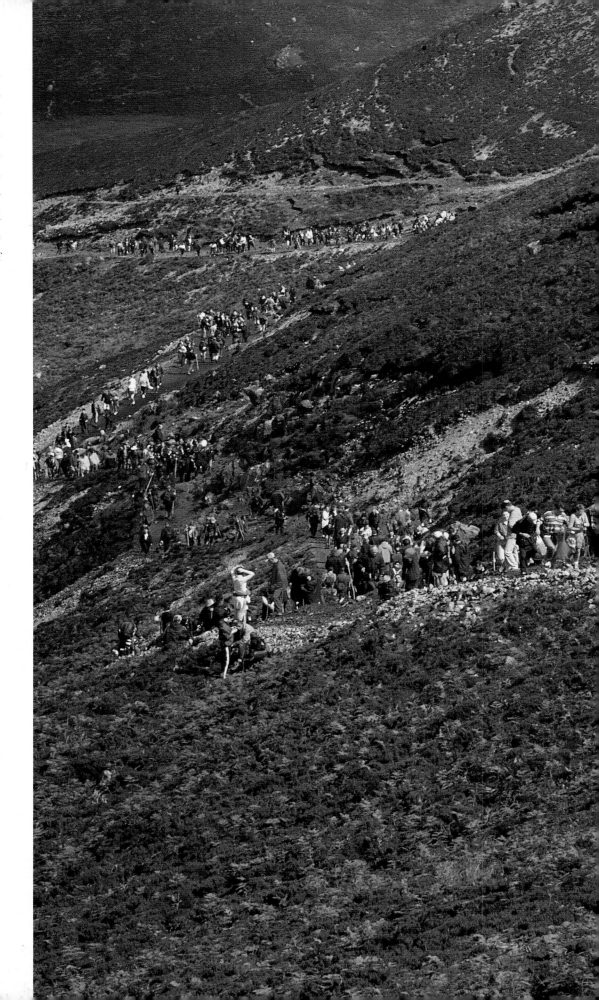

*t*he great human snake creeps up Croagh
Patrick. On one Garland Sunday a
forgetful bishop ascended the mountain with-
out his communion goblets. A message was
passed down to the base, carried like 'Chinese
whispers' from ear to ear. But they got the
message right and the bishop's goblets finally
reached the summit, being passed hand to hand
through the enormous line of pilgrims. The
mountain-top service began on time as if
nothing had ever happened. 〜

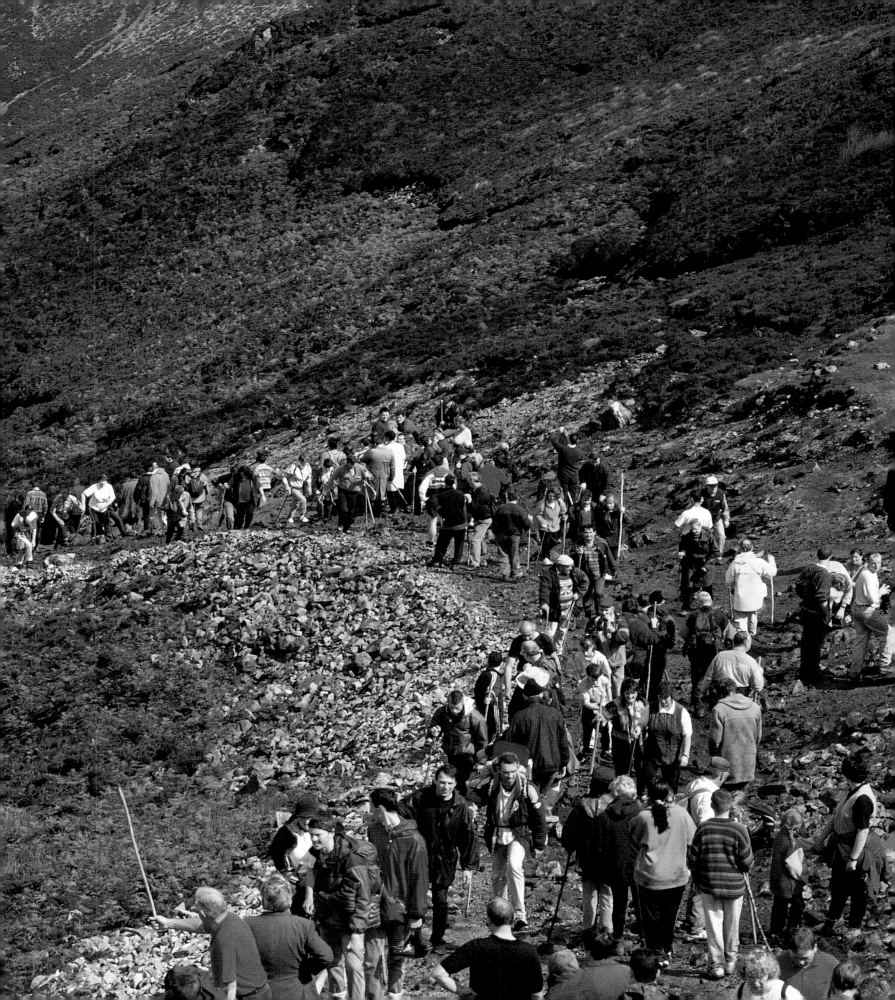

*e*ven in July, rain is an almost inevitable accompaniment to the climb up Croagh Patrick, creating just one more trial for the pilgrims. Perhaps the most extreme of the many acts of redemption to have taken place on Croagh Patrick's slopes was the carrying by a devout band of the 716 bags of cement needed to build the chapel that sits on the summit. For most of the pilgrims the acts of walking barefoot on the wet and slippery splinter-sharp rocks (right), or the endless incantation of the rosary in penance (opposite) are enough to satisfy their spiritual needs. ∾

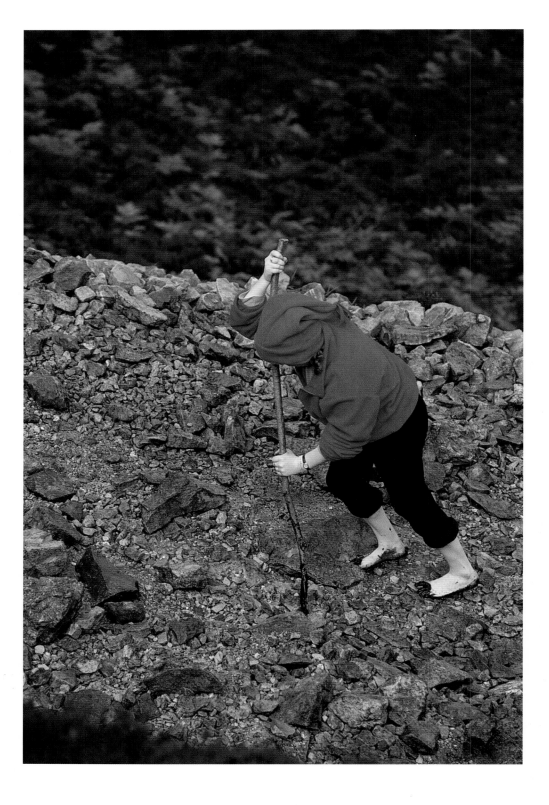

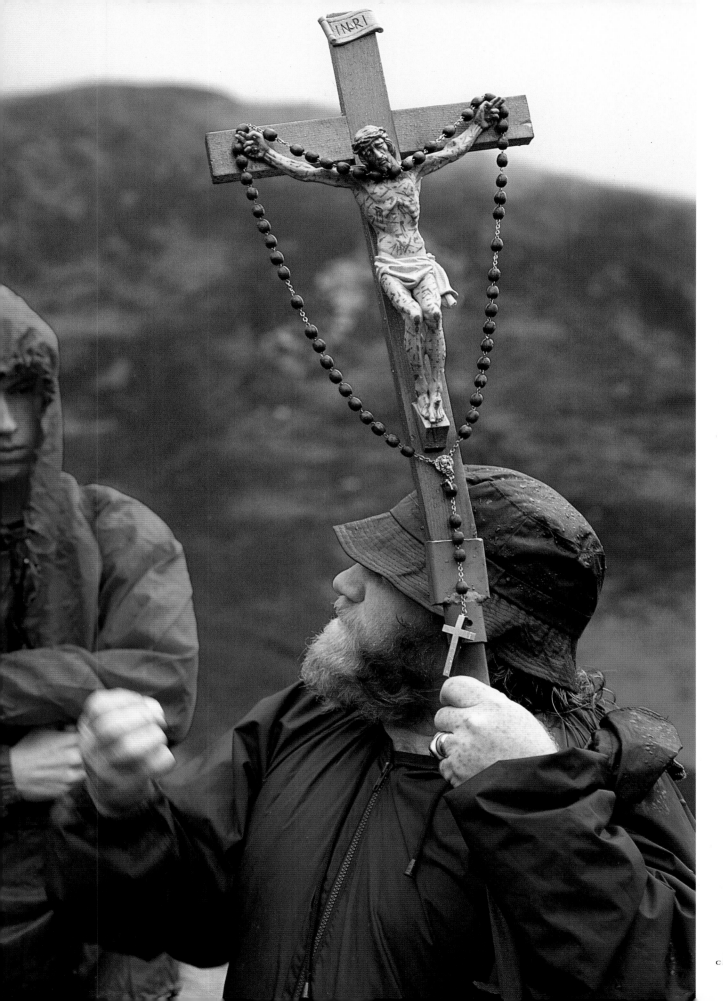

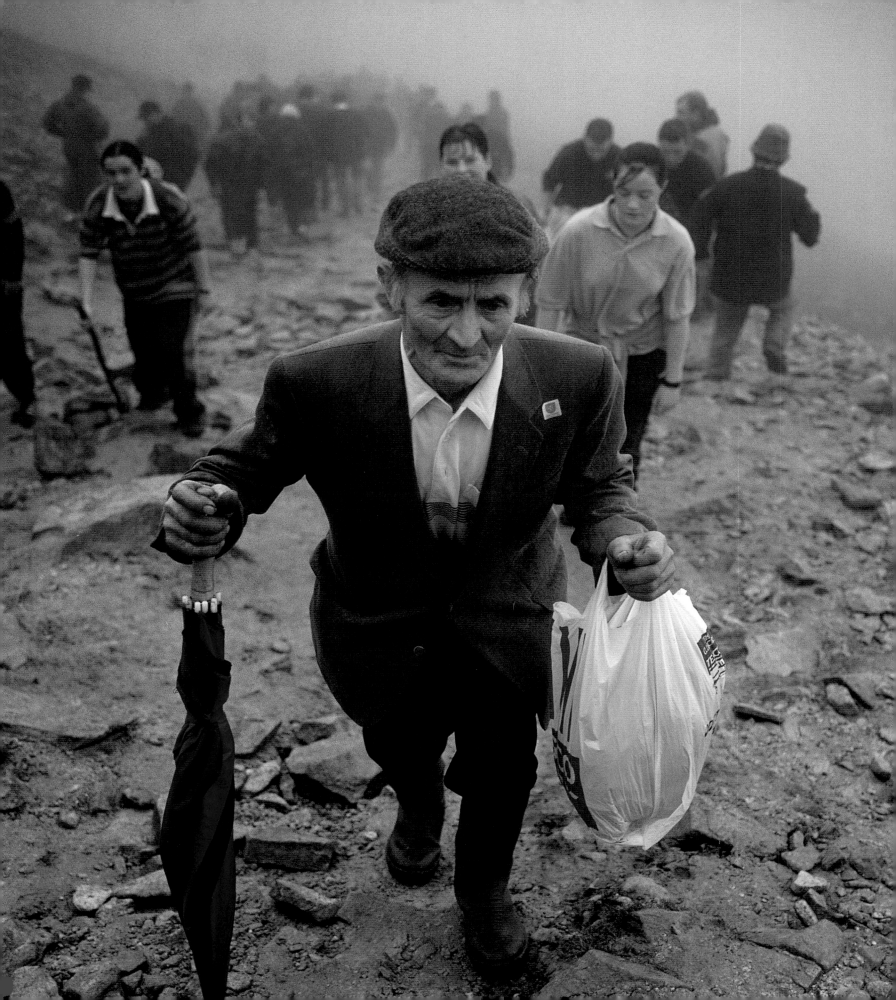

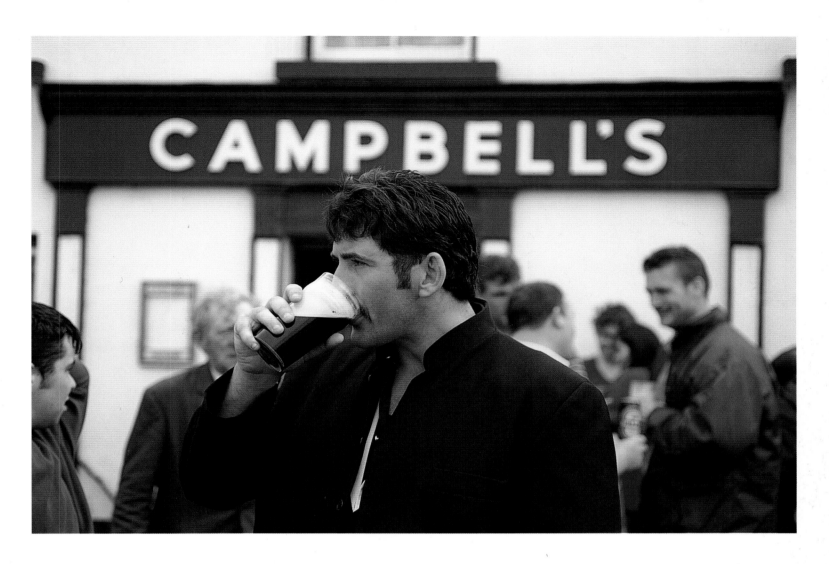

One of the most astonishing features of the Garland Sunday pilgrimage is the apparent lack of preparation of so many of the participants. Here an elderly man (left) dressed in everyday clothes, carrying a plastic bag of food and drink and aided by nothing more than an umbrella, strides purposefully up the steep, scree-strewn slopes. There's little sign among the crowds of the rainwear, walking boots or other specialised equipment that would be deemed essential by experienced walkers. The climb is thirsty work and the descent even more so, so the post-pilgrimage drink is *de rigueur*. A young man sinks a pint of stout; it no doubt tastes divine.

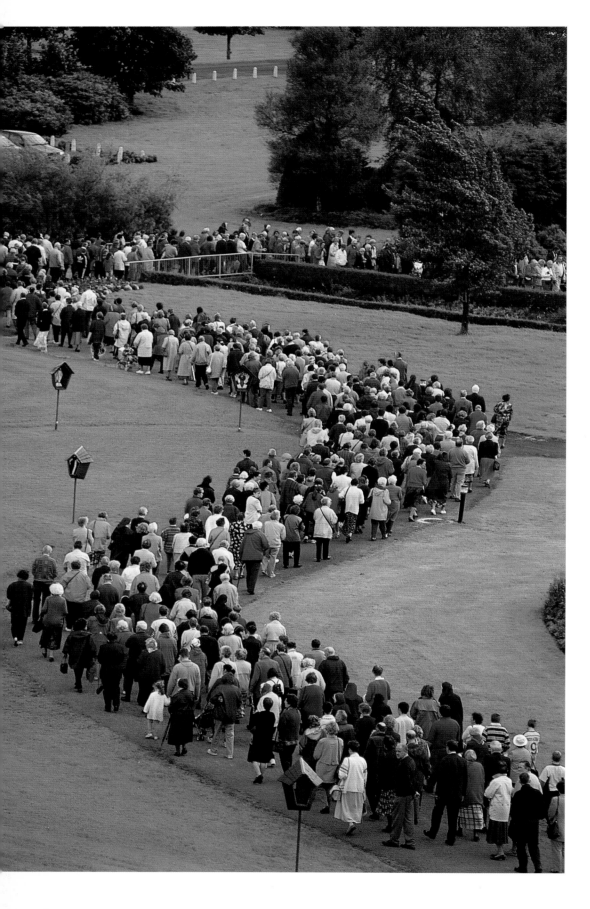

the rosary procession at Knock (left). The apparition of the Virgin Mary that appeared on the gable of Knock's parish church in 1879 has had enormous repercussions for the village. Now Knock ranks with Lourdes in France and Fatima in Portugal as one of the great Marian pilgrimage sites of the modern Catholic Church, and the Pope gave it his full blessing when he visited in 1979. Unlike Croagh Patrick, Knock is not a place of beauty: the massive basilica built in 1976, which holds a congregation of 20,000, is ugly to say the least, and the whole village is awash with commercialism. For many, a visit is a test of faith in itself and a hard trudge (right), though it is an undeniably fascinating sight even for the most convinced of atheists.

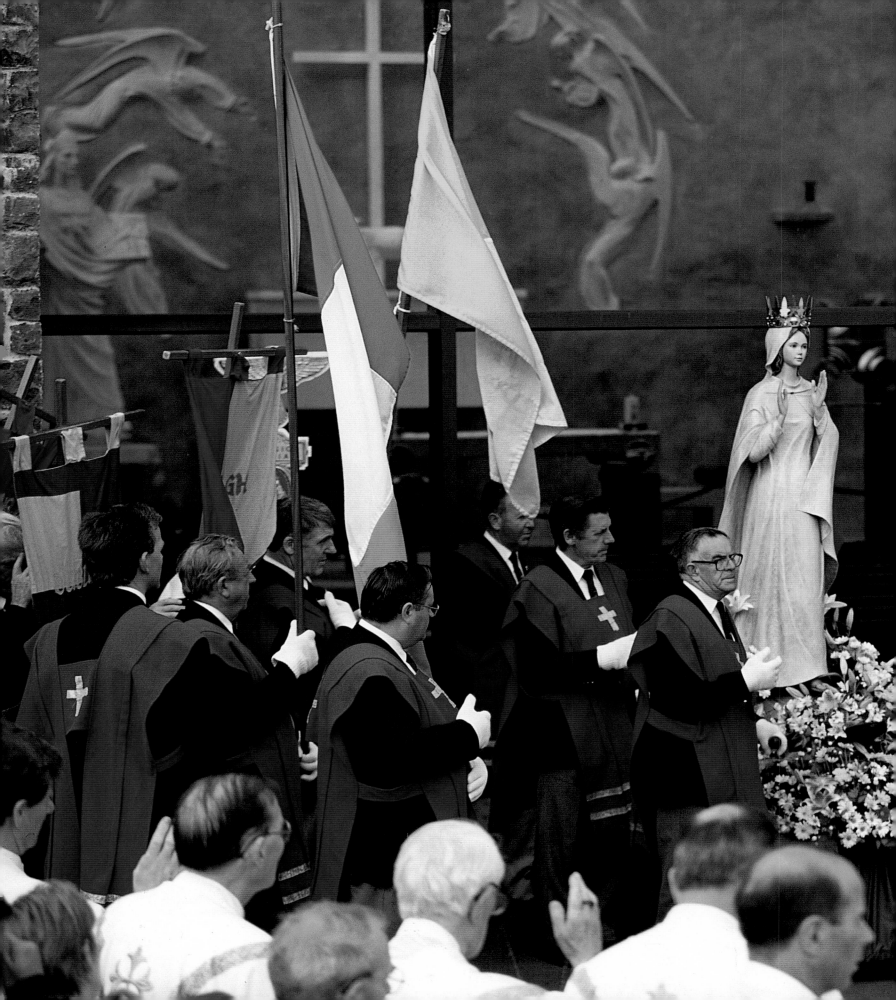

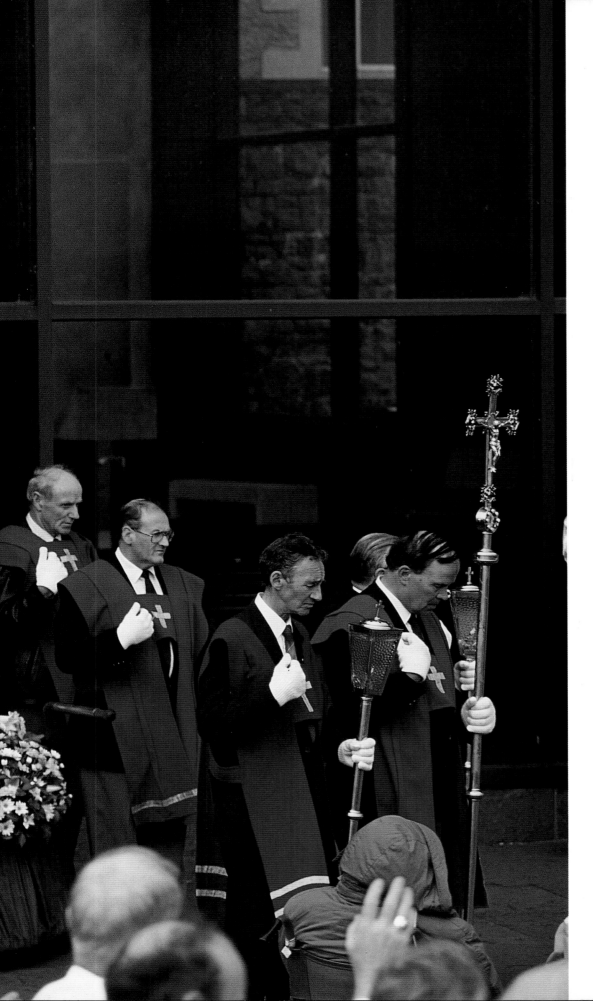

the Blessed Virgin who appeared at Knock was draped in white and wore a gold crown, as she does here at one of the numerous religious ceremonies that take place in the chapel built on the site of the original apparitions. Knock is now much more than a pilgrimage site; after the reforms of Vatican II, greater attention was paid to Knock's theological meaning, and a broader pastoral programme has been developed. The most far-reaching effect of Knock though has been on tourism. The opening of the airport at nearby Charlestown has brought the beauties of County Mayo to within one hour of London and, as a consequence, property prices have boomed as residents of England's prosperous south-east have snapped up holiday homes in the area and encouraged the growth of the service industry.

ilgrims pray and kiss the shrine that has been built where the visions were witnessed. So many pilgrims make the journey that facilities at Knock have been provided on the grandest of scales. In particular, the high proportion of elderly visitors has necessitated the construction of legions of public lavatories that rank as the cleanest and most modern in the Republic. There's no shortage of car and coach parks either, which are hardly in keeping with a scenario of heaven on earth.

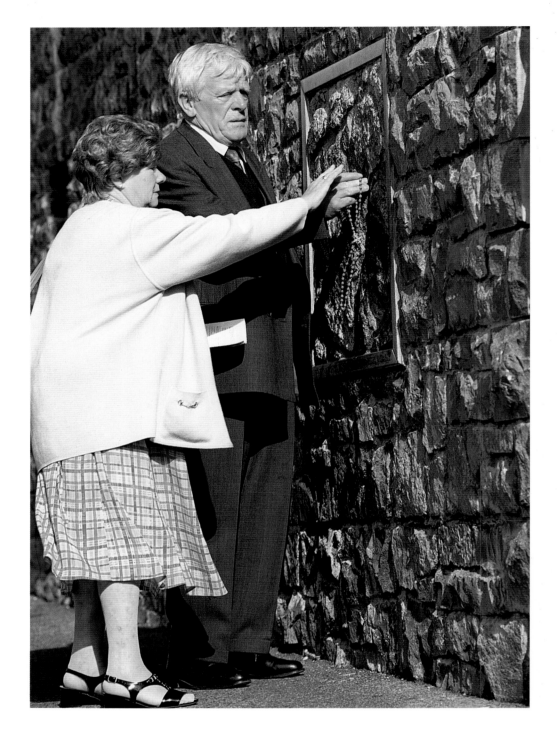

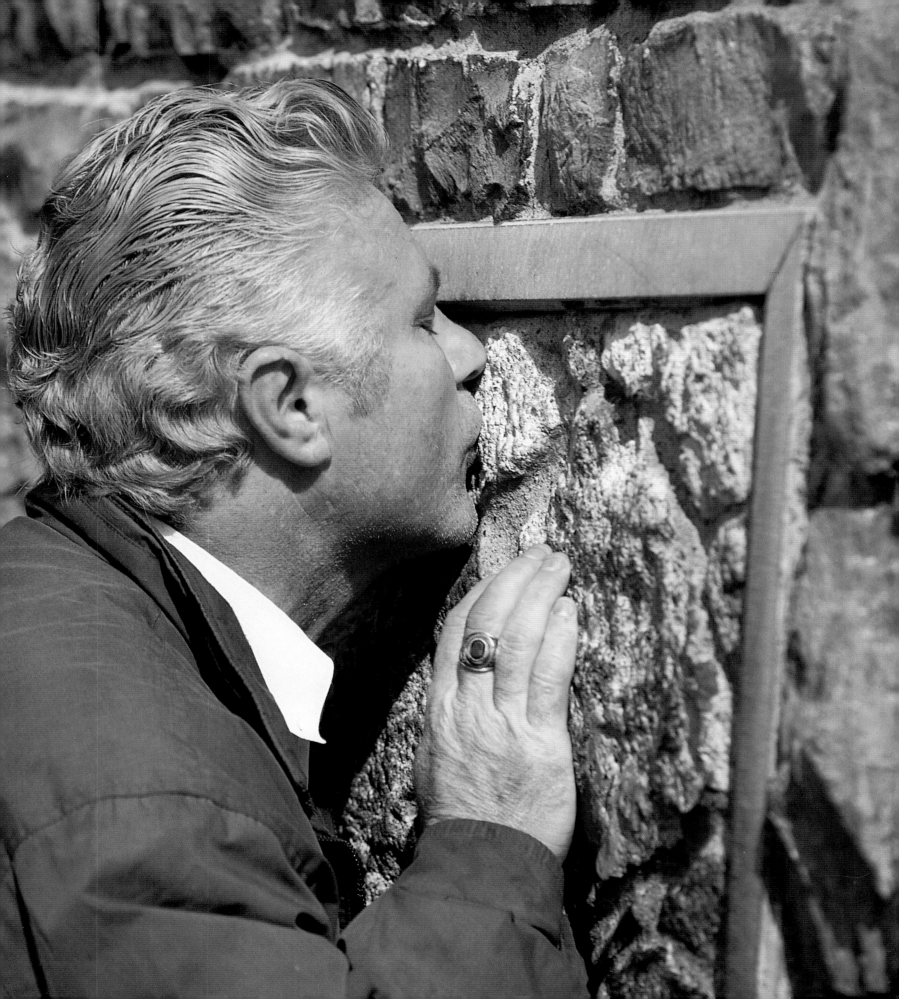

the Sunday church collection is taken on St Stephen's Green, Dublin (left). Unlike Knock, Dublin's churches must fight for attention against what the writer Anthony Cronin, contemplating the future of Irish Catholicism, colourfully described as 'the godless contemporary world, its extortionate and uncontrollable economics, its soulless spirit of enterprise, its willingness to contemplate the final holocaust.' At least it seems the good people of Dublin do such battle with a smile.

Connoisseurs of kitsch are drawn to the remarkable displays of religious memorabilia that pour forth on the streets of religious centres (right). Plastic figures of Christ and the Blessed Virgin abound, and nothing is deemed too vulgar: I once saw a toilet-roll holder graced with the image of Pope John Paul II for sale in a 'Lucky Shop' in Clonakilty, Co. Cork. ❧

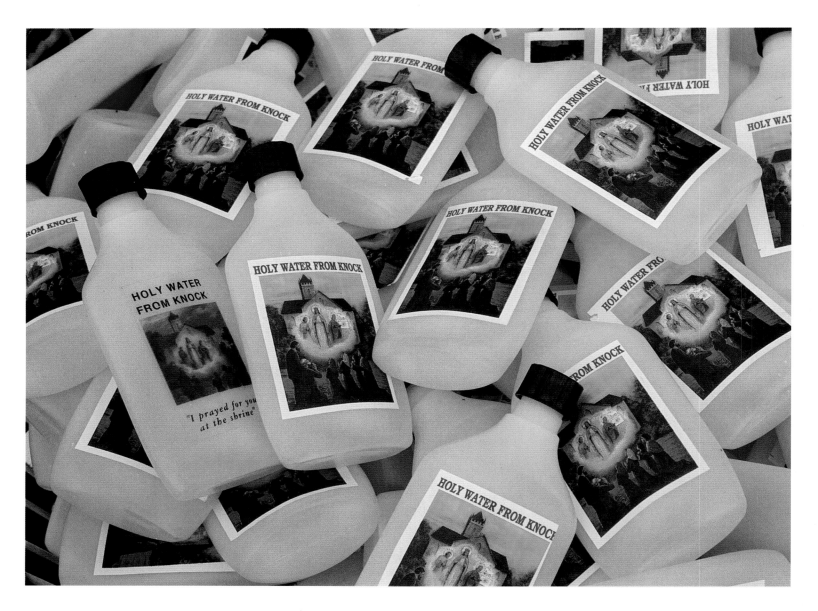

ℏoly water bottles for sale in Knock (above). Pilgrims watching the pennies prefer to fill their own containers (right) with water of similarly divine power from one of the numerous state-of-the-art chrome taps that are dotted at great frequency throughout the village. Catholicism and rampant commercialism walk side-by-side, and the pilgrims' demand for mementoes of their visit appears insatiable. ∽

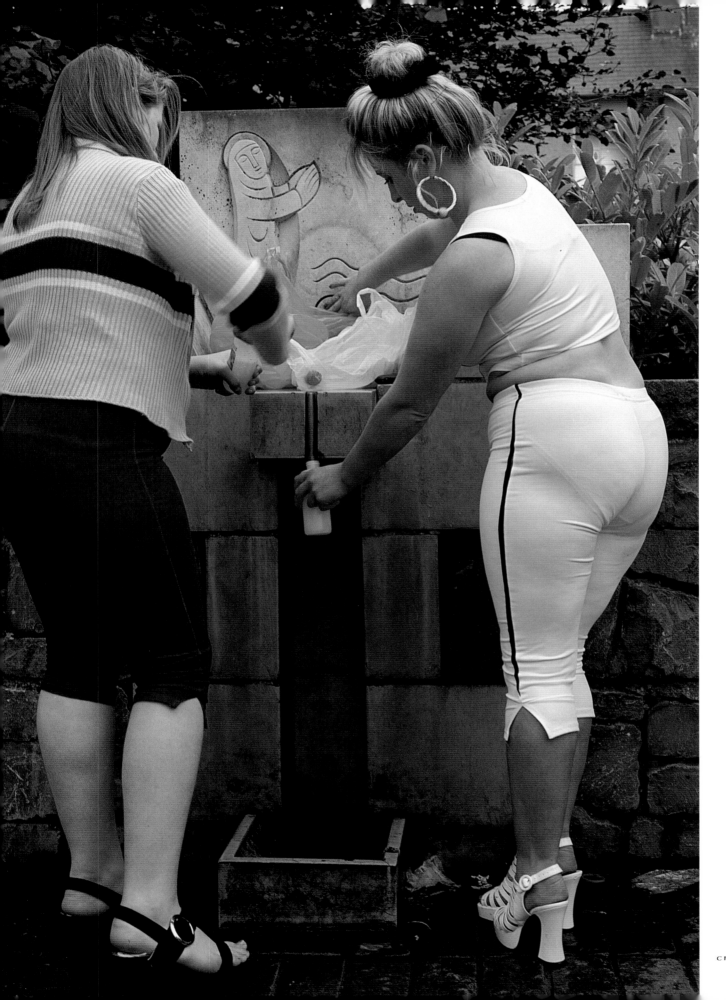

In stark contrast to Knock, Station Island is one of the more demanding pilgrimage centres of the Catholic Church, and commercialism is kept well at bay. The only luxury allowed to pilgrims, who must stay for a mandatory three days, is that they can sweeten the boiled waters of Lough Derg if their energies are flagging. There is no kitsch value attached to Station Island: a pilgrimage is a very real badge of honour for believers. Those whose faith is less strong and yet who are wearied by the rigours of modern life are increasingly attracted to Station Island's austere code. ❧

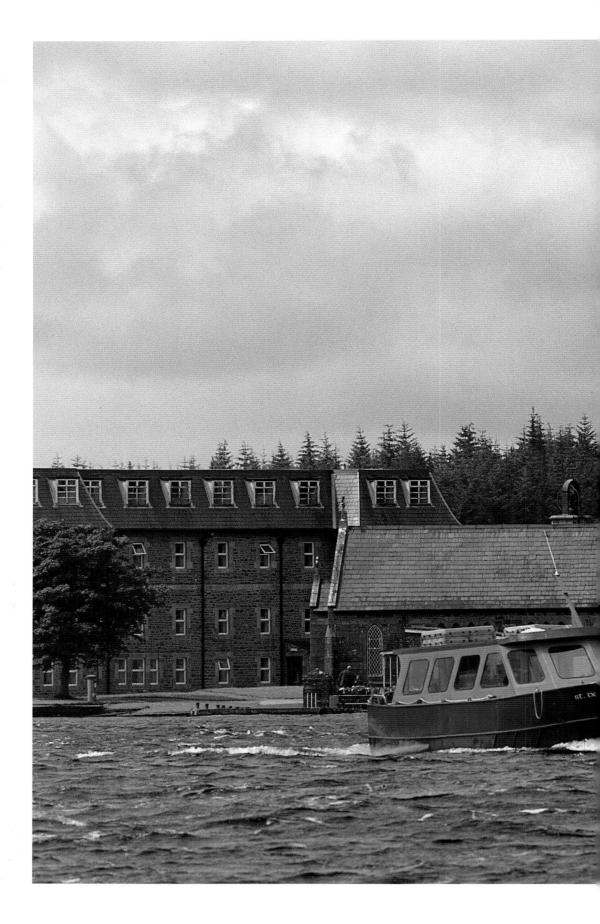

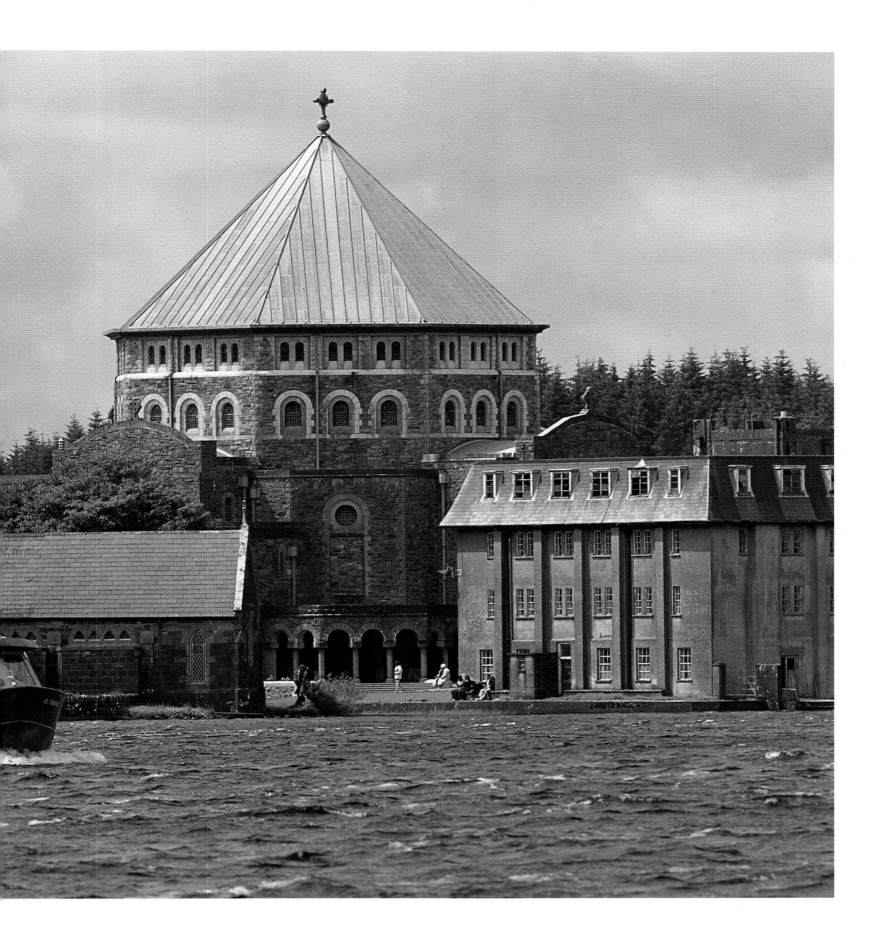

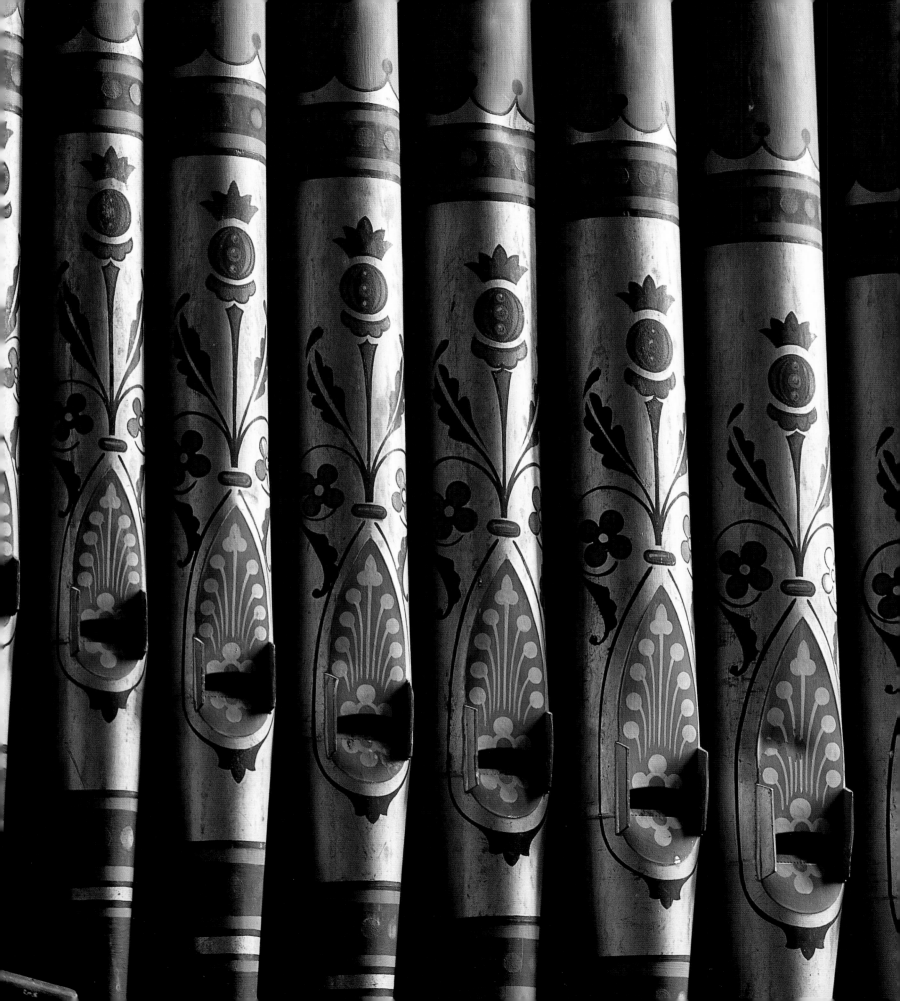

Clonfert Cathedral, with its decorative organ pipes (left), is one of Ireland's oldest and greatest extant religious structures. Built in 1167 by the chieftain Conor O'Kelly, Lord of Uí Máine, it boasts an extraordinary romanesque exterior. Devotional music in Ireland has had a chequered past; religious persecution meant that church music of Catholic origin was once all but banned, though a musical renaissance followed the founding of the Irish Society of St Cecilia (the patron saint of music) in 1878. This organisation devoted itself to the dissemination of church music from the earliest days, and found great favour with Ireland's newly prosperous middle classes. Many church organs were built with the funds that flowed in.

Despite its visual splendour, the church of St John the Baptist (right) in Cashel has a difficult task attracting visitors: it stands in the shadow of the Rock of Cashel, the most important tourist destination in Co. Tipperary. ∾

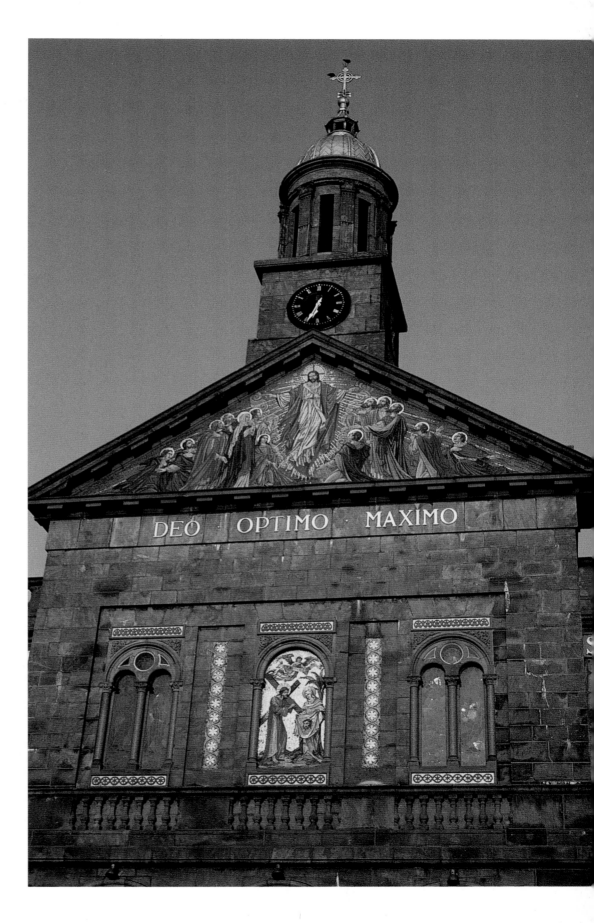

riders to the sea

it's the life of a young man to be going on the sea

J.M.SYNGE

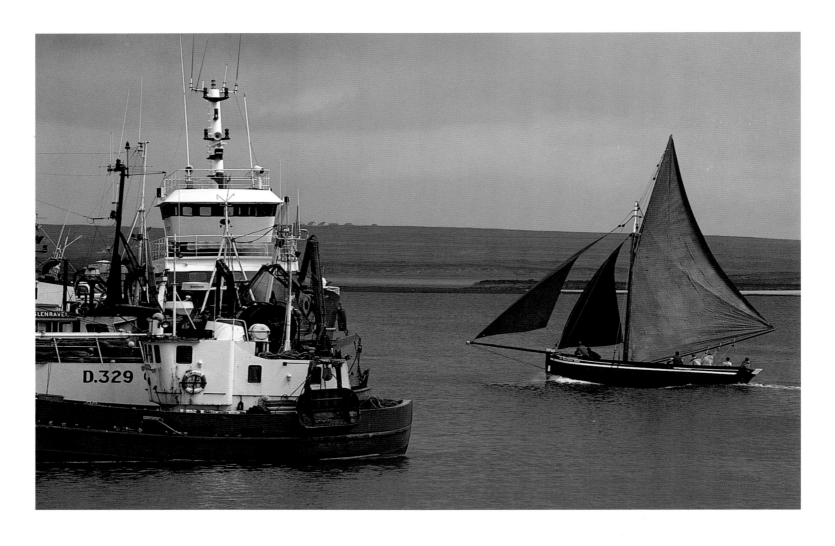

tHE SEA IS both a blessing and a curse, though on the Aran Islands it is more the latter. Inishmaan, the middle of the three limestone islands, was immortalised – one might even say 'discovered' – by the playwright J. M. Synge in his great trilogy, *The Shadow of the Glen, Riders to the Sea* and *The Playboy of the Western World*. It is the island that maintains closest links to a traditional past romantic in its endeavours, but scarred by penury. Here you may, on occasion, still see the distinctive island costume. The men wear a thick waistcoat over their dark blue shirts, made of unbleached wool and white in colour. They call it a *báinín*; *bán* is white in Irish. When it is cold, as it often is, they wear the Aran sweaters, now part of a lucrative tourist trade which offers hope that, in part, traditions will continue. Tellingly, their tweed trousers, too heavy to crease, are held up by a *crios*, a belt woven in a distinctive family pattern, the easier to identify the body of a drowned fisherman washed ashore. The presence of death, of tragedy, is never far away on Inishmaan. There are many stacks of stone that commemorate a local soul lost to the sea.

For centuries, the men of Inishmaan have sailed the *curragh*, the lightweight, frail-looking craft made of laths and canvas rendered seaworthy by tar. Turned upside down, resting on one of Inishmaan's empty strands, it resembles a giant beetle. Usually, the *curragh* is crewed by three men, each with two long, bladeless oars that swivel in their thole-pins. Sometimes a sail is fitted, though that is a rare sight today; outboard engines are preferred.

a Galway 'hooker', a vessel perfectly adapted to the harnessing of the eponymous bay's fierce winds, sails into Inishmore, the largest of the Aran Islands.∽

They offer a nervous ride, but are crafted for strong seas, with a straight stern and sharp bow. Until recently visitors to Inishmaan, which has no deep water quay, were transferred from the Galway boat half a mile offshore, to a *curragh* that rose and shifted in the swirling sea, an exacting test of a first-timer's balance and nerve. The visitor was manhandled on board to a background chatter of Gaelic, and slammed on a bench that was wet and slippy with spray. For what seemed a lifetime the *curragh* remained lashed to the side of the big boat as live pigs and sheep in sacks, and gas and beds and boxes of cornflakes were rushed on board; the visitor would wonder how much more a *curragh* could hold. And then the craft with its capable crew broke free and plunged into the surf, battling the forces of Galway Bay. Half a mile on it was greeted by women assembled on the concrete pier, their shoulders draped in colourful shawls, and by children for whom Gaelic was their first tongue and Galway another world away. In the background stood the donkeys and carts that would whisk the produce home.

Synge said of the man of Inishmaan that 'The danger of his life on the sea gives him the alertness of a primitive hunter, and the long nights he spends fishing in his *curragh* bring him some of the emotions that are thought peculiar to men who have lived with the arts.' It is a long time now since Inishmaan's men set sail in *curragh*s laden with harpoons to do battle with basking sharks. Even in the 1930s when the filmmaker Robert Flaherty followed in Synge's footsteps and made the memorable *Man of Aran*, he had to call on the fishermen of Achill Island, further north in Mayo, to show the men of Aran how it was done. Yet these people of 'ungovernable eyes' still fish from the *curragh*, and snare lobsters, and make much of the mere 6 per cent of their island that is fertile.

In other parts of Ireland's long indented coastline, the sea can bestow greater blessing, and some who live in its embrace seek to share their good fortune with the world. Along the southern shores of Galway Bay there are hundreds of little piers that jut out into the water; this is oyster-fishing territory. In September, every hamlet from Galway City to the border with Co. Clare is given over to a grand celebration of the tiny, native mollusc, made even more precious in recent years by the threat of disease. Thousands of travellers make this pilgrimage of indulgence every year.

The 'Oyster Country', as it has come to be known, is pretty and bears none of the harshness of so much of the West Coast. In the early years of the 20th century it was the haunt of W. B. Yeats, his patron Lady Gregory and other leading lights of the Gaelic League. And nowhere are the attractions of the landscape's gentle beauty more apparent than in the village of Kilcolgan and its swan-bedecked weir. Here, in a setting that borders on the twee, but is both compelling and comforting, stands *Moran*'s, a pub famous for the excellence of its oysters. That Guinness is the perfect accompaniment to a plate of half-dozen, only reinforces the feeling of being a little closer to heaven when one dines here.

Nowadays the sea offers other nourishment. There has been huge growth in recent years in the numbers who take to its waters for leisure. Mayo's Clew Bay, where 365 islands shelter in the shadow of Croagh Patrick, is a favourite spot for Ireland's youthful, young and old, to learn the basics of seamanship. There are few *curragh*s here, but many Toppers, Lazers and 420s – the fast, fibre-glass vessels that bring the Atlantic, with its risks and its thrills, within reach of the weekend enthusiast. Many of them are inspired to hear that Clare Island, the great rock that marshalls Clew Bay, was once the lair of the pirate queen Grace O'Malley, Granaille, the scourge of the Tudors. There are many myths and legends that surround her: one tells of how, at the age of forty-five, she gave birth at sea. Astonishing enough. But one hour later her ship was boarded by Turkish pirates who threatened to capture her vessel. Just in time, Grace appeared, wrapped in a blanket, and shot the enemy captain with a blunderbuss.

Europe's western fringes remain as wild as Grace knew them, though the islands, the headlands and the promontories are no longer a refuge from the marauding English. They are increasingly a retreat from the stresses and strains of an ever-more demanding urban existence – an Irish arcadia, perhaps.

a young girl in traditional West Coast garb offers the fruits of the sea (above) at the Galway Oyster Festival. The tiny harbour at Rossmuck, Co. Galway (opposite), at the farthest reaches of Gaelic-speaking Iar-Connacht.

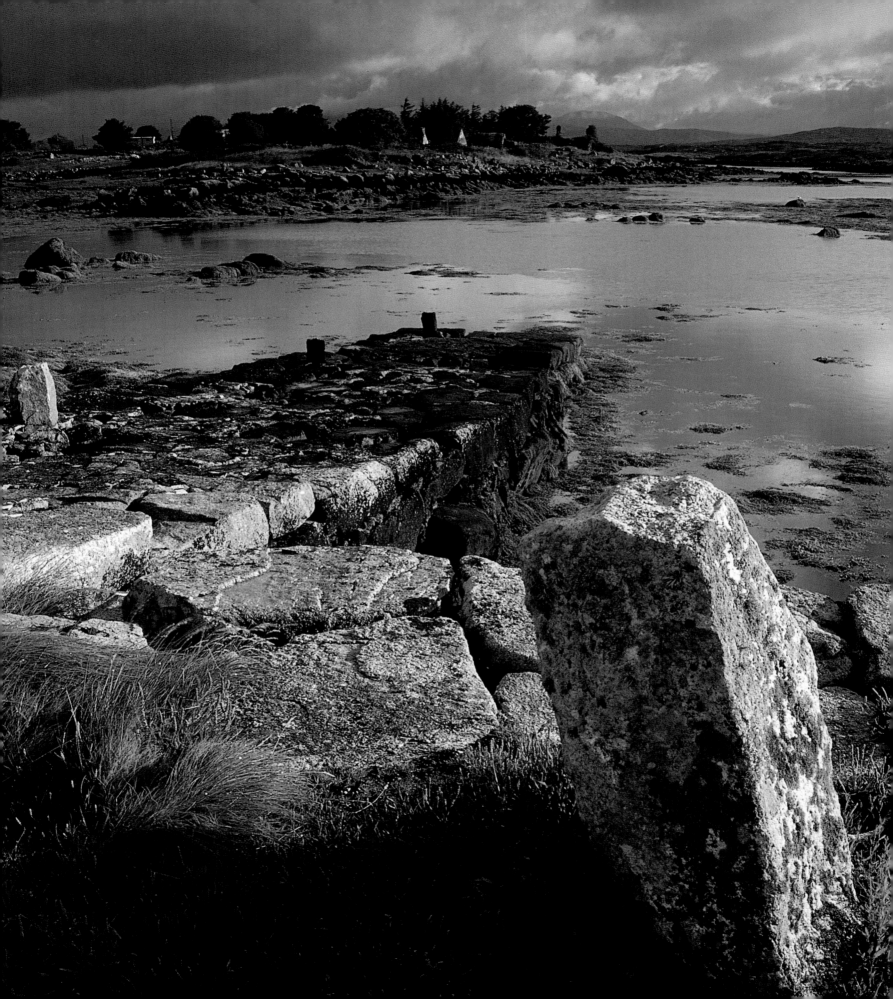

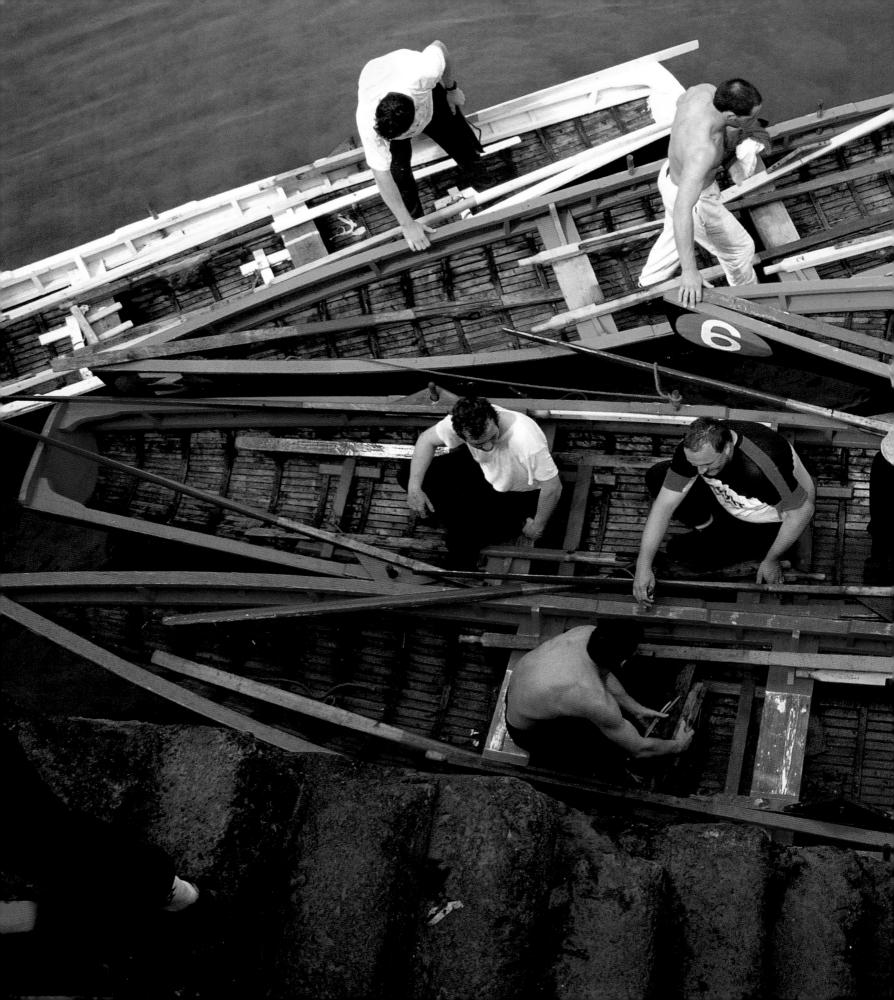

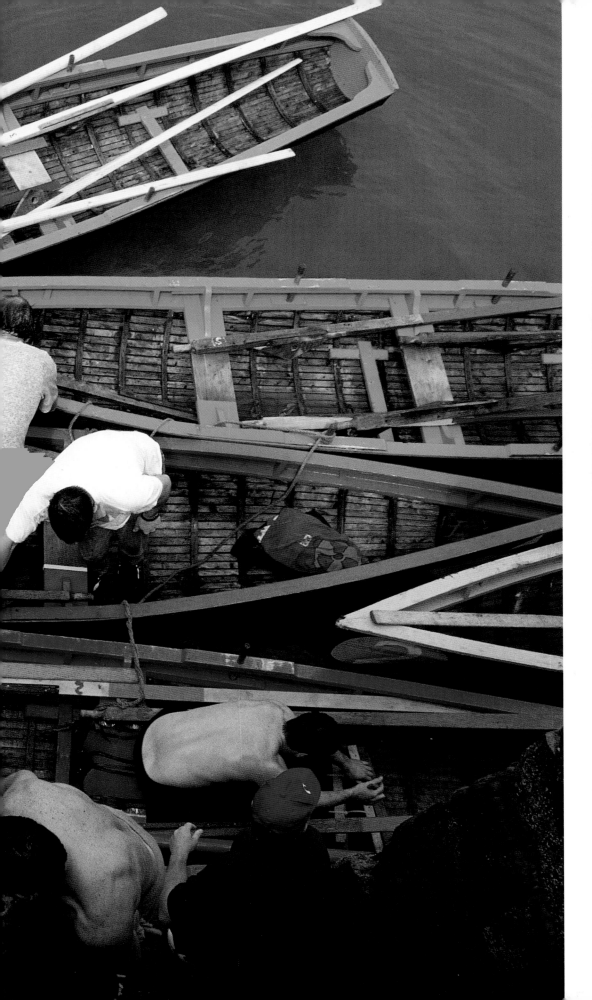

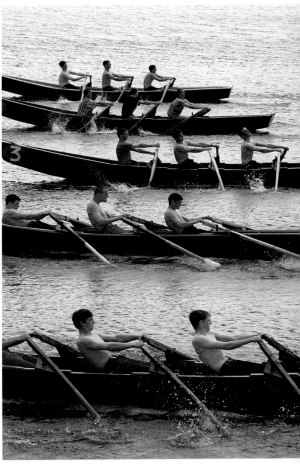

The *curragh* is the superb sea-going vessel of the Aran islanders. They are not much to look at, but have withstood the fiercesome weather of the windswept West Coast for generations. Every year in the months of June and July there are *curragh* races off Inishmore (above) where the three-man rowing technique is demonstrated to perfection. The innate skills of the rowers and the speeds they attain are remarkable to witness. ~

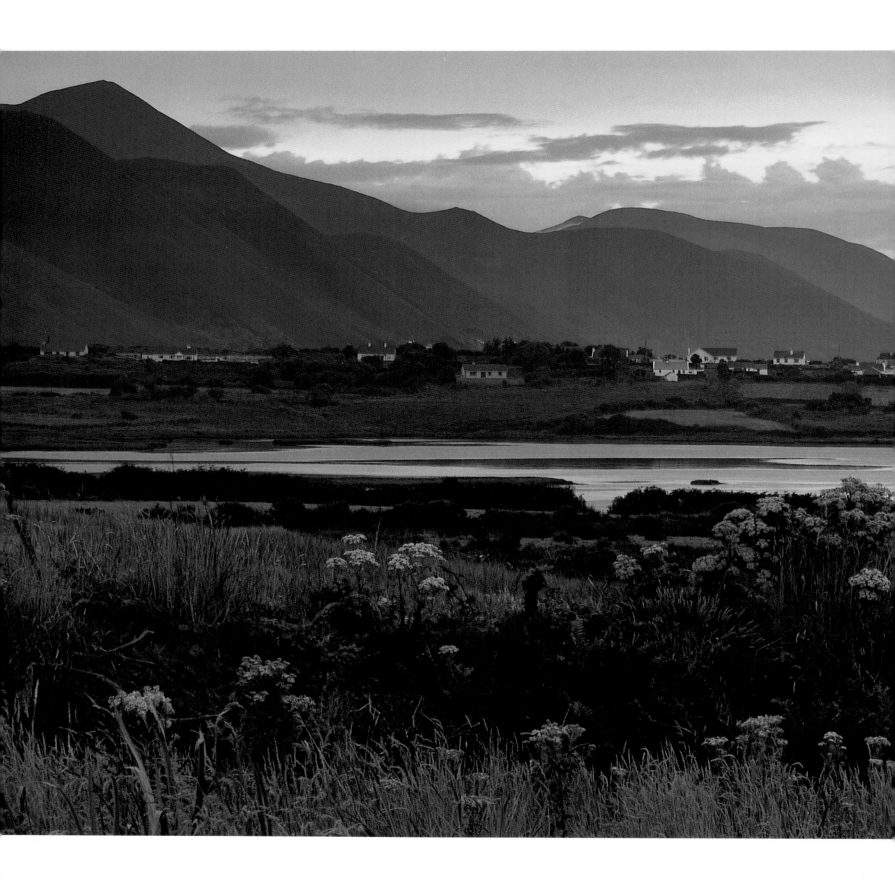

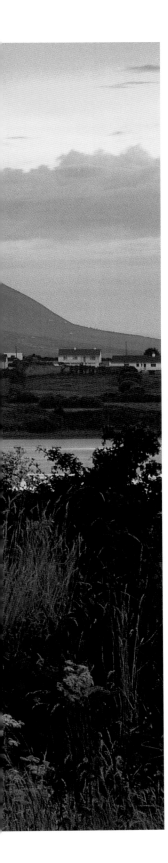

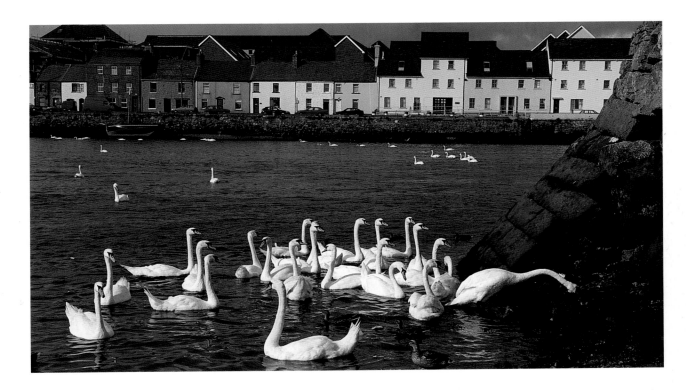

Rossbeigh Creek (left) with Mount Seefin in the background. In the Ring of Kerry, the West's premier tourist attraction, this is a wildly romantic location, strongly associated with the legend of Oisin, the son of Fionn mac Cumhaill, who returned here after his long sojourn in the land of youth. The creek feeds into Dingle Bay. Much more gentle, but no less beautiful, are the southern shores of Galway Bay (above), the centre of Irish oyster farming. The waters, inspiration for the poet W. B. Yeats, are often graced by groups of swans.

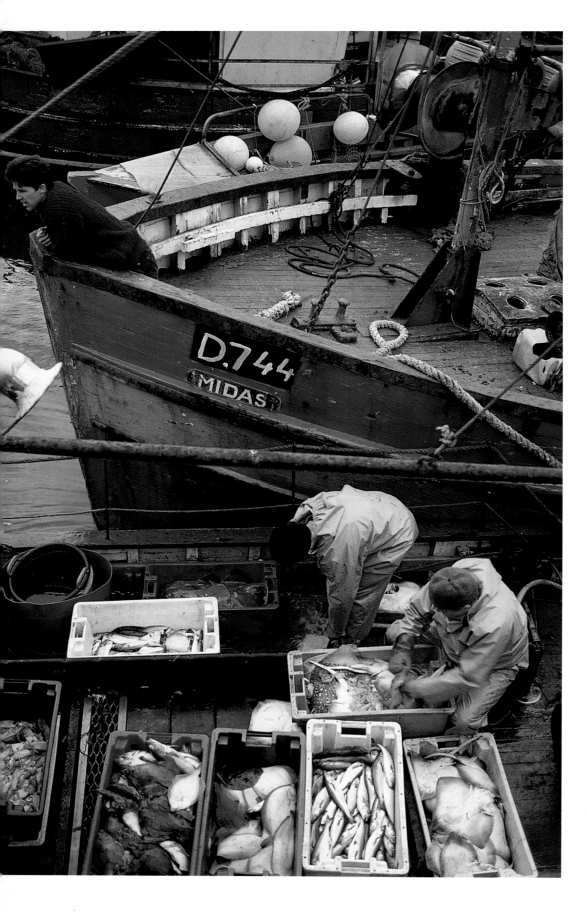

ishermen gut their catch in Killala harbour, north Co. Mayo (left). Despite the country's abundance of fertile fishing grounds and traditional Church entreaties to eat fish on Friday, the consumption of fish has never been especially popular in Ireland and much of the produce is sold abroad. Most of Ireland's more productive fisheries are based on the East Coast: fishing in the West promises a difficult and dangerous life and one that is often economically precarious. Ireland's fresh-water fishing, especially in the West, is a huge attraction to anglers all over the world. The salmon is of the highest standard. And what other country can provide such exquisite, solitary beauty as that surrounding this fishing hut (right) that stands on the shores of Lough Ahalia in Connemara, Co. Galway?

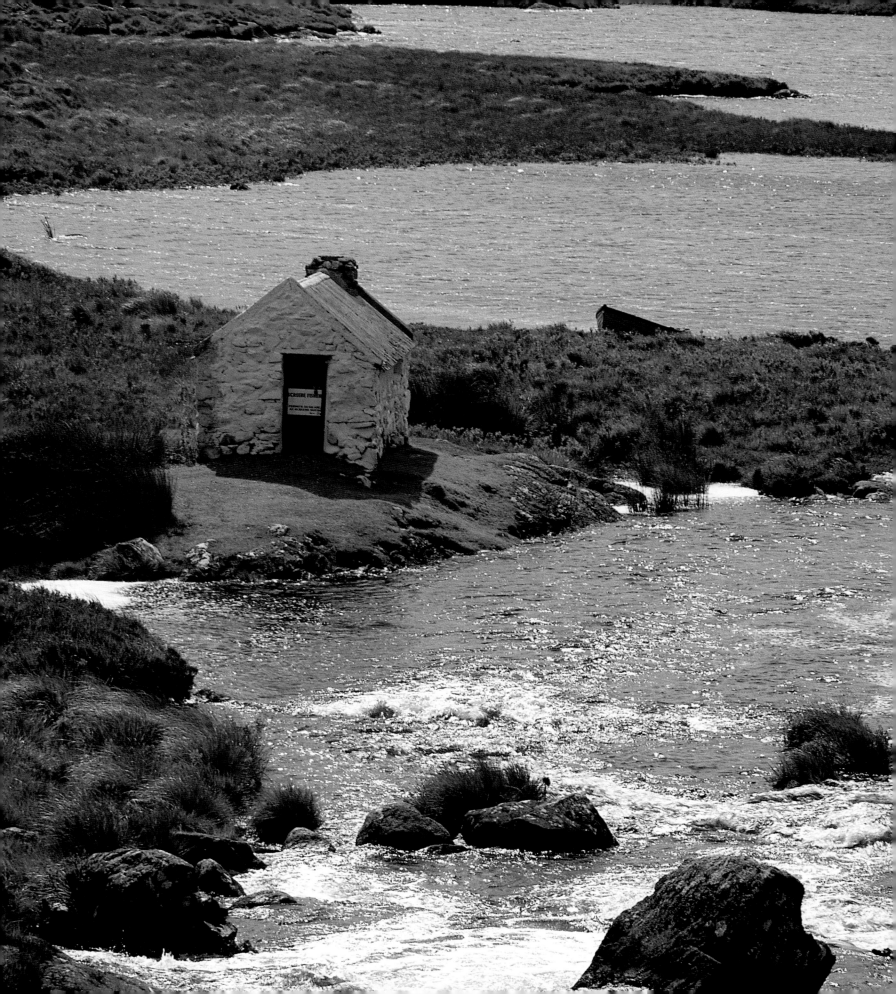

a wrought-iron fence in the shape of a racing cyclist brings colour to the streets of Belvelly, Co. Cork. There is no better way of travelling through this large, sumptuous county than by bicycle. The peninsulas of West Cork combine wild mountains and unspoiled beaches with all but empty coastal roads, and in the south of Cork there are wide bays and woods that reach all the way down to the sea. ∾

the pleasant seaside town of Kinsale, 29 km (18 miles) south of Cork City, has established a reputation as a gourmet's delight with many fine restaurants that make the most of the fresh local seafood, and fine pubs like *The Bulman* (top right). For those who can't get enough of the Irish pub Dingle, at the head of the eponymous peninsula in Kerry, is the place to head for. At the last count there were fifty-two such institutions (right) crammed into the 'westernmost town in Europe'. ∾

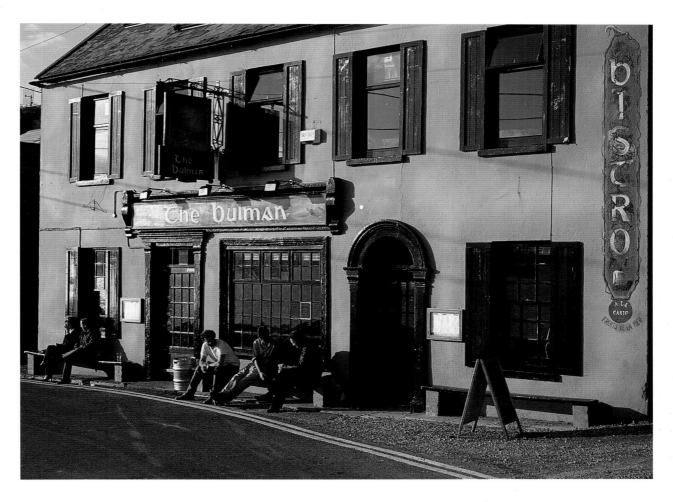

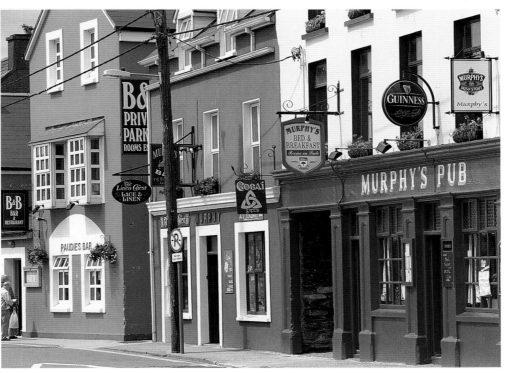

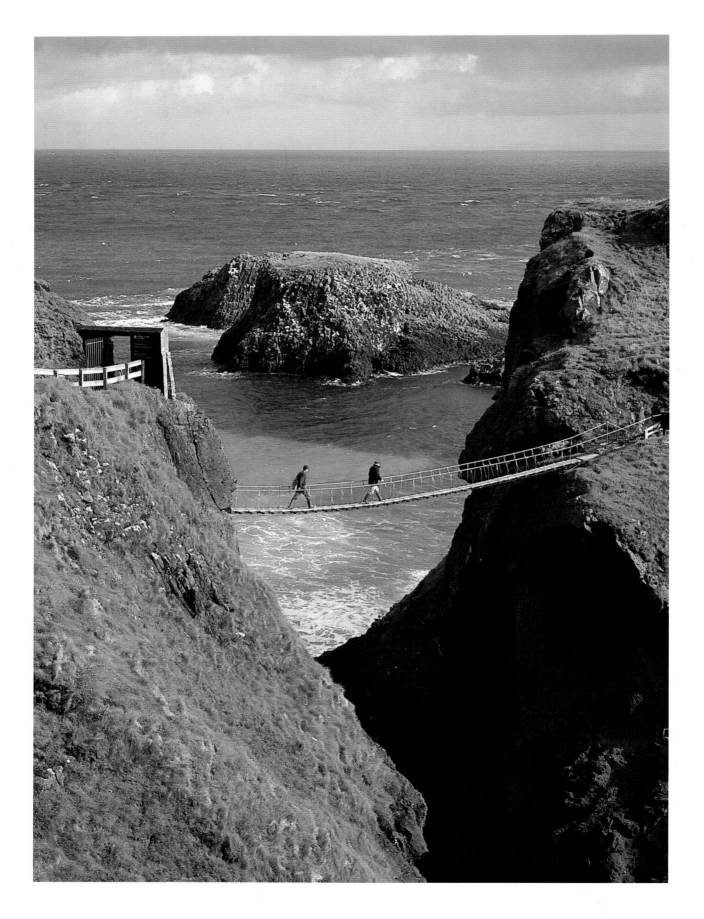

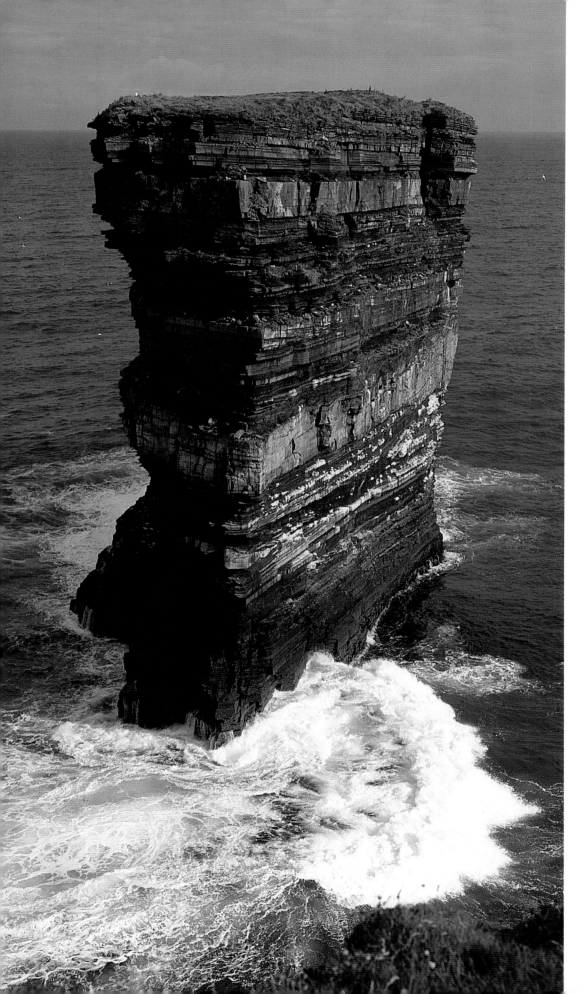

he untamed north coast of Co. Antrim in Northern Ireland is dominated by the basalt splendours of the Giant's Causeway, but there are other attractions. One is the precarious rope bridge (far left) that sways 24 m (80 ft) above the sea and links the mainland to Carrick-a-rede Island, famous for its salmon fishery. Sea stacks, such as this one (left) off Downpatrick Head in Co. Mayo, are strictly for the birds: terns gulls, skuas, guillemots and razorbills abound, as well as puffins. ～

obh, a quaint port which retains a sizeable fishing fleet, is proud of its long and distinguished maritime history. Ireland's first yacht club was founded here in 1720, and the first ever transatlantic steamer embarked from the pier in 1838. Many more were to carry thousands of Irish emigrants to new lives in America and Australia. Even the *Titanic* called in on its disastrous maiden voyage. There is something schizophrenic about the town: during summer it is an elegant, conservative seaside resort, similar to many found in Britain, but in autumn and winter, when the fishermen move in, it adopts an altogether more raucous, earthy demeanour. ⟡

espite the fact that it is in the Republic, Malin Head in Co. Donegal (right) is the most northerly point of the island of Ireland. It stands at the head of the Inishowen Peninsula, possibly Ireland's most beautiful coastline and certainly its least visited. On a clear day the hills of Scotland are visible to the east. ∾

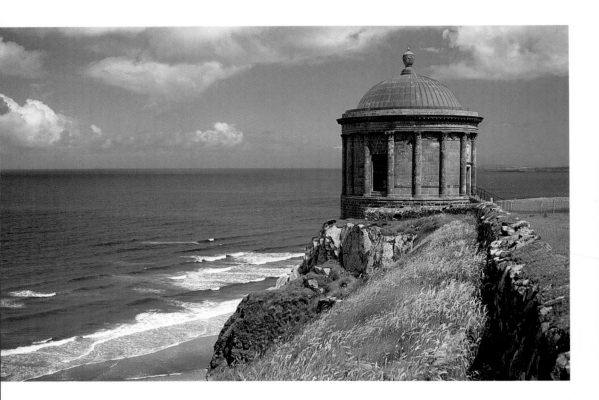

ussenden Temple (above) balances atop the Derry cliffs in Northern Ireland. It was the creation of the 18th-century Anglican Bishop of Derry, Frederick Harvey. He built the temple in honour of his cousin, the strangely named Frideswide Mussenden who died before it was completed. In an unusual example of religious tolerance for its time, Harvey allowed the local Catholics to use the temple for Mass, as there was no local church. ∾

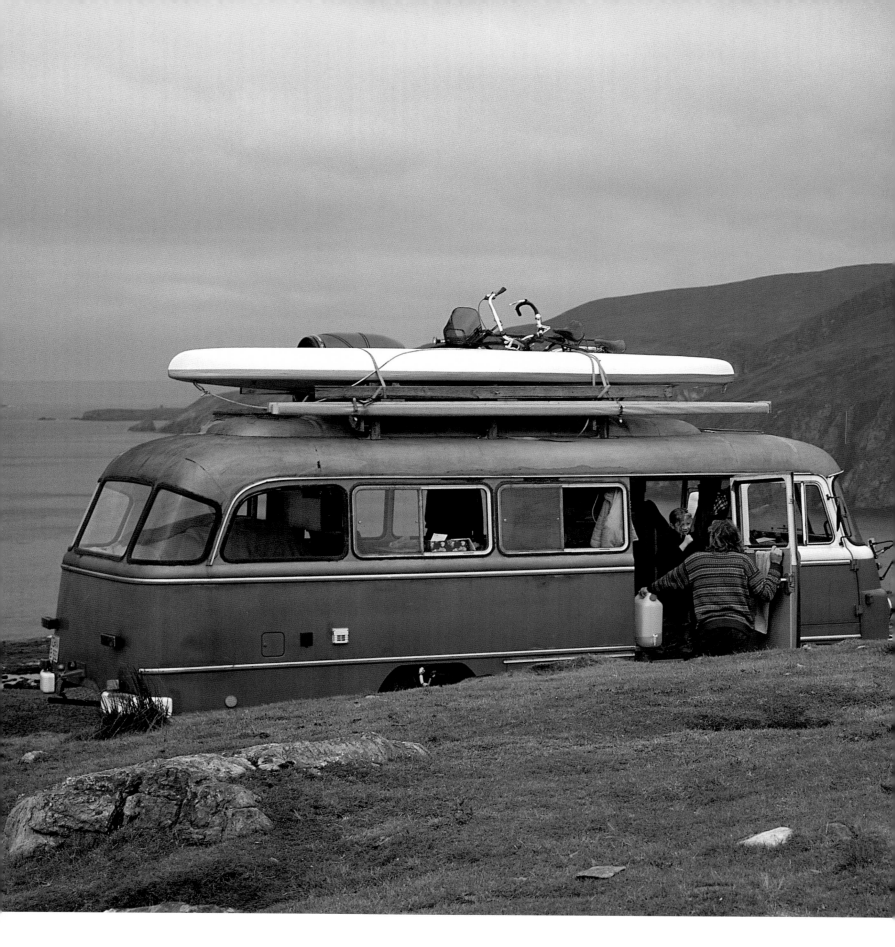

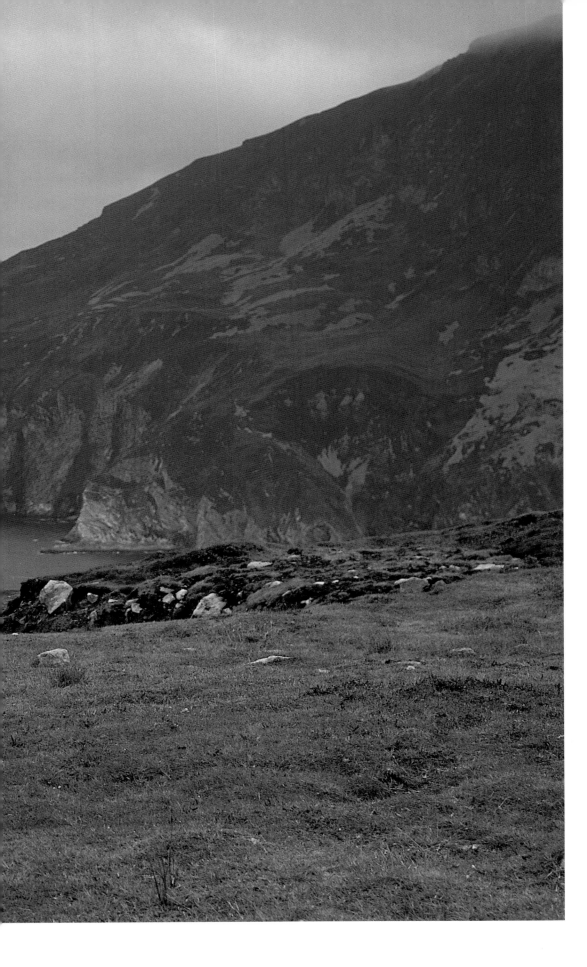

a camper van, a favourite of Ireland's many German and Dutch visitors, stands before Europe's highest cliffs at Bunglass on the Slieve League peninsula in south-west Donegal. Nowhere in Ireland is more dramatic, more thrilling than the Amharc Mór, the 'Great View' that is the reward for a long day's hike from the village of Teelin and which looks down from 610 m (2000 ft) on Atlantic breakers whose roar is drowned out by the perpetual wind that racks the top of the cliffs. ~

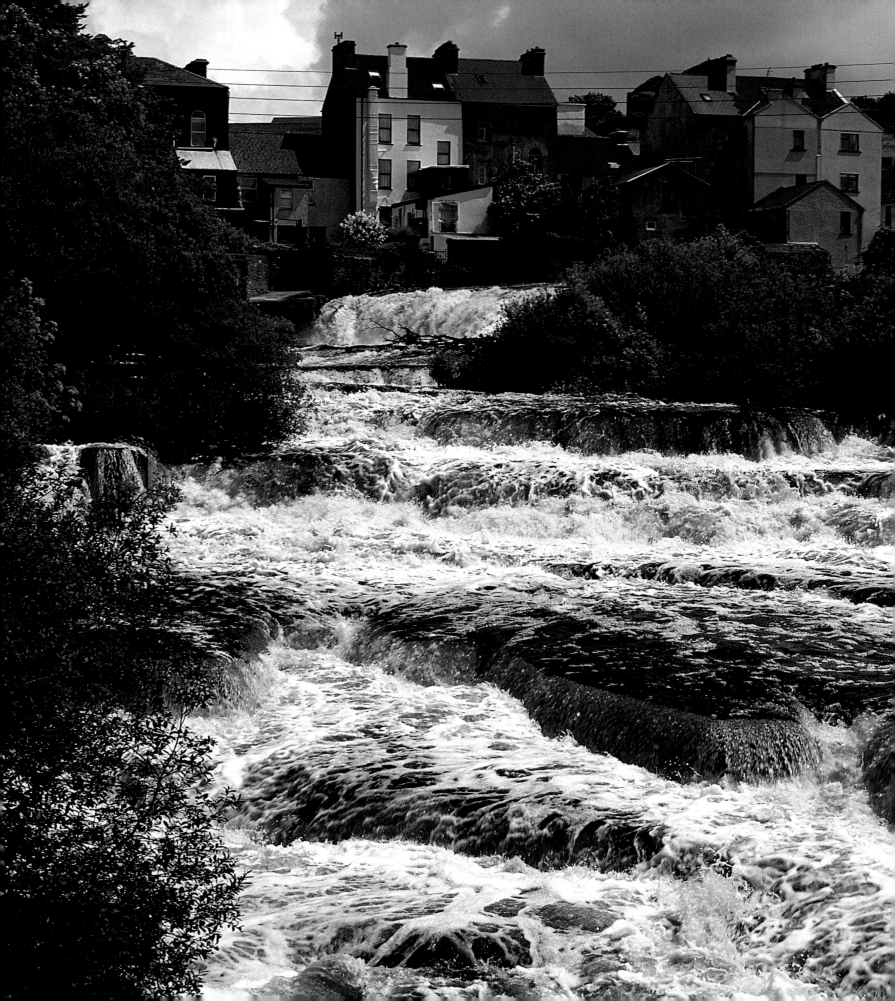

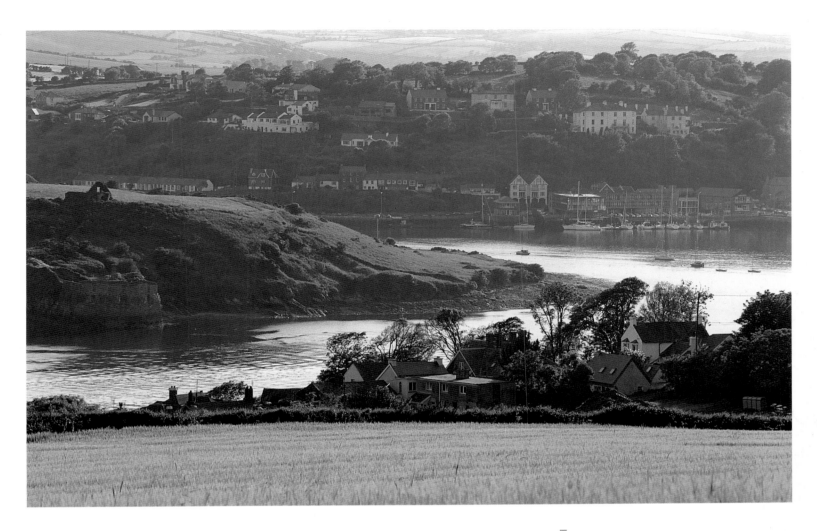

ennistymon, an old market town close to the Burren of Co. Clare, is famous for its Cascades Walk (left) that runs alongside the River Cullenagh as it dashes over slabs of rock. Ennistymon's Falls Hotel even has its own rather primitive hydroelectric station housed in a nearby shed which caters for all the building's energy needs. ∾

Kinsale harbour (above) is serene now but it has seen its share of conflict. The Battle of Kinsale in 1601 was a decisive defeat for the Irish aristocracy. The Spanish fleet anchored in the bay never met up with their allies, the O'Neills and O'Donnells who attacked the English forces from the north, and the result was the 'Flight of the Earls' to mainland Europe. Eighty-eight years later the Catholic James II arrived to fight for his crown with the full support of the French. A year later he left for good after his defeat by William of Orange at the Battle of the Boyne. ∾

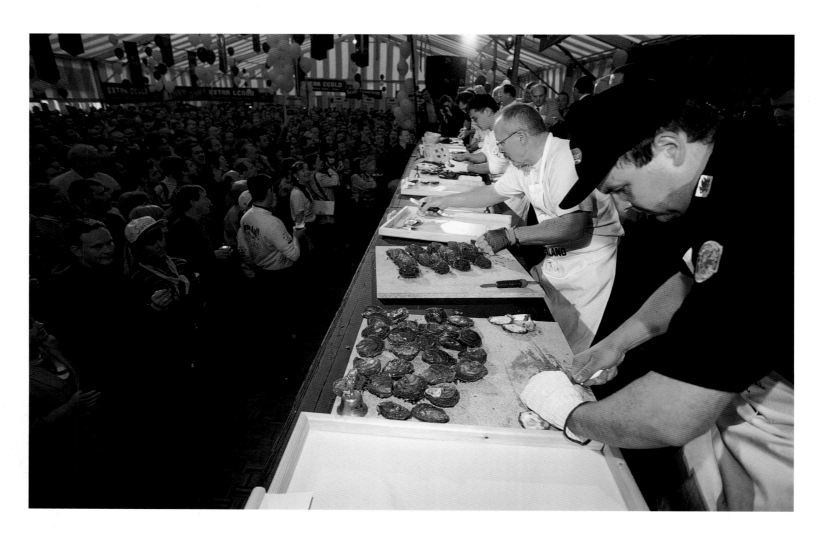

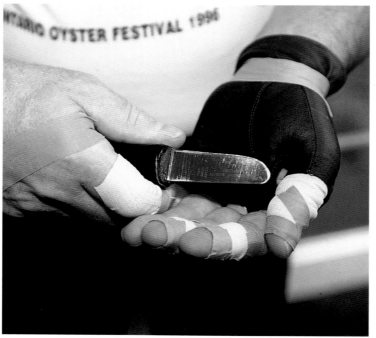

Competitors battle it out (above) in the oyster-opening competition that is a mainstay of Galway's hugely popular Oyster Festival. One expert demonstrates his technique: the impressive-looking bandages (left) are intended to protect competitors' hands from the sharp shells of the precious molluscs. The ideal accompaniment to wash down the salty tang and acquired taste of the oyster is a rich, creamy pint of Guinness. A perfect pairing. ∾

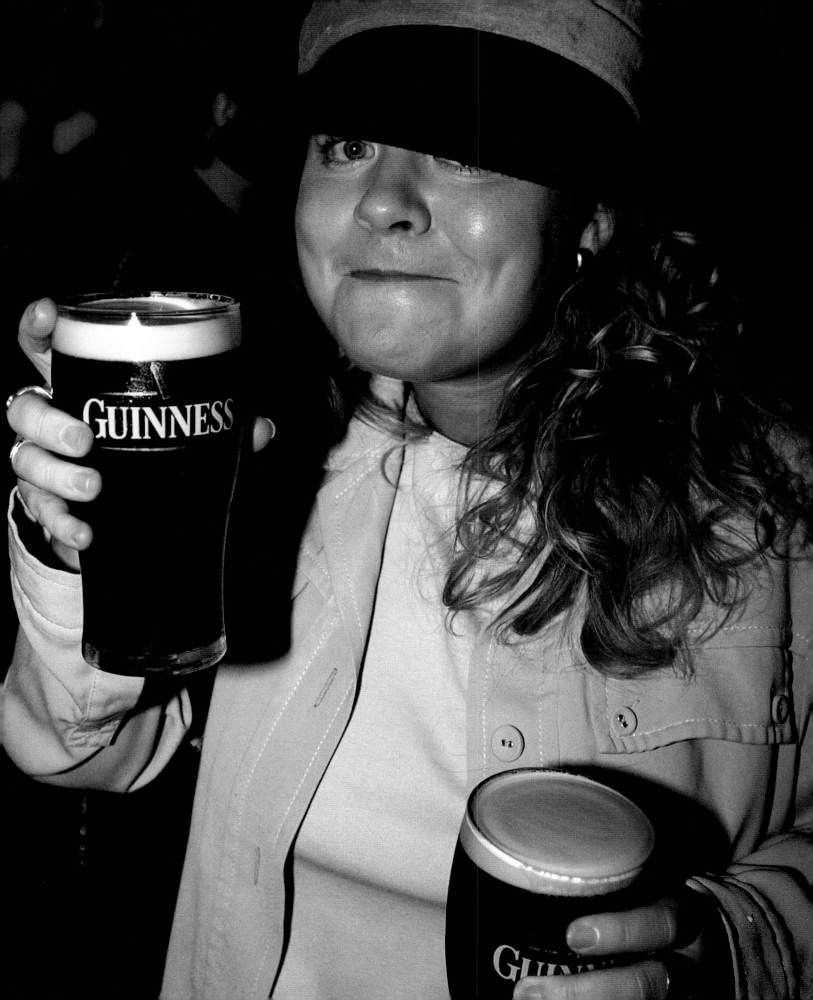

the great day ou

quadruped, gramnivorous ... sheds coat in the spring in marshy countries ... age known by marks in mouth

CHARLES DICKE

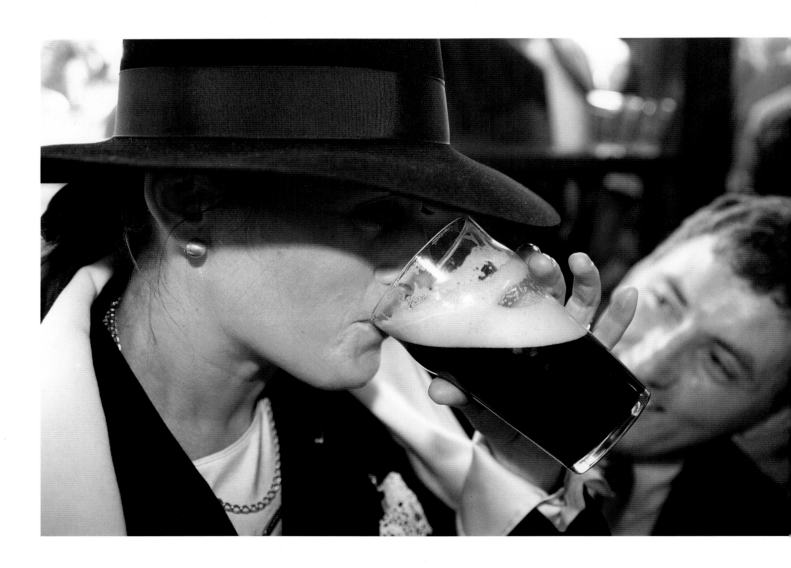

HE IRISH LOVE their horses, and they love a great day out, and the two combine at Ballinasloe where the famous horse fair held over eight days every October transforms this non-descript and quiet Galway town into a bustling, bacchanalian carnival that sets few limits on behaviour. The town's green becomes a dealer's pit, where spit and handshakes set the seal on a horse-trading deal and – though one suspects that the combatants, the hustlers, are just playing to the gallery – traders barter and tussle over the price of a mare or the value of a foal, prising jaws open to inspect the beast's white wall of teeth, and stroke the sheen of its coat. Horse fairs attract a broad range of visitors, but these are particularly the strongholds of Ireland's travellers. Gypsies, Tinkers, itinerants, call them what you will, for once they escape the prejudices, the suspicions of the now long-settled and put on a show that delights.

Ballinasloe is, in some ways, a last redoubt. Horse fairs were common until the sixties, when the car and tractor took dominion of the land, though they have long been threatened by authorities suspicious of popular expression. Dublin's Donnybrook Fair was suppressed as long ago as 1867, and the Local Government Acts of 1872 and 1898 were designed to neuter riotous and unruly behaviour. How ironic then that that great ally of the wealthy Irish farmer, the European Union, may be the agent that finally puts paid to relics like Ballinasloe. The EU is set to insist that horses be valued by weight; the healthy gums, the bright shine of the eye, the bold posture, the honed instincts of the horse handler may soon count for nothing. The ancient aesthetics and instinctive judgements of the horse fair are slowly fading away.

'Lady' sinks a pint o'plain at the exclusive owners' bar of Ballybrit racecourse, Galway City, during Ladies Day at the famous horse-racing festival held every July. One of the more enjoyable aspects of Irish society is the apparent intermingling of social classes: the Galway Races are about as high society as the West Coast ever gets.

The Irish may be less intimate with horses than once they were; the slow decline of rural life results in many fewer working horses. But at the top end of the market, that of the breeding and training of thoroughbreds, they remain insurpassable. Ireland's handsome equine elite, the pride of Co. Kildare, earn their spurs from Epsom to Longchamps, Hong Kong to Kentucky, and no one makes a day of the races quite like the Irish. Cheltenham, a soporific spa town in the west of England, becomes a little Emerald Isle once a year as hordes of Irish racegoers cross the sea to recreate the *craic* of the great original festival of racing, the famous Galway Races, the subject of many a ballad. Here the West's social elite herd together at Ballybrit racecourse and throw money at the bookies as the Galway Plate and the Galway Hurdle go under starter's orders.

The race days belong to the tradition of moral holiday – a period of lax behaviour and cathartic relief sanctioned for a brief stretch every year. Such passages of ethical relaxation have long been a fixture in Ireland, as they have in most societies with a predominantly rural past. The 'Puck Fair and Pattern' held every August in the town of Kilorglin, Co. Kerry is perhaps Ireland's finest exemplar. The whole shebang lasts for three days: Gathering Day; Fair Day; Scattering Day. On the evening of the first of these, a long procession of people makes its way to the town's pub-packed central square. They follow a lorry, on which is mounted a cage containing a wild, be-ribboned billy-goat: *puck* is the Gaelic for goat. Throughout the rest of the fair the enthroned goat presides over proceedings, nourished by a substantial crop of cabbages.

It is claimed that this great, surreal celebration is in honour of the wild goats that ran amok through the town as Cromwell's army approached, giving fair and necessary warning to the local population. There may be truth in that, but the roots of the festival go deeper dating back, like the pilgrimage at Croagh Patrick, to the pre-Christian festival of Lughnasa on the 1st of August, Lammas Day, or Lewy's Fair, as it is also known. There is drinking, dancing and courting. A sense of the seasons and of the essence of fertility is recaptured, notions that are not so important anymore as a global food market takes care of the traditional anxieties of a farming community, but crucial once and retained in the folk memory.

Music is an essential ingredient of any fair, always Irish folk music, the living tradition. Most of what we now recognise as

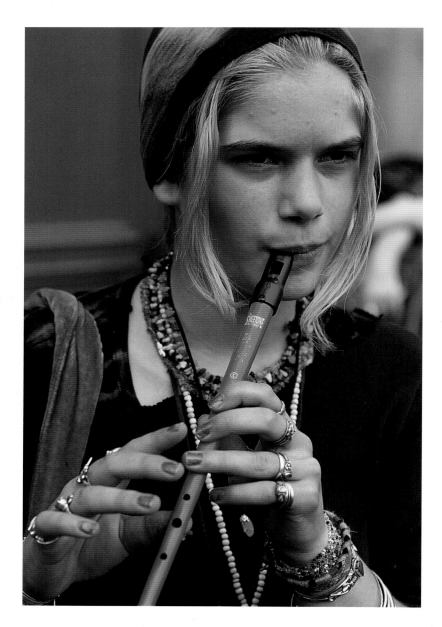

such is dance music, the reels and jigs performed in a 'session' by some combination of fiddle, flute, whistle and the devilishly difficult Uillean pipes, though for the purist even that is a dilution. Irish music depends ultimately on clarity for its bewitching spell and that is best achieved by a single performer, a fiddler playing Donegal style, or Clare style, or like the best of them all, the legendary Michael Coleman of the Sligo style, flamboyant and pulsing. It is a beautiful music but bereft of dynamics: watch the puzzled visitor try to reconcile the musician's mastery of a frenetic passage and his apparent lack of emotional involvement bar the tapping of the foot. Only the singer displays passion, in the *sean nós*, the 'old style', where no two verses can be sung the same way, though the song in question may consist of a mere two lines. It is, like jazz, an improviser's art and depends for its appeal, in part, on the fact that it is a perilous pursuit, full of pitfalls.

The great day out is not always spent among thousands to the accompaniment of noise and bustle and barter, or the sound of the pipes. There are many, especially foreigners, and Dubliners – and some in the West say that's the same thing – who search for solitude, for peace and quiet, for the slow pace of life, for the rugged scenery and gentle ways. Rural Ireland is an easily attainable refuge from overpopulated, stressful environments. Some of the best days are spent largely alone: on Mayo's River Moy casting for salmon; or on a bike, spinning the gears across Europe's remote edges, a jaunt punctuated perhaps by a lunchtime stopover at a pub so remote it should not exist but does, by doubling as a post office or grocery. Though it rains often in Connemara, in Inishowen, in Dingle, the intrepid cyclist knows it is worth the discomfort, because when the sun shines – and it does – there is no more beautiful place in the world.

The essentially inclusive nature of Irish life finds its ultimate expression in the country's fairs and festivals: a busker plays a penny whistle at the Puck Fair, Kilorglin, Co. Kerry (above). A firm handshake and a sliver of spit seal a deal in the traditional manner on horse fair day (opposite). ∽

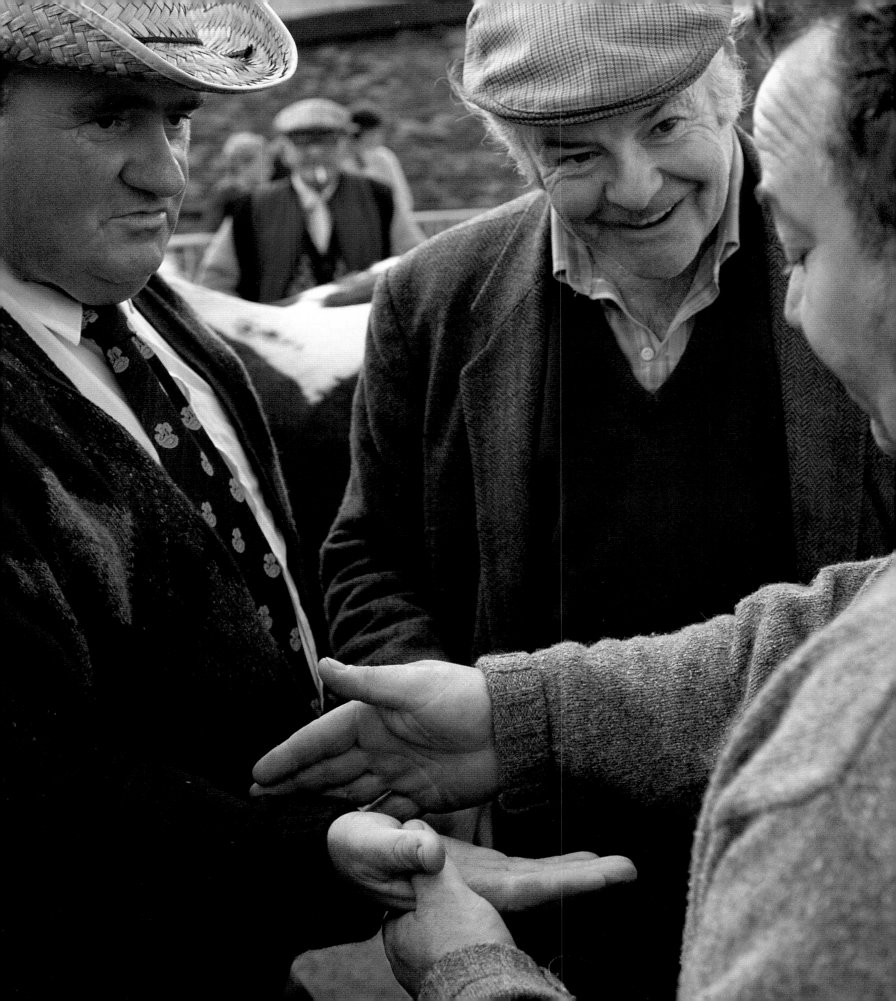

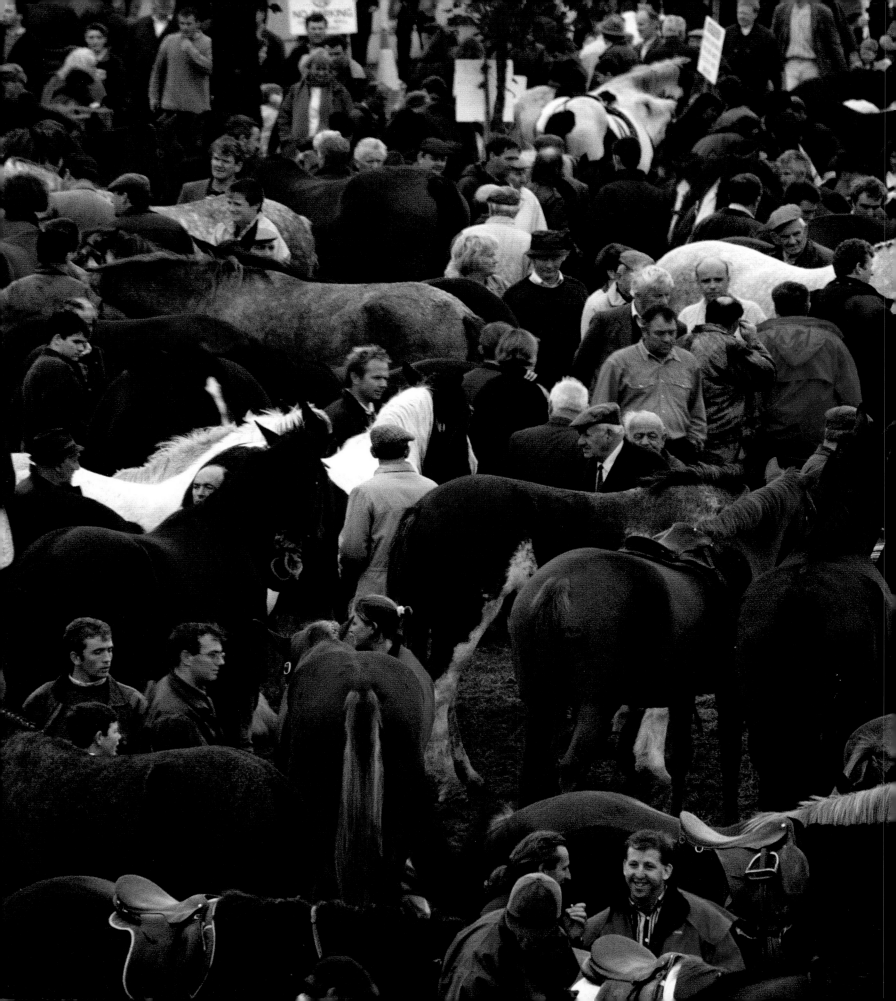

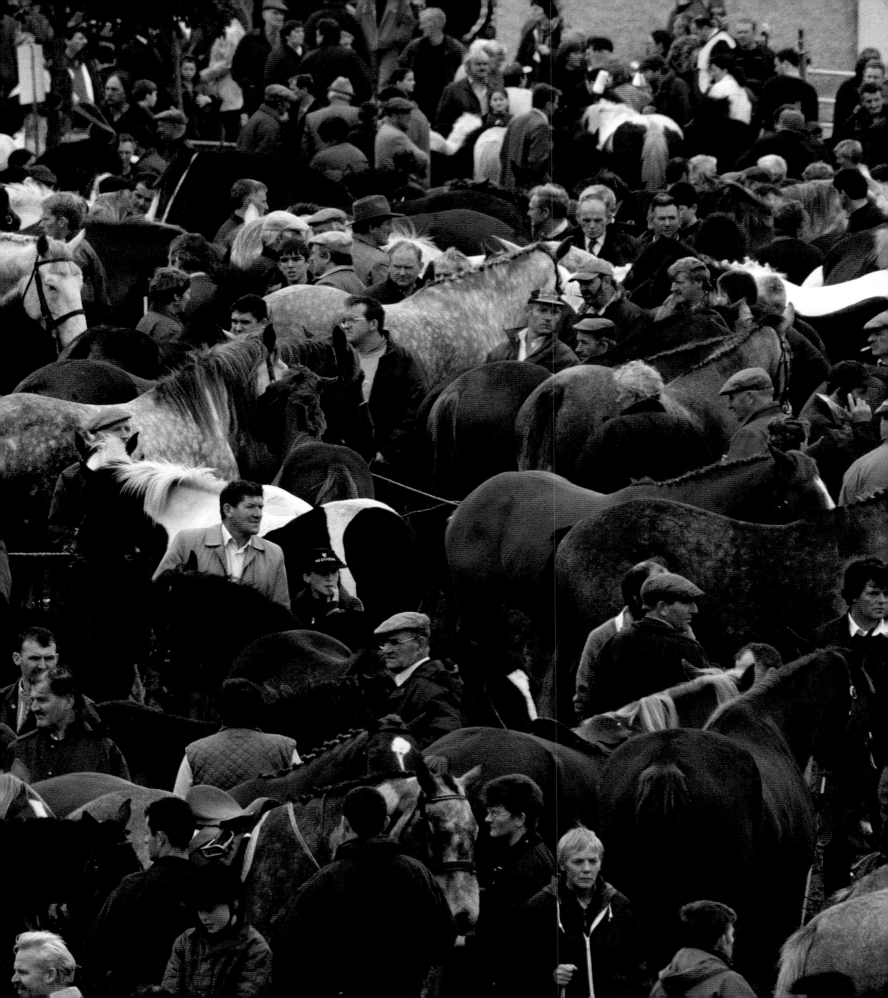

he green at Ballinasloe teems with the trade of beasts (previous page), a scene from the annual horse fair held in October. This was once the greatest horse fair in Europe, and its status is confirmed today as much by tourism as by trading. Here, a trader displays a working horse (right). ∽

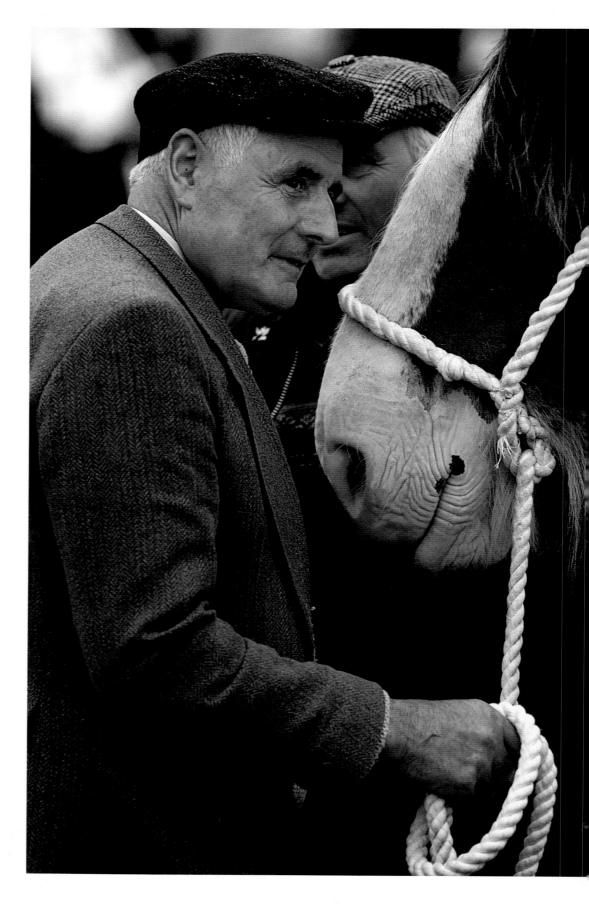

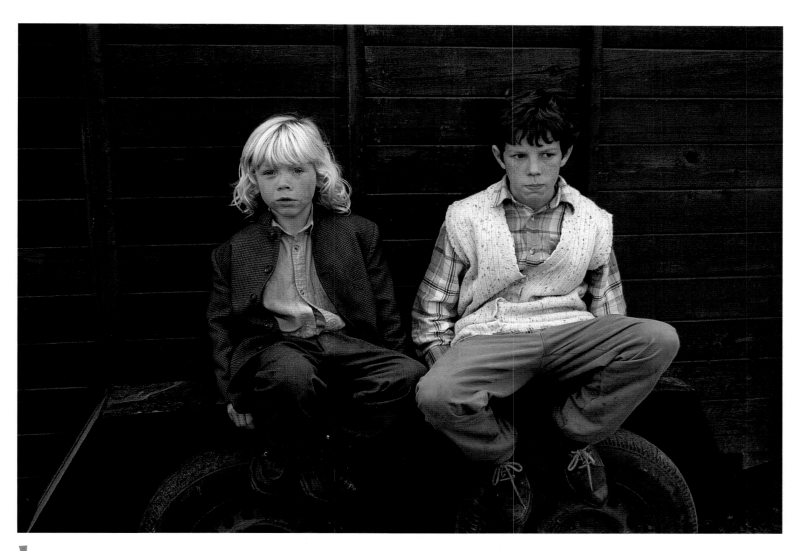

horse fairs like that at Ballinasloe are one of the few points in Irish life where the country's travellers take centre stage: prejudiced against, marginal, and alienated from settled existence, children like these (above) may not reap the benefit of Ireland's new prosperity.

Despite the noise and the bustle and the bargaining, not everyone is thrilled by a day at the fair (right). ∾

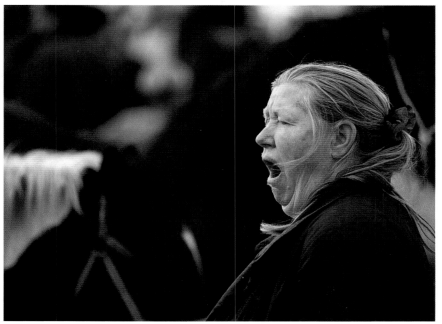

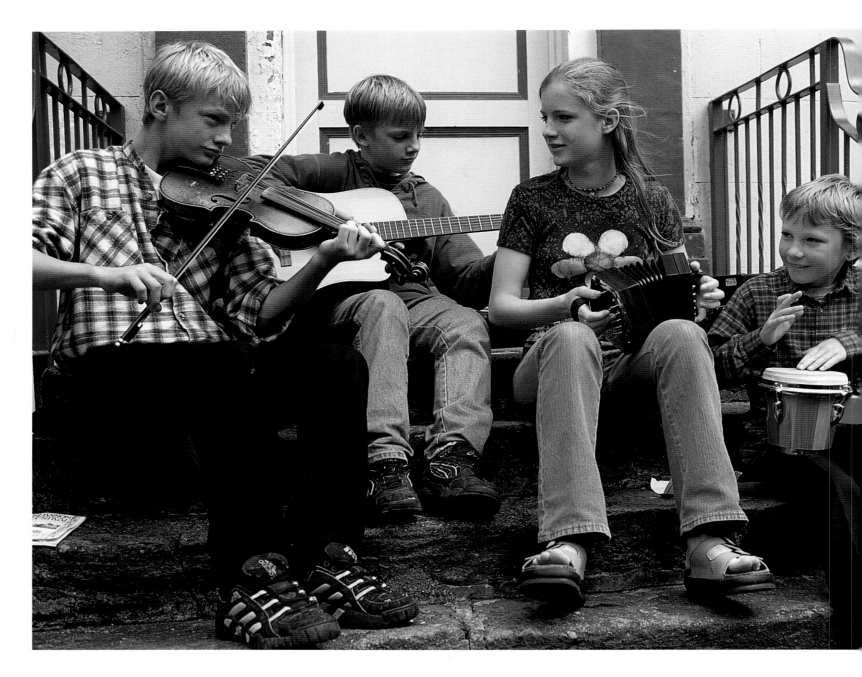

Young musicians at Ballyshannon Traditional Music Festival, Co. Donegal (above). The fiddle, acoustic guitar and accordion are fixtures of traditional music sessions – the bongos less so. But instrumental permutations in traditional music are essentially infinite. The *bodhrán* (right), a shallow goatskin drum played with a small wooden stick or just the back of the hand, is an ancient instrument but a relatively recent addition to the traditional music line-up. An awful lot of people have made fools of themselves attempting to play the *bodhrán*, thinking it easy: it's anything but, and requires remarkable rhythmic dexterity.

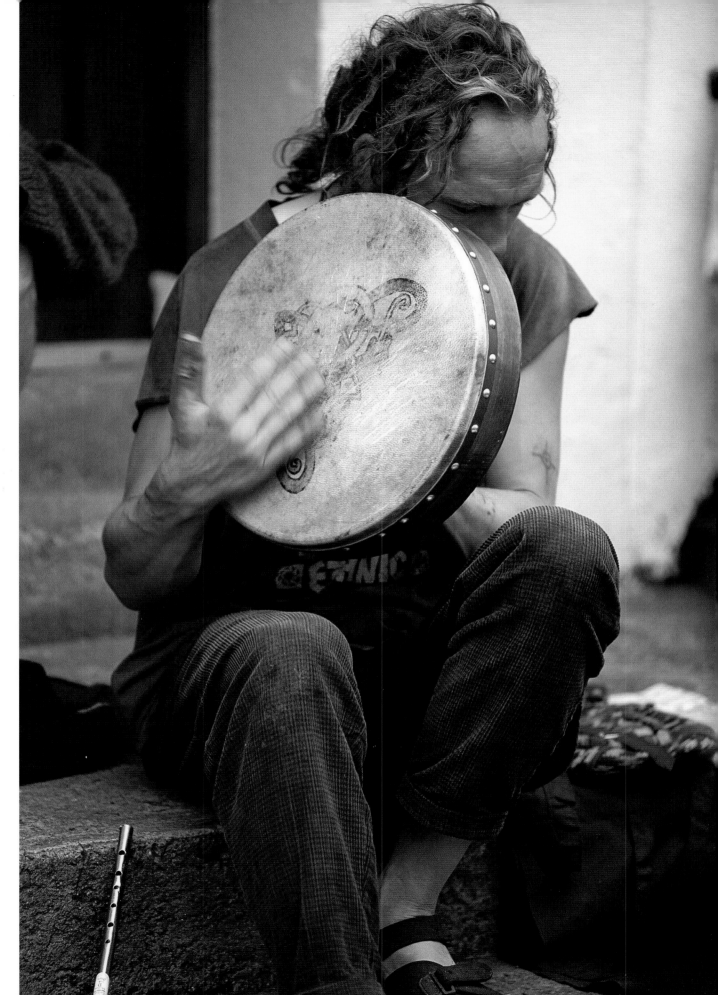

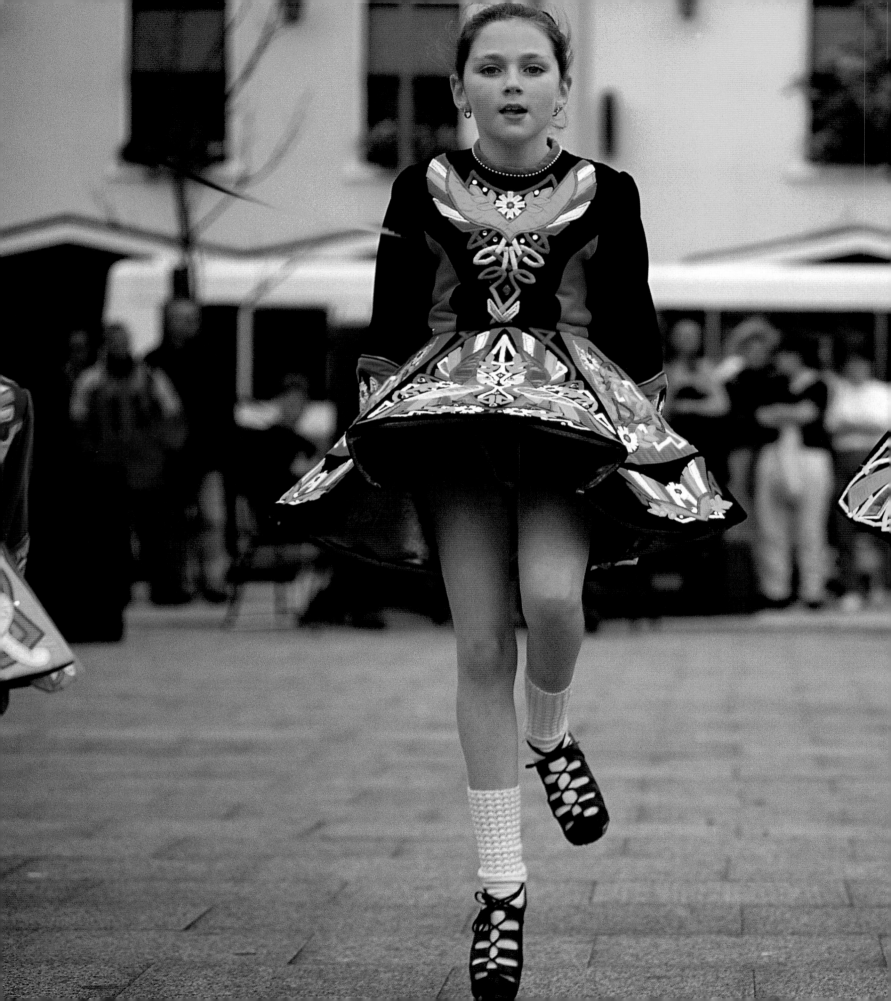

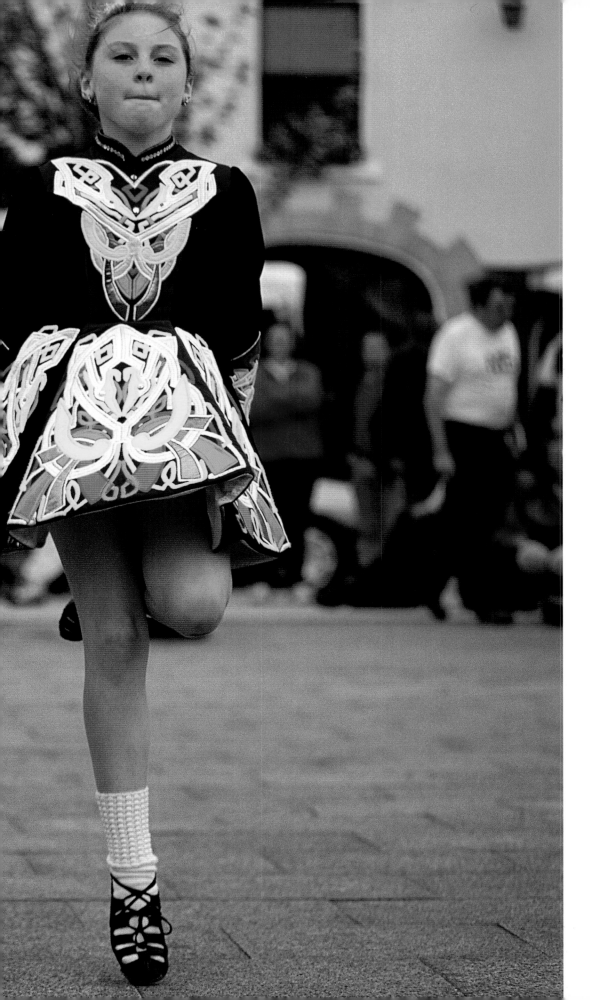

here's no mistaking Irish set dancing, performed here in Main Square, Donegal Town. It all takes place below the waist, encompassing a dazzling array of synchronised steps danced to the accompaniment of jigs, reels, hornpipes and other variants of traditional dance music. Set dancing was largely ignored during the traditional music revival that took place in Ireland during the sixties, but it returned to the fore in spectacular fashion with the astounding commercial success of 'Riverdance' which gave this once parochial and much disparaged artform an unlikely world stage. ❧

*g*reyhound enthusiasts in Cashel, Co. Tipperary. The sport of greyhound racing has a long pedigree in Ireland: Irish hounds were held in high esteem in both Ancient Rome and Elizabethan England. The sport has its background in hare-coursing, which began in the 17th century, though its modern incarnation came to Ireland in 1927 with the installation of electric hares in stadiums in Belfast and Dublin. It's now a multi-million pound pursuit on both sides of the border. ∽

a man grapples with a cake and flowers at Clonmany agricultural festival in the remote and beautiful Inishowen Peninsula in the far north of Co. Donegal. Small festivals like this one are essentially for the locals, a celebration of traditional skills and culture, and a welcome chance to catch up with old friends: rural life in such a difficult landscape can be unbearably lonely. ∽

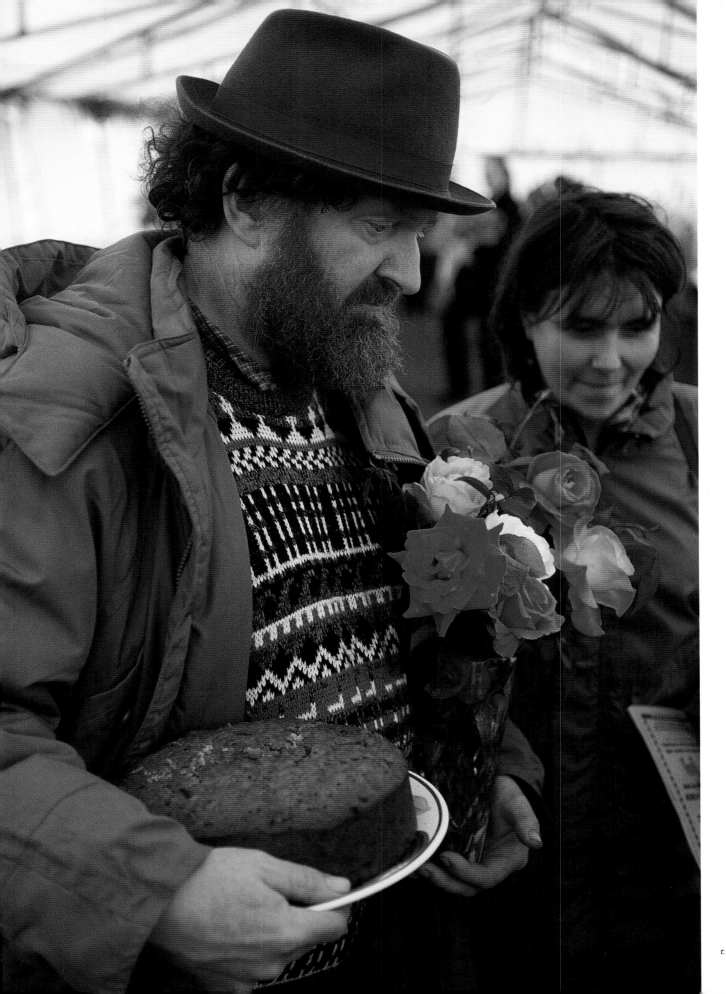

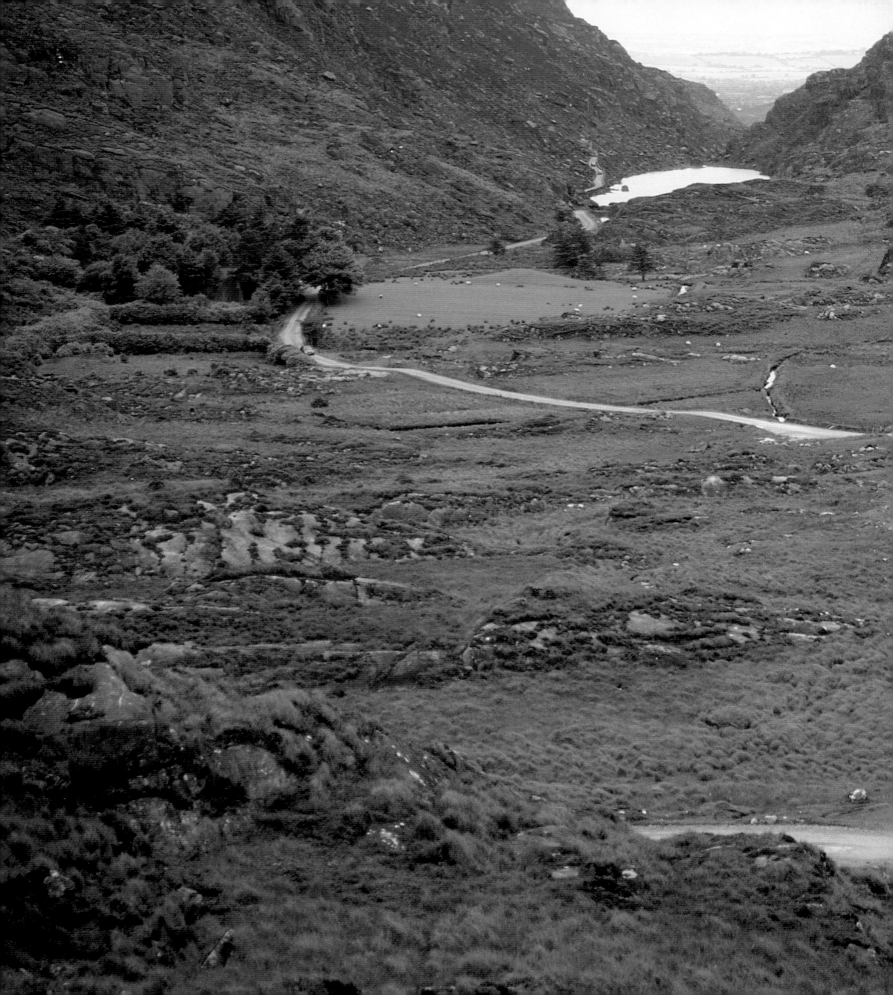

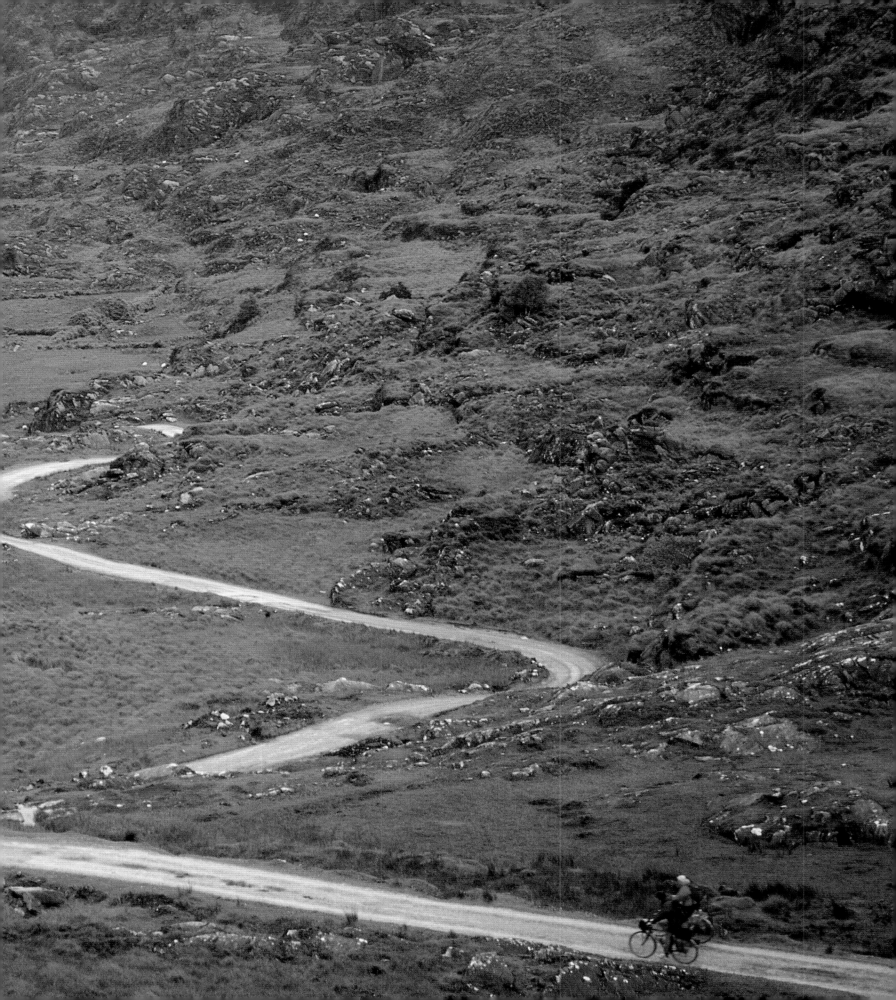

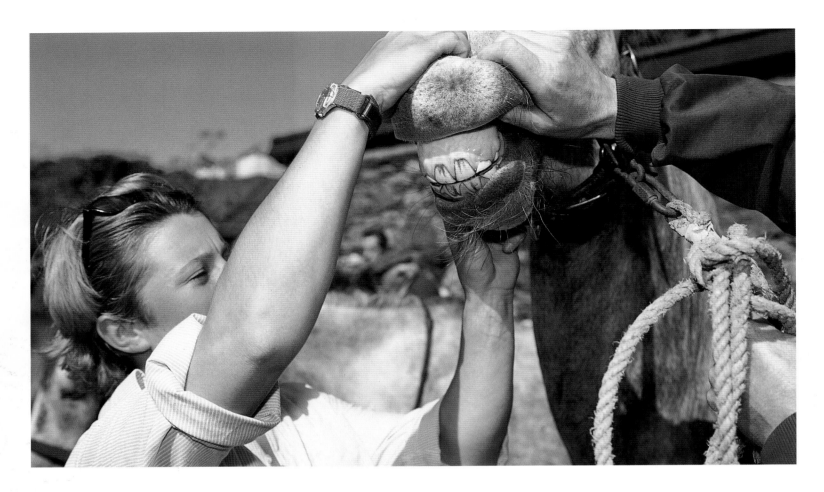

there is no better way to gain the measure of a landscape than under one's own steam (previous page). But cycle-touring in such a challenging environment as the Gap of Dunloe, Co. Kerry, requires strong legs, low gears and state-of-the-art waterproofs. The rewards are immeasurable. Others prefer a less physical though no less exacting day out: a woman inspects the teeth of a horse – prime indicator of equine health and age – at Kilorglin's Puck Fair, and a child sidles up (right) to a favourite pony. The real business of the day takes place at the Puck Fair's cattle market (opposite), where hard bargains are made, but which most tourists ignore.

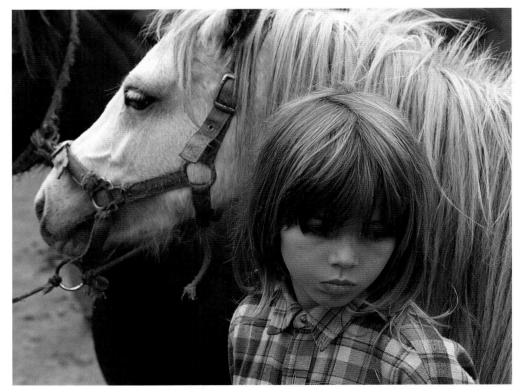

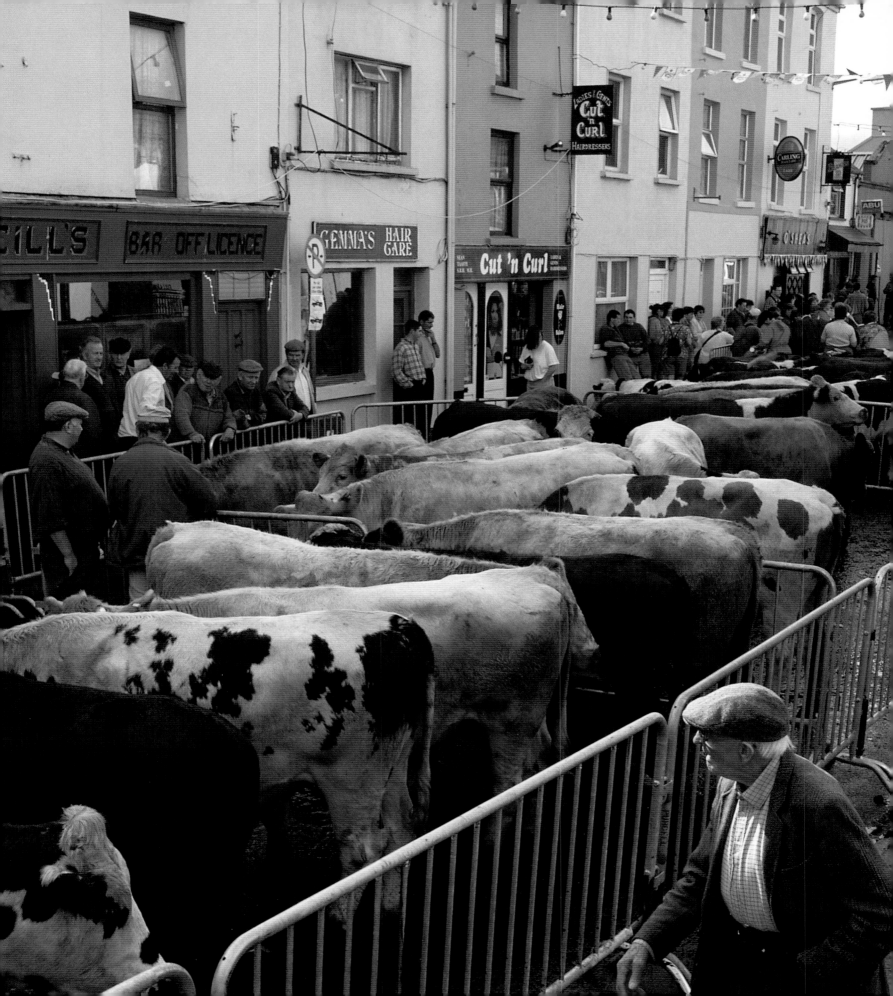

the wild, be-ribboned billy goat lords it high above the town, tethered in a showpiece of the scaffolder's art surrounded by three days supply of cabbages in reward for his ancestors' timely warning of Cromwell's advance. Certain aspects of the celebrations, though, date back to pagan times. Whatever its true origins, Puck Fair is a wonderful excuse for a knees up, though there's a day given over to serious horse trading, too.

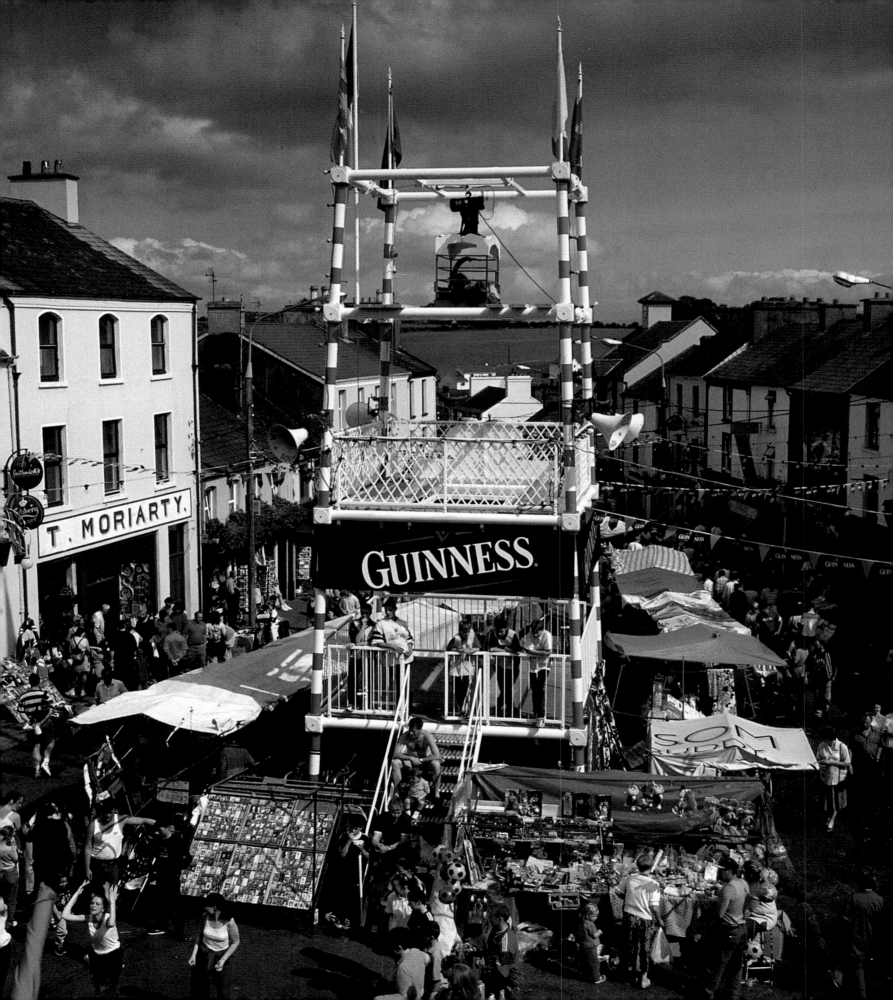

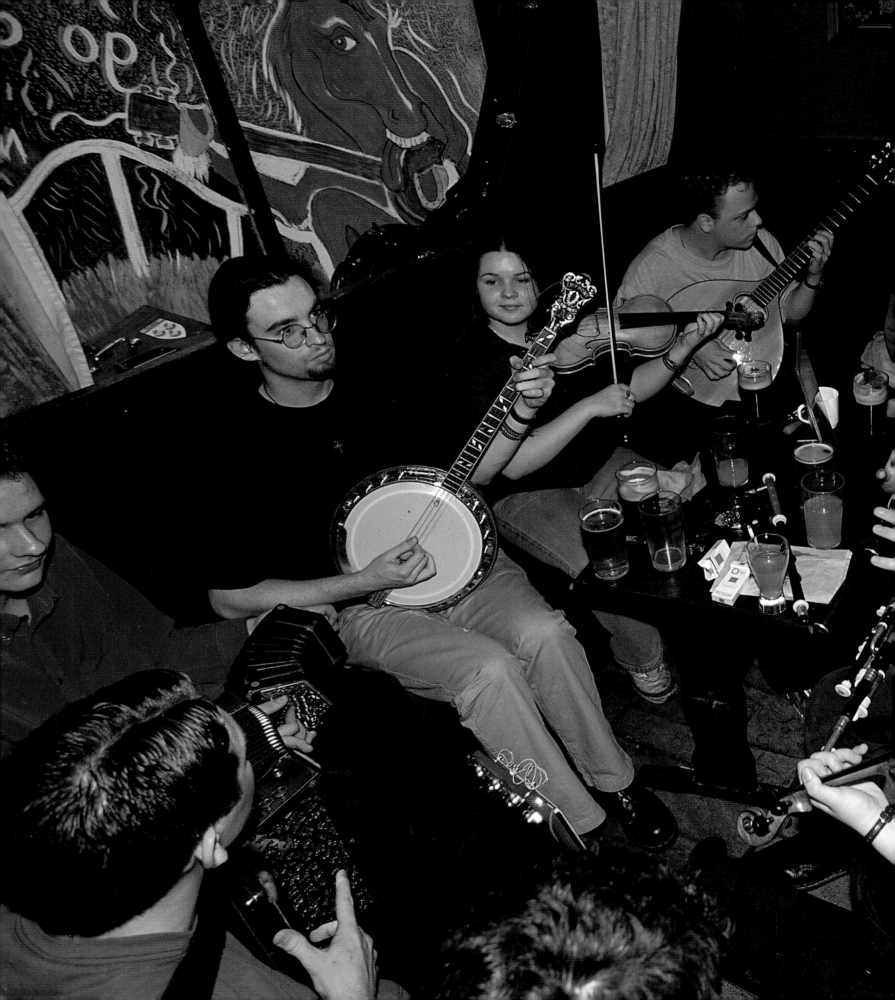

a traditional open pub session in full flow at Taaffes Bar, Galway City, prime destination for 'folkies' from around the world. One of the most intriguing and surprising aspects of Irish music is the emotionally uninvolved posture of the musicians. This is because traditional Irish music unfolds in cycles and lacks the diminuendos and crescendos of most western music. Instead, the musicians seek subtle ornamentation around a basic repetitive structure. After several pints of Guinness the effect can be hypnotic.

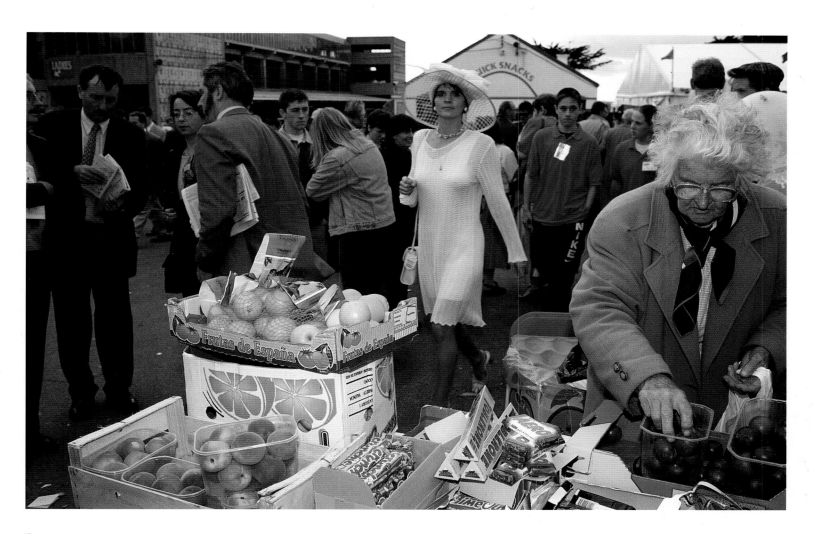

horse racing is little short of an obsession among the Irish, and one that is a huge earner – not only in terms of the wagers made, but also because of the trade in thoroughbreds for which Ireland enjoys a world-wide reputation. Ladies Day at the Galway race festival (left) is one of the great and colourful social events of the West – though women dressed up to the nines still look somewhat out of place among the hard-bitten regular punters (above). The whole event is accompanied, of course, by a great deal of drinking: a racegoer enjoys a chaser (right) – a bottle of Guinness followed by a smooth Irish whiskey – in the Owners' Bar.

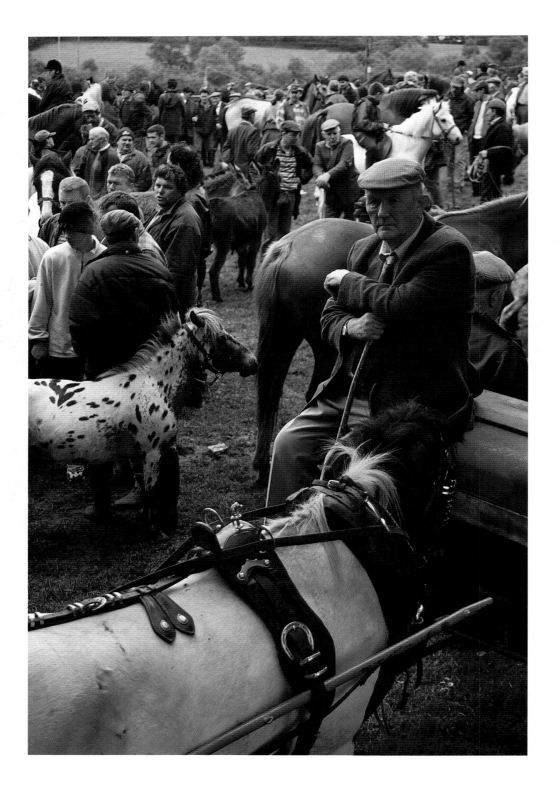

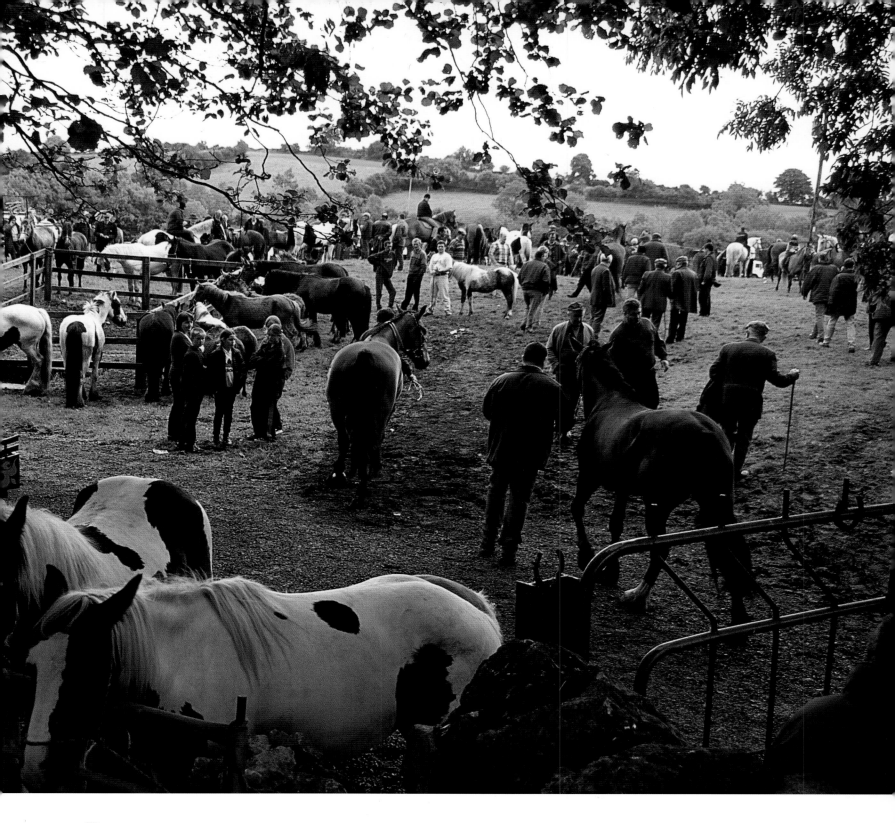

armers and horse traders gather at the small Spancihill Horse Fair in the gentle pastoral land around Ennis, Co. Clare. Such assemblies have been a feature of Irish life for millennia. Horses were introduced to Ireland in about 2000 BC, at the beginning of the Bronze Age, and endowed their masters with high social status. ⌒

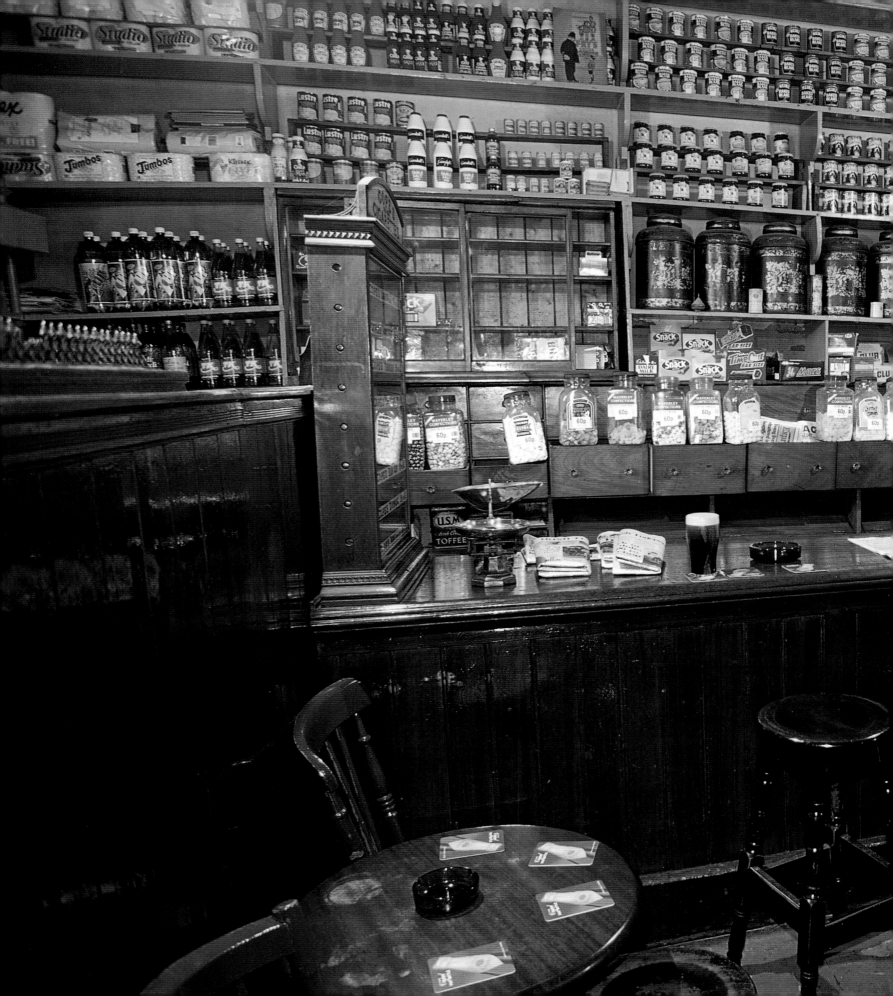

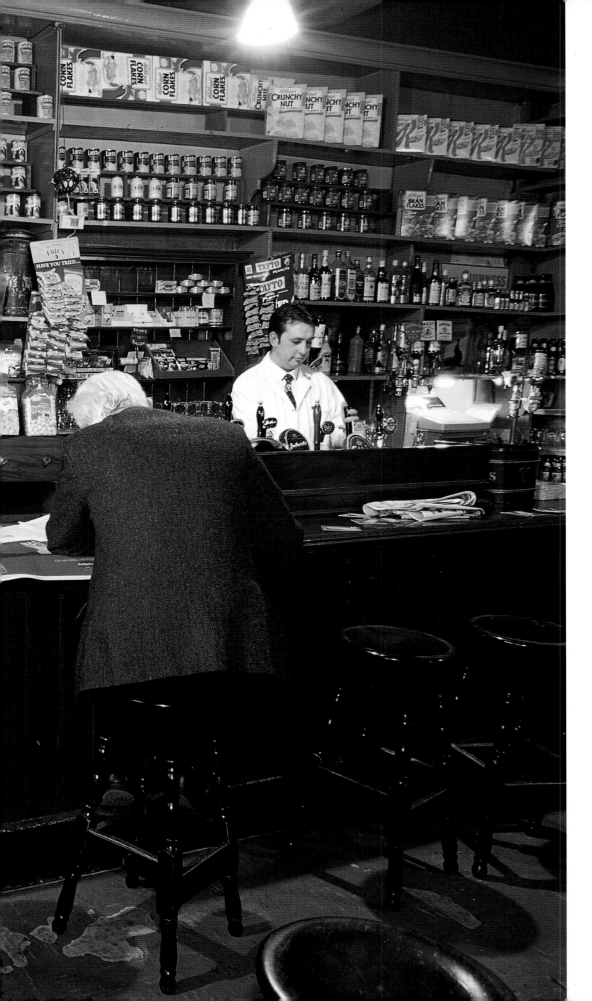

hopping in style: Morrissey's, in the estate town of Abbeyleix, Co. Laois, is one of the most famous pubs in Ireland, in part because it also happens to be a fully stocked grocery store. Nothing seems to have changed in decades: there's a brazier, elegant pew seats and advertisements that date back to the beginning of the century. A day spent here is as rewarding as any imaginable.

the long goodbye

the sort of yearning i feel towards those lonely rocks is indescribably acute. the town that is usually so full of wild human interest, seems in my present mood a tawdry medley of all that is crudest in modern life.

J. M. SYNGE

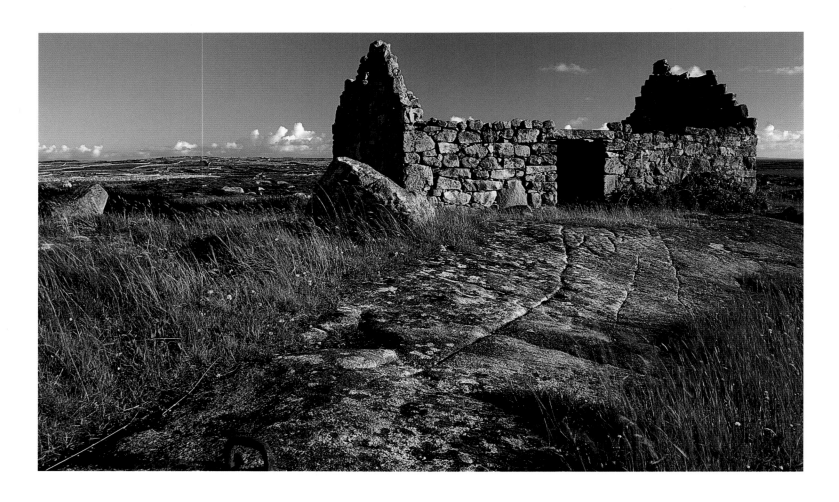

ROM THE END of the Napoleonic Wars to the beginning of the First World War no fewer than 8 million people left Ireland for good. The sheer scale of Irish emigration was best summed up by the former President Mary Robinson in 1990 when she claimed, with strong evidence, that there are some 70 million people spread throughout the world of at least partial Irish descent. It is a lost nation greater in number than the present day United Kingdom, and the living memory of its leaving is expressed in the hundreds of songs of regret, of sadness, of longing, of perished hope. The titles of the most famous tell all: *Sweet Inishcara*; *The Green Fields of Canada*; *Erin's Lovely Home*, and here, *Farewell, My Own Dear Native Land*:

Farewell, my own dear native land, for here I cannot stay,
For I do intend to cross the sea bound for America.
To leave the land that gave me birth it grieves my heart full sore,
So fare thee well, old Ireland around the shamrock shore.'

It was not Ireland's Catholic population who, despairing of their land, first felt the pull of emigration, but the Ulster Scots, the Planters, lured to Antrim, Down and Tyrone by the promise of low rents and cheap land, and who found Ireland a bitter disappointment. Bad harvests forced 4,000 a year to Canada during the early 19th century. But that was a mere trickle compared to the en masse emigration of the poorest of the rural Catholic population during and in the years immediately following the Great Famine of 1845–9.

The direct cause of the Great Famine was a fungal disease, *Phytophthora infestans*, possibly brought to Ireland by bird droppings imported as fertiliser from South America. It had a devastating effect on that wretched third of the Irish population for whom the potato was an overwhelming staple. The absolute dependency of the Irish peasant on the potato strikes the modern reader as near absurd: some individuals ate up to seventy potatoes a day, every day. But it is that rare food, a provider of near all the nutritional requirements of the human body and, supplemented with butter and milk, it provides a healthy if insanely monotonous diet. And the Irish poor had little choice in the matter.

There had been potato blights in Ireland before: some historians have estimated that the one that struck in the 1740s was every bit as deadly as those that followed. But it is the Great Famine whose memory lingers, a haunting presence for the people of the West, and Irish communities abroad, and a source of anxiety for those who stayed and prospered. The remote lands of the West – Mayo, Sligo, and West Cork especially – are still scarred with roofless, empty cottages left in haste. As many as one-and-a-half-million people died of hunger and fever in those bitter years, the same again 'chose', though that's hardly the word, exile.

Unique in the annals of modern migration, women and children made up as great a number as men on the 'coffin ships' that sailed from the West and took up to two months to cross the Atlantic in grim, insanitary and overcrowded conditions where fever was rife. This balance of the sexes allowed the exiles

to develop Irish communities abroad wholly from within their own ethnic group. And their priests followed too, especially to the USA, where they founded churches amid their displaced congregations. Starving and diseased, loathed as much in their new home as in the old, Irish emigrants established a culture 'more Irish than the Irish', often and understandably virulent in its hatred of 'England' who it blamed for this appalling episode.

There is no doubt of the contempt in which the Irish poor were held by the great majority of 19th-century Britons, especially those who had a hand on the levers of power. The British Empire's unswerving commitment to the ideology of *laissez faire*, the power of the free market, was never likely to be revised for the benefit of a disparaged and marginal population. But the idea that the famine was a deliberate genocidal act is a case unproven and has depended for its veracity on the 'fact' that Ireland's food exports, controlled by Britain, far surpassed those of her imports. Yet the truth is that food imports exceeded exports by a ratio of two to one throughout the famine years. More troubling is that many Irish themselves, especially the Protestant Ascendancy and the Catholic middle classes, benefited from the mass evictions of the poor, the so-called great leaving, and improved their lot considerably as a consequence.

Connemara is studded with hastily abandoned buildings like this one at Ballynahown, Co. Galway (previous page), a despairing testament to those who left to seek a better life elsewhere. A couple sit before Eamonn O'Donnell's impressive metal sculpture (above), his impression of a Galway hooker, that stands in Galway City's Eyre Square. The hooker, a fast, capacious vessel of great manoeuvrability was a lifeline for the inhabitants of Ireland's islands, such as Achill, Co. Mayo (right).

One of most important of them was Sir William Gregory, whose infamous amendment to Ireland's Poor Law legislation of 1847, the Gregory Clause, stated that any family which held more than a quarter of an acre of land would not be granted famine relief unless they gave it up. 'A more complete engine for the slaughter and expatriation of a people was never designed,' said one critic. Because of such measures, the Great Famine concentrated changes that in many other European countries were spread out over generations: the transfer of property that enabled the modernisation of agriculture. Cruel evictions and clearances took place at the point of a bayonet and the bellow of a landlord with his eyes on the prize of his peasants' land: a land ripe for transformation by the latest farming methods from one of anaemic subsistence to profitable surplus. It was also the dividing line between the old Gaelic Ireland and the modern nation. Three million people spoke Irish before the famine. Only 2 million of them remained just a decade later, and their language was all but to fade out in a generation. How ironic then, as the writer Colm Tóibín has pointed out, that almost thirty years later the elderly Sir William was to marry Augusta Persse, a woman thirty-five years his junior, who alongside W. B. Yeats became one of the leading lights of the turn-of-the-century Gaelic revival. The very culture her husband helped to destroy, she and her circle sought to regain.

Things have changed unimaginably over the last century. For the first time in her troubled history, Ireland no longer sends her children away but calls them back. The hi-tech industries of the rampant Celtic Tiger are ravenous for ever-more skilled workers: it is the English who make their way across the Irish Sea these days. Yet, as Mary Robinson and other progressives have pointed out, if there is a lesson to be learnt from the Great Famine, it is that there are no simplistic truths, no sentimental, comforting certainties about Ireland's past. She remains divided: socially, culturally, economically and, enduringly, by religion. If these divisions are to be resolved in the future, the complexities of the past must be confronted. Such a challenge should not be beyond the ken of this vibrant, beguiling, richly talented and thoroughly modern European nation.

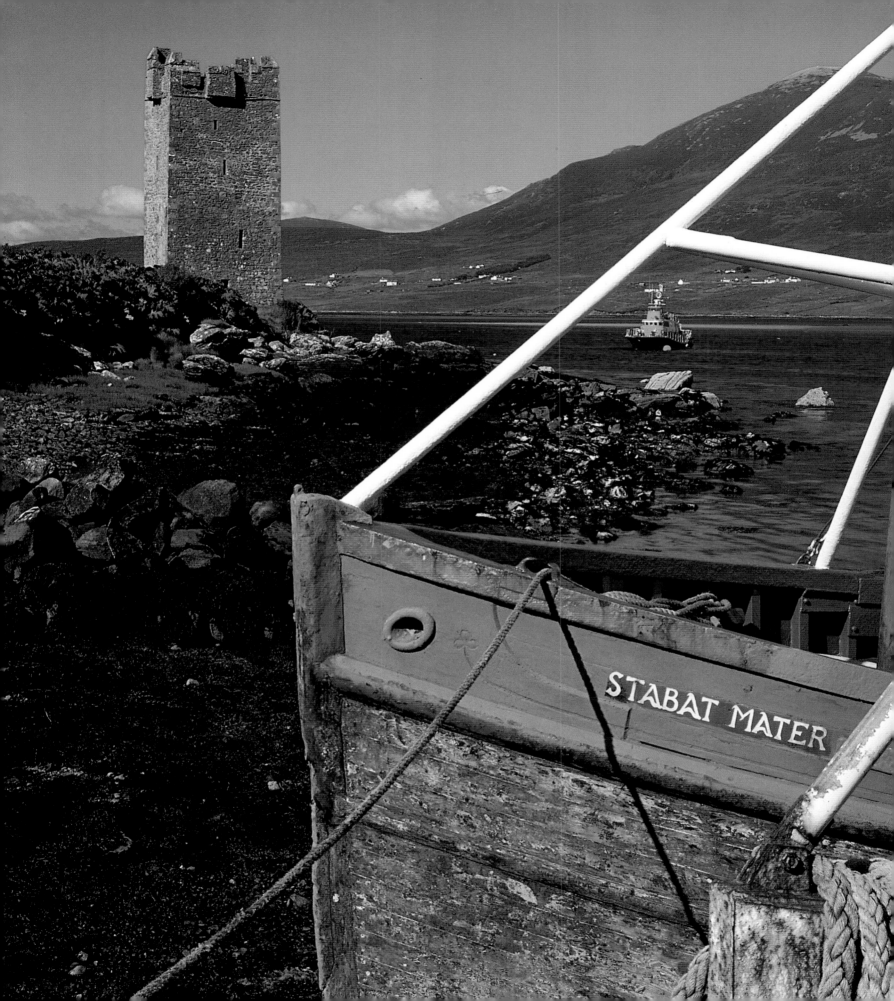

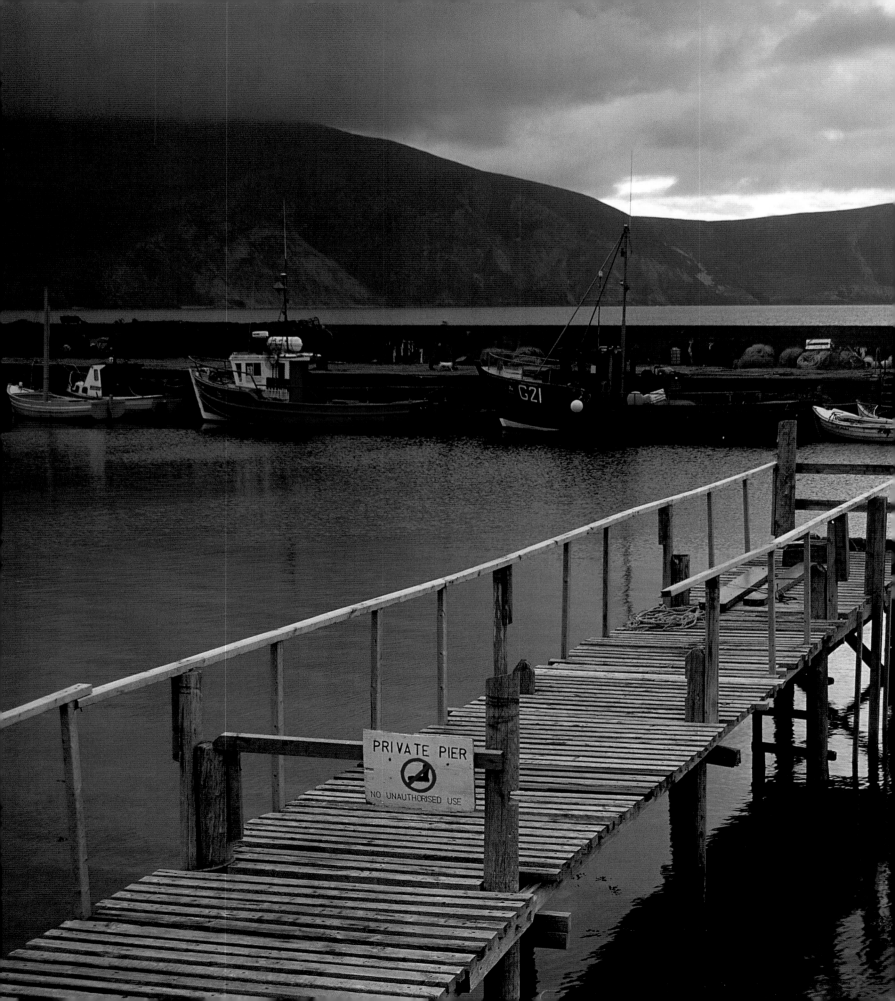

PRIVATE PIER

NO UNAUTHORISED USE

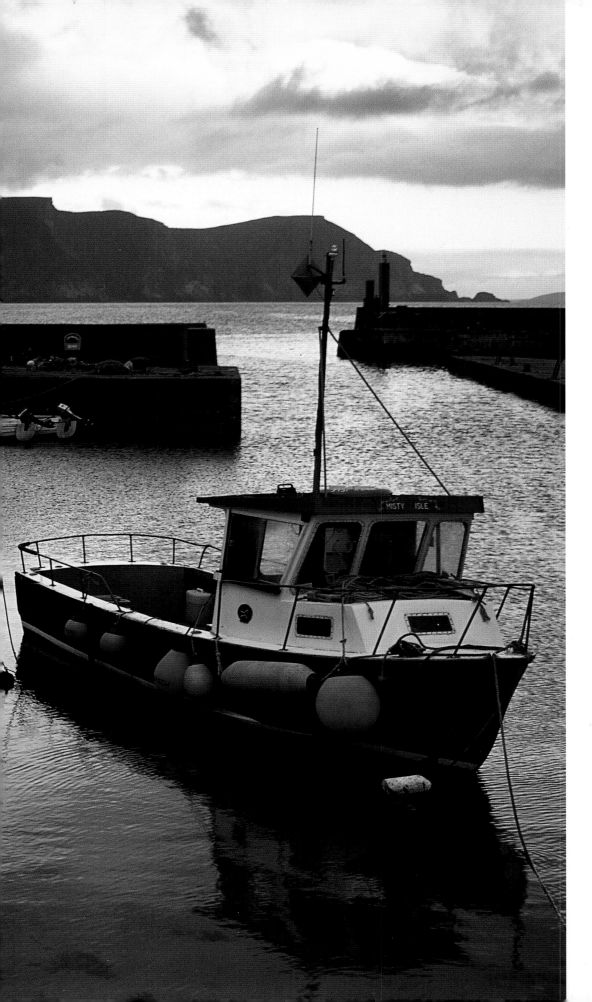

Purteen harbour, Achill Island. The largest island in Ireland, Achill is harsh, mountainous and home to some of the finest sandy beaches in the West. Many have emigrated from its shores but it has transformed itself into one of the most successful tourist locations in the country, much to the relief of the Gaelic-speaking locals who, until recently, were almost entirely dependent on money sent from relatives abroad.

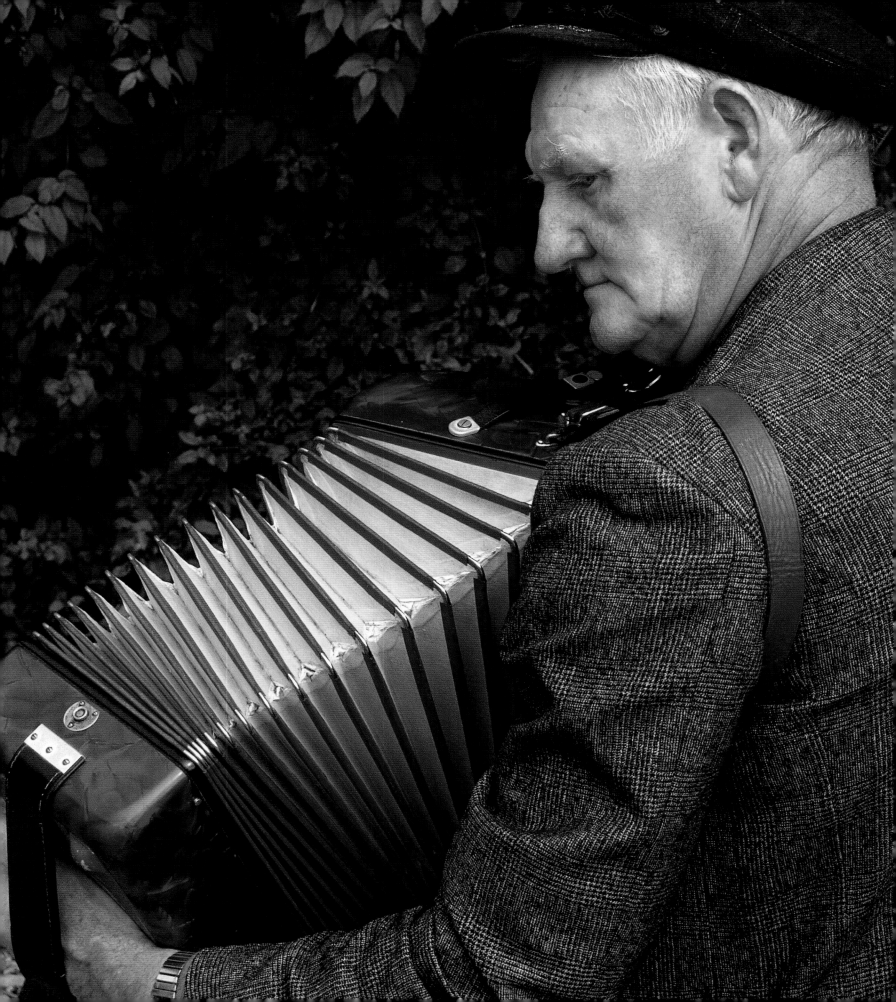

p addy Quinn, a resident of the Aran Island of Inishmore, Co. Galway, plays his accordion. The piano accordion is looked down upon by some traditional music followers because, in terms of its tone and its rhythmic capabilities it's rather a law unto itself. It comes into its own when a joyful, filling sound is required for a *ceilí*, a celebratory affair with mandatory dancing. ➳

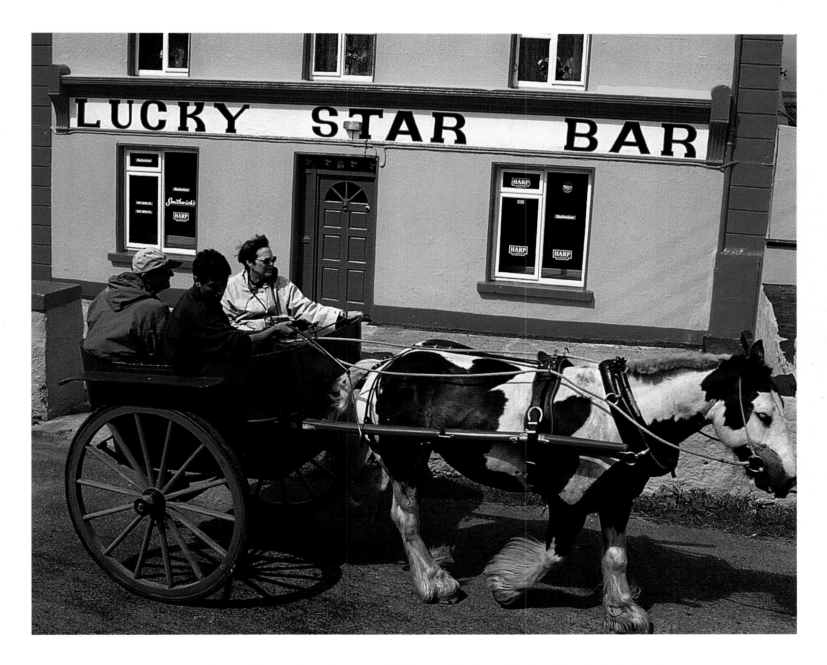

a horse pulls a cart along the streets of Inishmore. The Aran Islands are imagined as isolated, yet they are visited increasingly by foreigners. Many local residents have chosen to return after long spells spent abroad, particularly in Britain, Canada and the USA. ➳

he plain front of a pub in Sneem, Co. Kerry. The village, which stands at the foot of Knockmoyle mountain, is one of the most colourful in Ireland: every house is painted a different colour, reputedly to help drunks find their way home safely. Such delightful tales ensure a steady stream of visitors, helping to bolster the local economy.

*a*n old 'Button A' style telephone box in Cromane, Co. Kerry. These rather outdated means of telecommunication are still found in rural areas. They get their name because when callers insert a coin and receive a reply they must then press the A button and the phone should accept the coin. If there's no answer, they press the B button and the coin is returned. So much for the information superhighway.

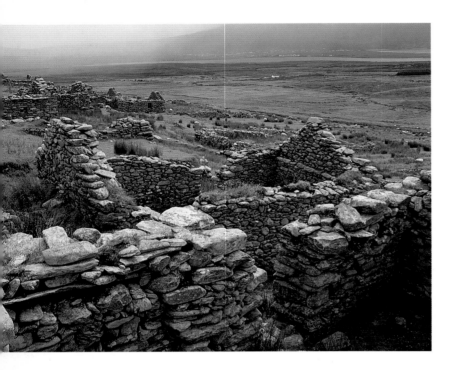

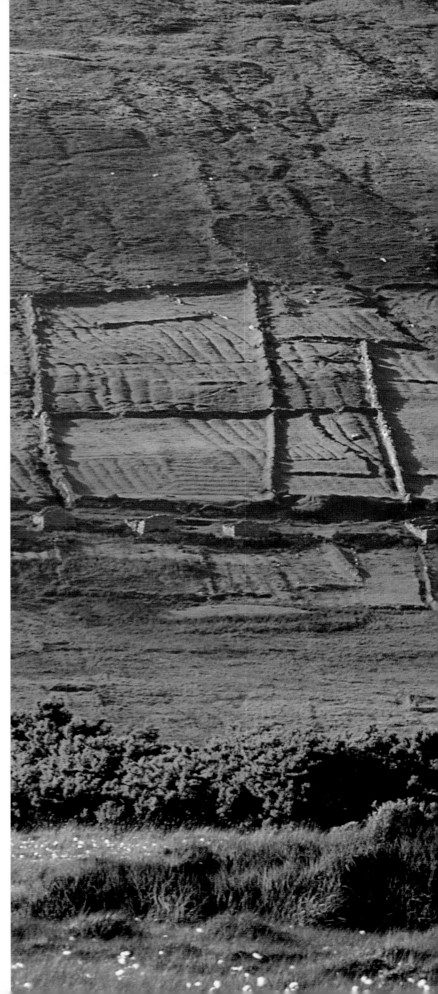

*t*he deserted village of Slievemore, Achill Island. This ghostly place of stone and lichen was once a 'Booley' village, one occupied only during the summer months when herds of cattle were driven to the island's uphill pastures. The practice of seasonal migration, called transhumance, dates back to ancient times and died out relatively recently. ❧

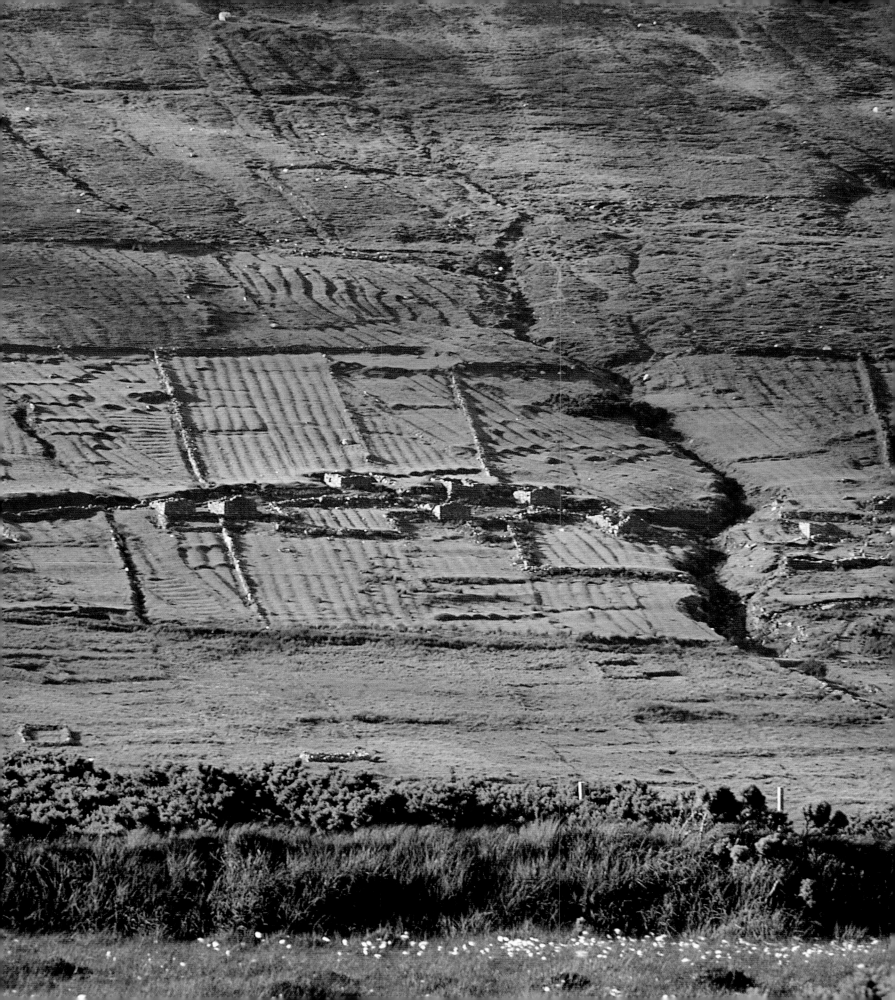

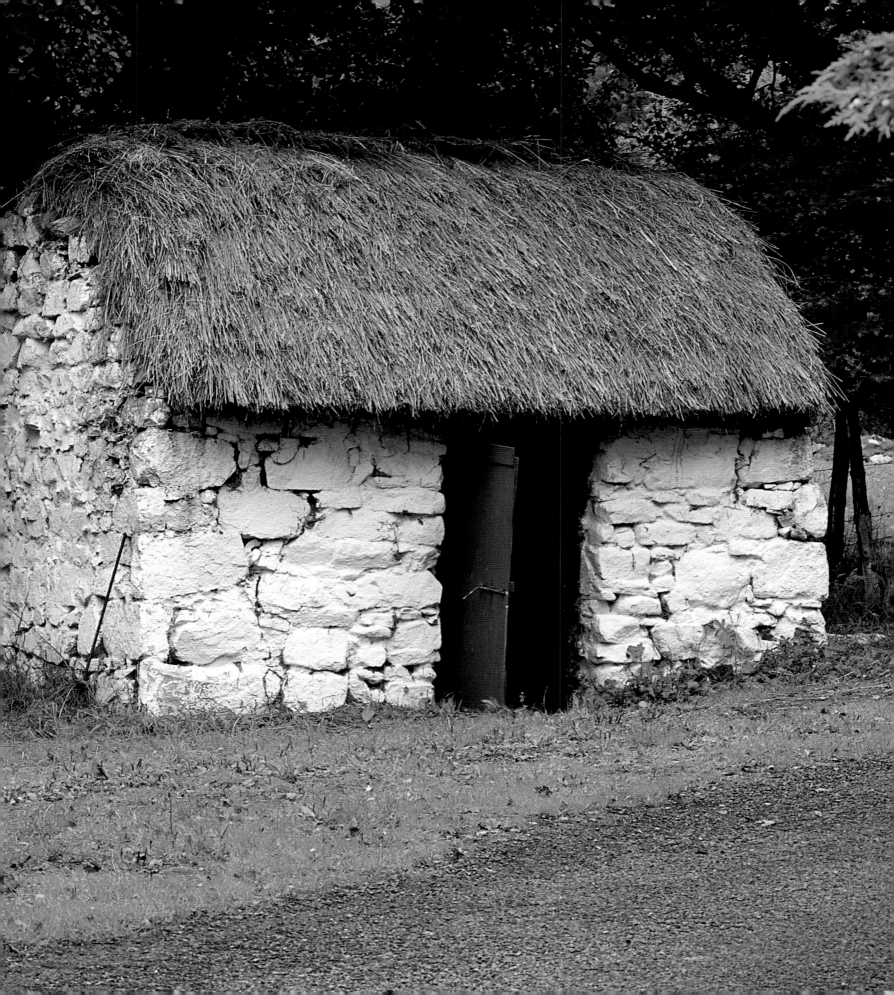

pubs, like the ancient institution of Wren's in Castleisland, Co. Kerry (left), were the traditional solace of the hard-pressed agricultural labourer. ∾

the Lusitania Memorial in Cobh's Roger Casement Square (right) commemorates the sinking by a German U-boat in 1915 of the liner *Lusitania*, torpedoed as it made its way to Cobh harbour. Cobh is the principal port of south-west Ireland, and the setting-off point for thousands upon thousands of Irish emigrants. Its place in maritime history is secured by the fact that the first ever transatlantic steamer set sail from here in 1838. ∾

a thatched hut near Lough Gill, Co. Sligo (previous page). Built of clay with rarely more than two rooms, these traditional homes of Irish peasantry may look romantic but were far from comfortable to live in. Critics of the much-disparaged modern Irish bungalow should spend some time living in this enduring symbol of poverty. ∾

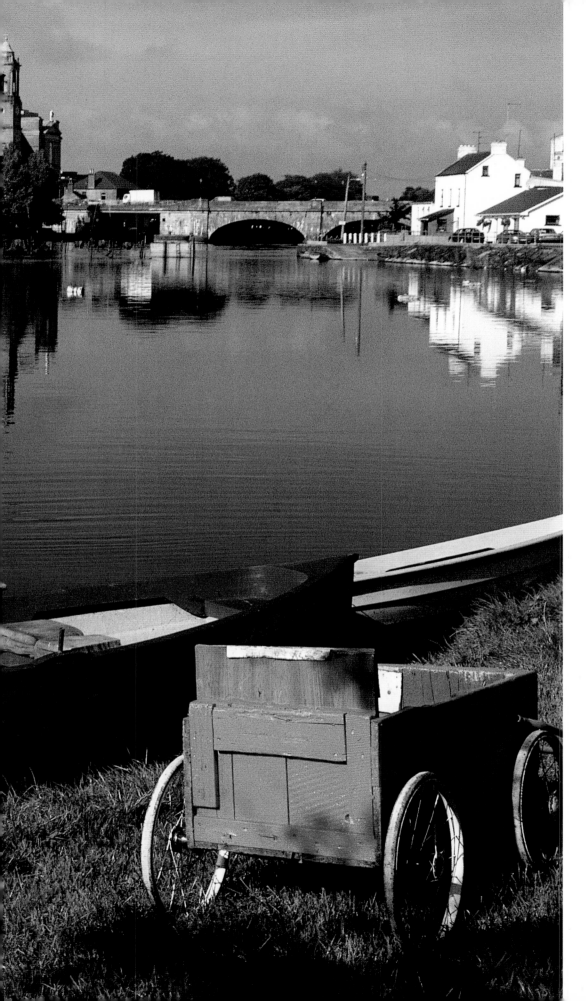

a boatman on the River Shannon, the British Isles' longest, at Athlone, Co. Westmeath. The town was the last bastion of the Anglo-Normans: beyond this crossing of the Shannon lay the Gaelic lands and, during the Williamite wars, most of its Catholic population was forced to flee west. Even today, half of Athlone stands in the eastern province of Leinster, the other in the western province of Connacht. One native who left Athlone and gained international success was the tenor John McCormack, one of the greatest singers of the century and a star of New York's Metropolitan Opera. The gramophone with which he travelled the world is now displayed in the town's museum. ❧

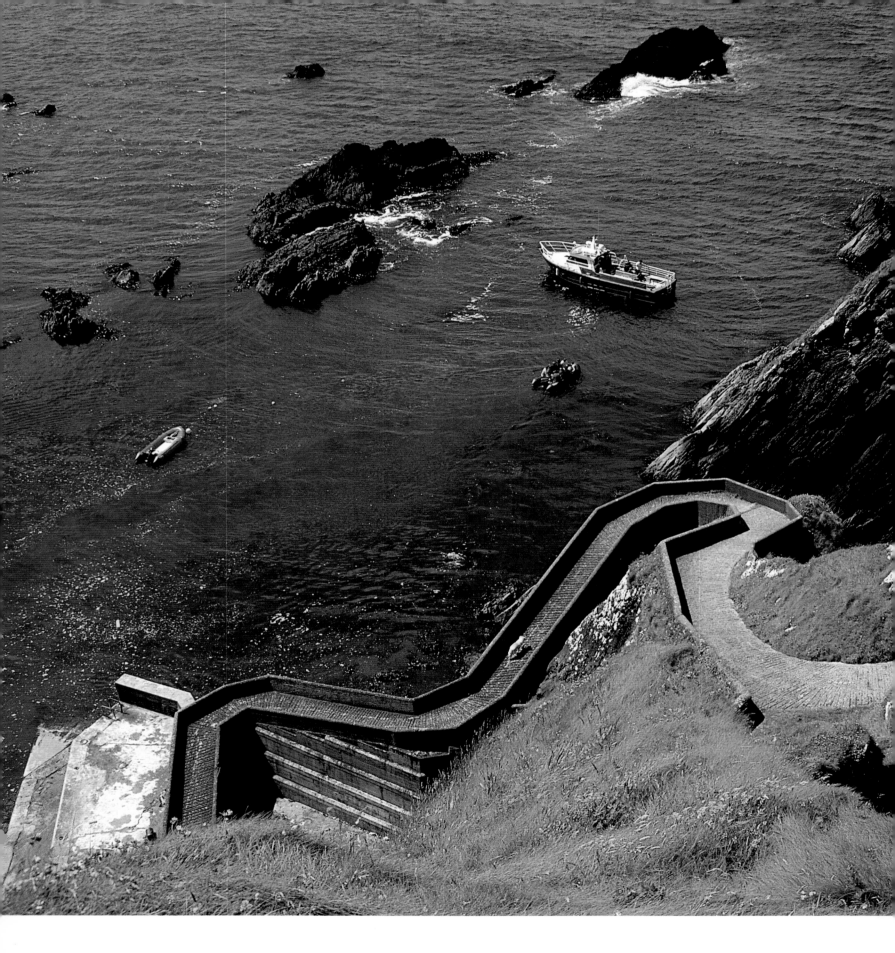

he pier at Dunquin, Co. Kerry, from where visitors take the boat to the Blasket Islands. Deserted since 1953, the Blaskets were once home to a thriving, Gaelic-speaking community, famous for its literary achievements. Writers such as J. M. Synge and Brendan Behan idealised the Blasket islanders as a communitarian Celtic society, artistic, courageous and classless. The islanders spoke of the mainland as another nation, yet the harshness, the rigours of their lifestyle proved unattractive to the young, and their culture survives only in the work of writers like Peig Sayers, Thomas O'Crohan and Maurice O'Sullivan.

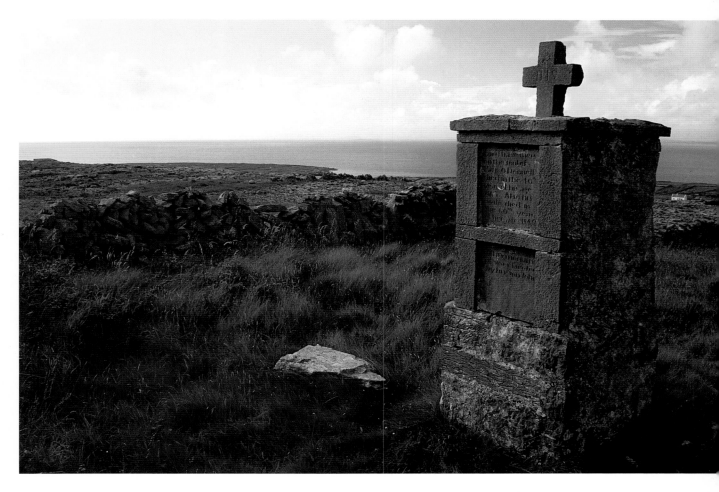

memorial cross on the Aran Island of Inishmore, Co. Galway. There are many crosses on these islands, and most of them commemorate fishermen lost to the sea. The harsh reality of life on the Aran Islands would almost certainly have gone the way of the Blaskets had it not been for the incredible mythologising which took place during the time of the Gaelic Revival. Tourism now sustains Aran and the islands' fascinating culture. Standing above the cliffs, looking out on to the wild Atlantic, it is not difficult to imagine America as the next landfall. Many Aran islanders have struck out on that course in search of 'honour and promotion'.

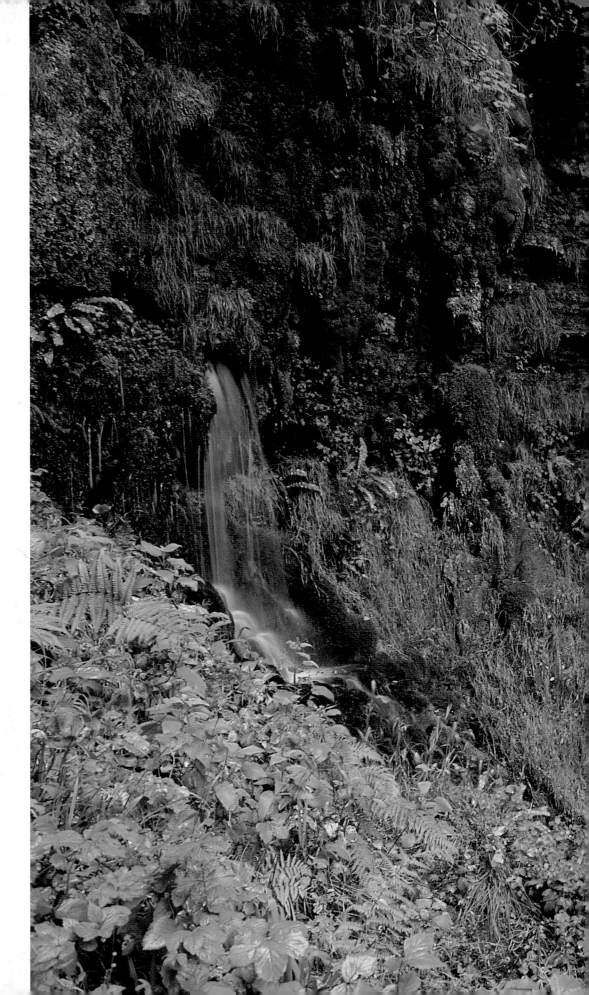

'Where the wandering water gushes
from the hills above Glencar.'

Glencar waterfall, Co. Leitrim, the setting for one of W. B Yeats' early masterpieces, *The Stolen Child*. The loss of Ireland's children to emigration was the great tragedy of Yeats's generation and, at the time, seemed irreversible. Yeats's poem continues with some of the most famous lines in Irish literature:

'Come away , O Human Child!
To the waters and the wild
With a faery hand in hand,
For the world's more full of weeping
 than you can understand.'

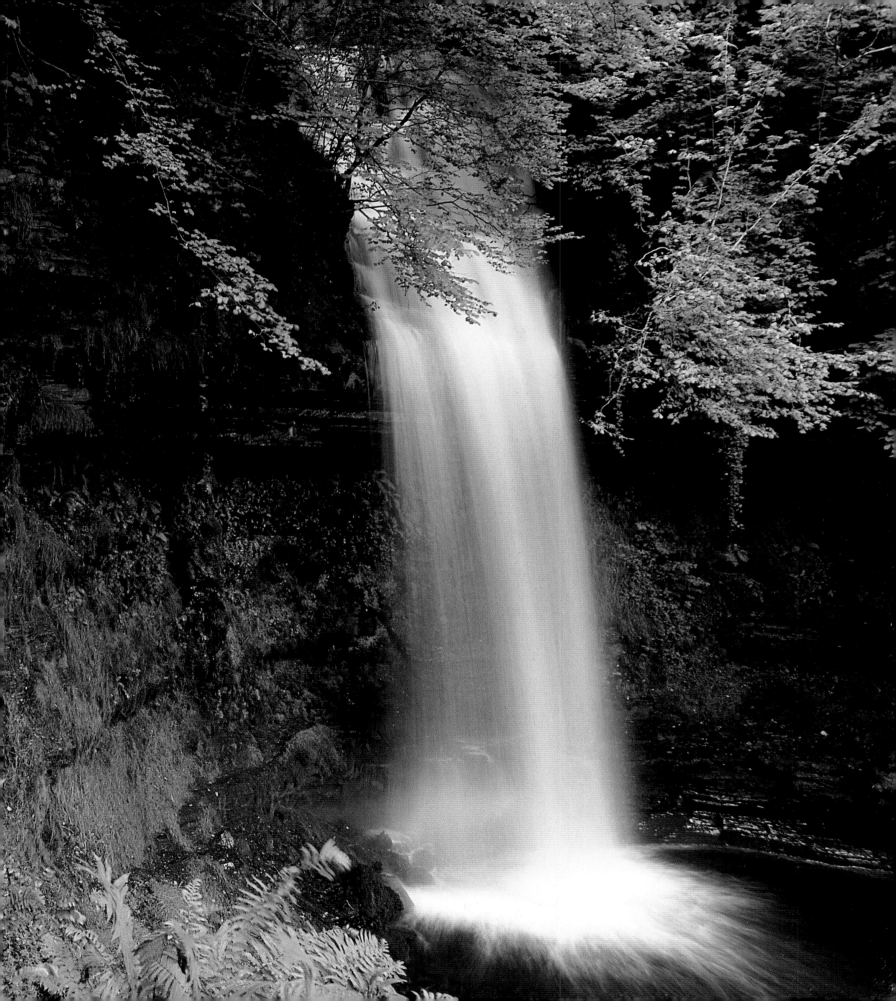

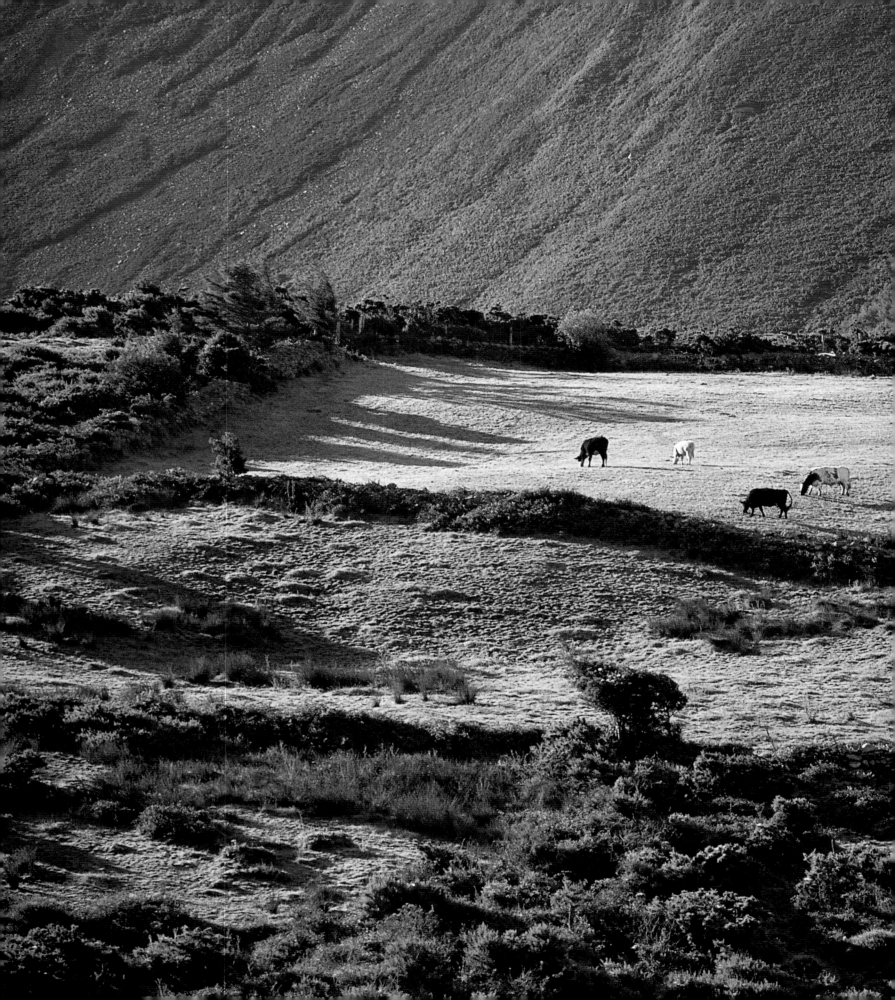

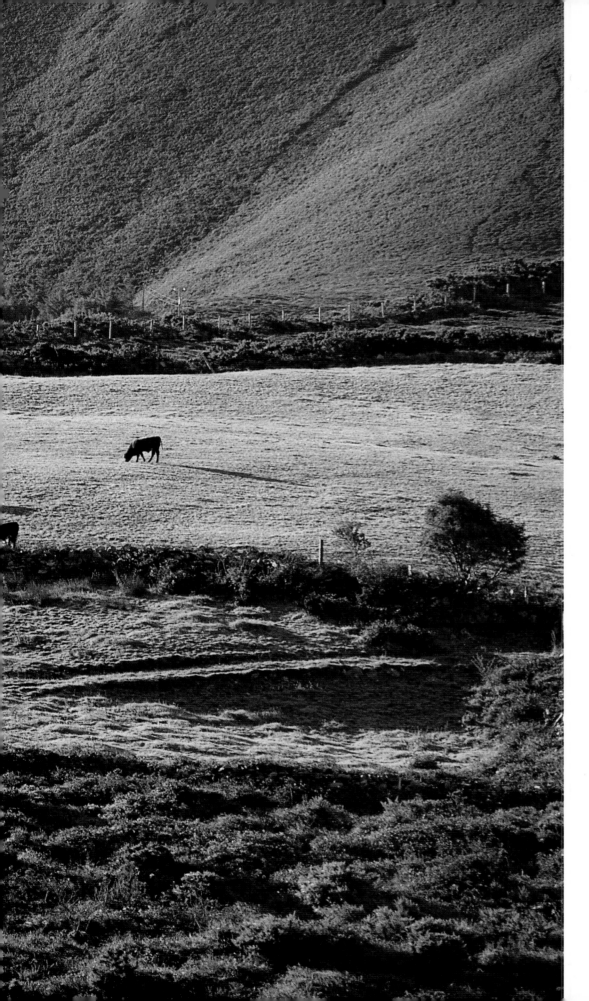

attle graze in the lush Kerry landscape near Kilorglin. Not everyone in Ireland lost out in the years of emigration. Many landlords were able to amalgamate the plots abandoned by arable farmers and concentrate on the more prosperous pursuit of pastoral farming. Kerry is famous for the quality of its dairy products, especially butter. ❦

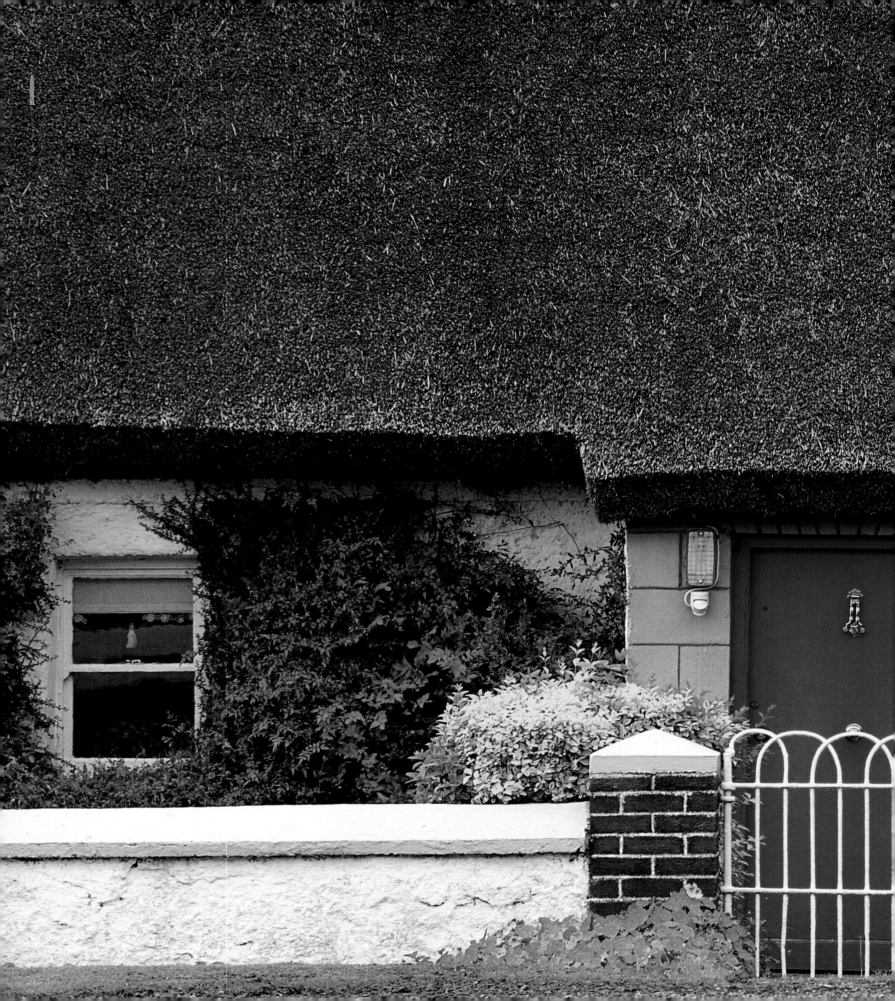

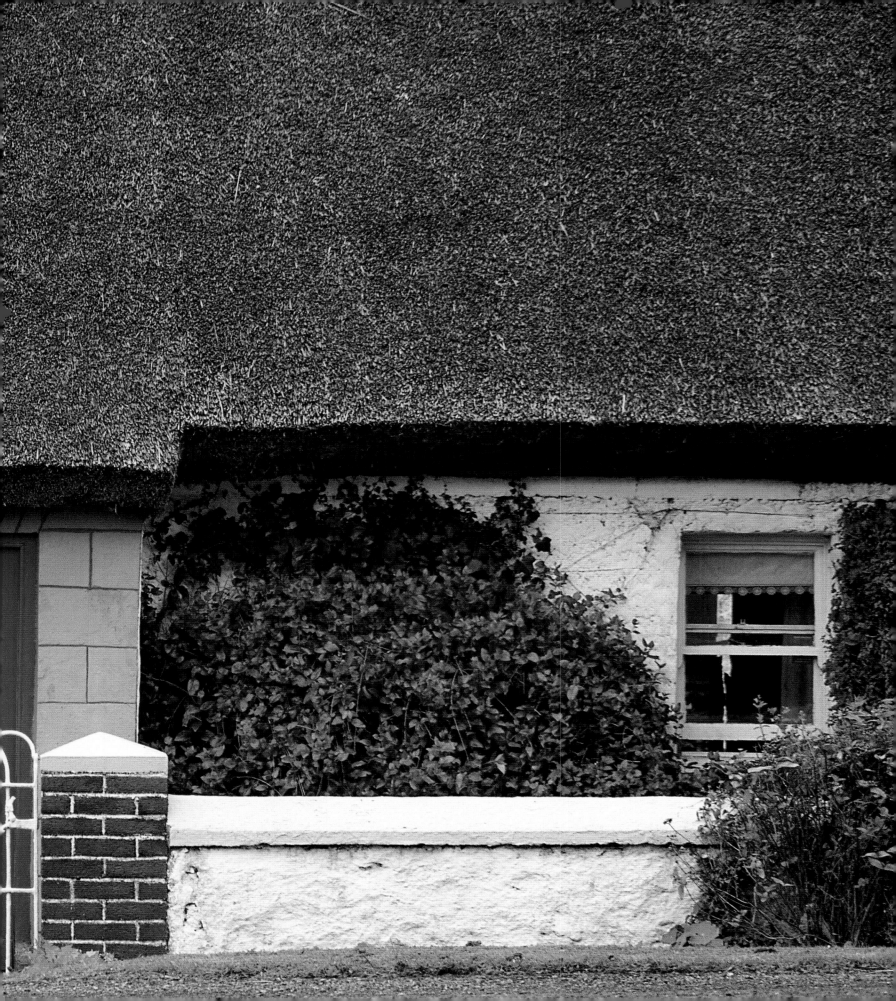

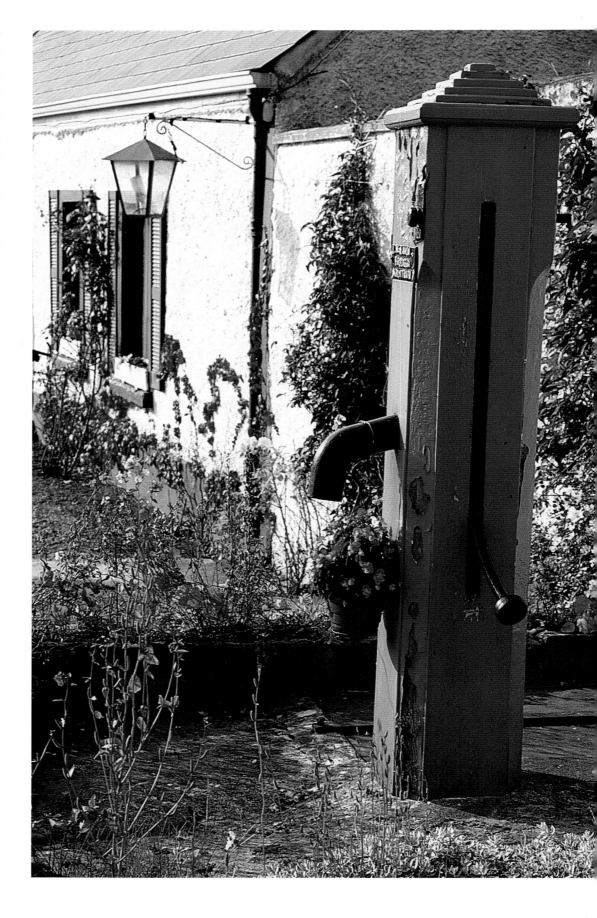

a thatch cottage in Ballysadare, Co. Sligo (previous page), that stands in some contrast to the poky, damp cottages associated with the Irish peasantry. This cottage, altogether larger, bears more relation to the English style of thatched cottage, and was a symbol of the prosperous Protestant Ascendancy, who could trace their ancestors back to medieval Anglo-Norman immigrants. Some middle class homes make the most of features from a previous age such as this village pump (right, Ballinakill, Co. Laois). ∽

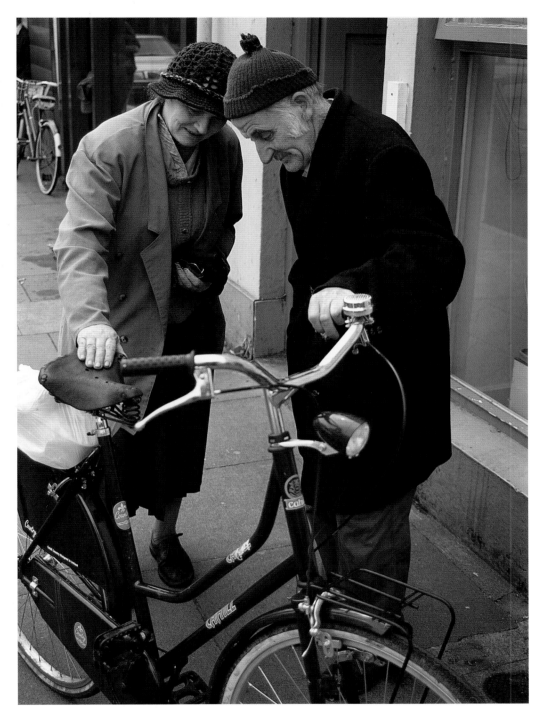

the Irish have long had a love affair with the bicycle, a vehicle perfectly attuned to the quiet roads and langorous pace of rural Ireland. No other means of transport brings you closer to the rhythms of life. Flann O'Brien's classic comic novel *The Third Policeman* envisaged a creature that was half-human, half-bicycle, while some literary critics have claimed that Samuel Beckett's long-awaited character Godot was named after a famous Tour de France rider. The bicycle first became popular in Ireland in the early years of the 20th century: it was all most people could afford. Its suitability for leisure and sport has made it a permanent fixture of the Irish landscape. ✑

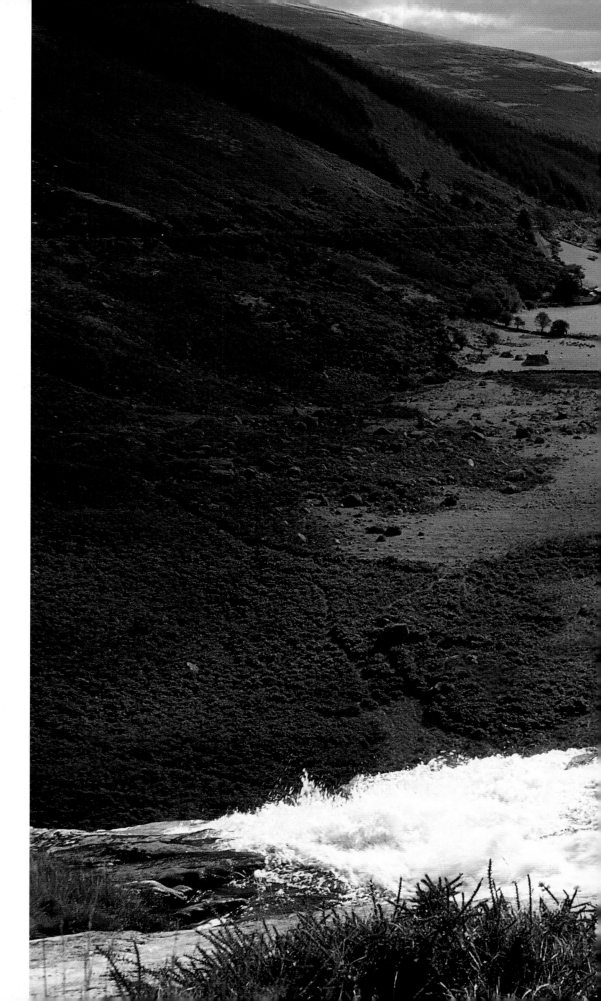

lenmacnass waterfall, Co. Wicklow. It is hard to believe that the savage, inhospitable Wicklow Mountains are just half an hour from Dublin. For centuries they were a stronghold of Irish rebels who fought and harried the English forces of the Pale. But the Great Famine had a devastating effect on the local Gaelic population: 25,000 died or were forced to emigrate from Wicklow's famished land in the 1840s. ∾

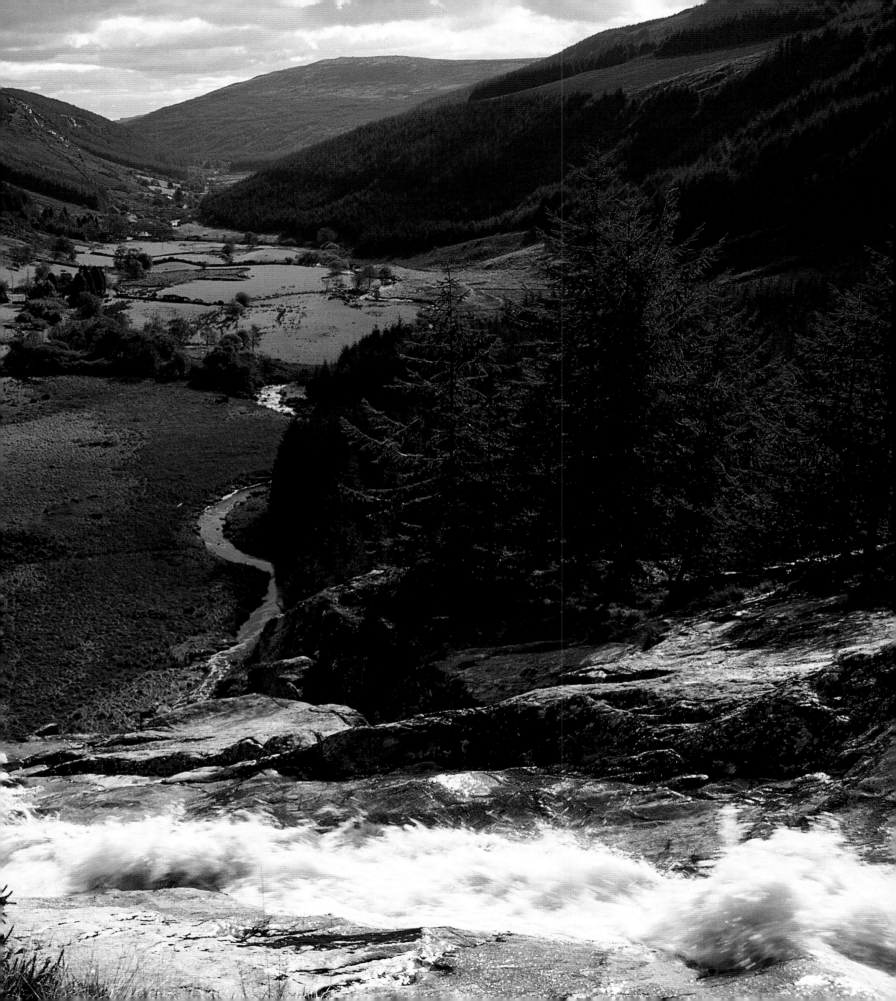

Raincín's newsagent in Adare, Co. Limerick displays Gaelic lettering and the newspapers of the world. Ireland is famous for its diaspora, yet it has received its own share of immigrants, too. The area around Adare is known as the 'Palatine' because of the German Lutherans who, escaping religious persecution in the south of their country, settled here in the 18th century. Watch out for locals with names like Ruttle and Teskey.

*t*his is what is meant by diversifying: James J. Harlow's fine little pub in Roscommon town stands next to his undertaking business and furniture store. What the connection between the three is may be hard to establish, but this juxtaposition gives new meaning to the idea of a leaving drink.

Index